TX
MAGAZINE

Pirate radio dispatches
from eighties London

Edited by Stephen Hebditch

TX MAGAZINE: PIRATE RADIO DISPATCHES FROM EIGHTIES LONDON

Edited by Stephen Hebditch.

Published by TX Publications, BM Box 9867, London, WC1N 3XX.
Web: www.amfm.org.uk / E-mail: amfm@amfm.org.uk / Twitter: @amfmldn.

First edition 2017.

Printed and distributed by Ingram Spark.

ISBN 978-0-9932652-1-1.

Contents

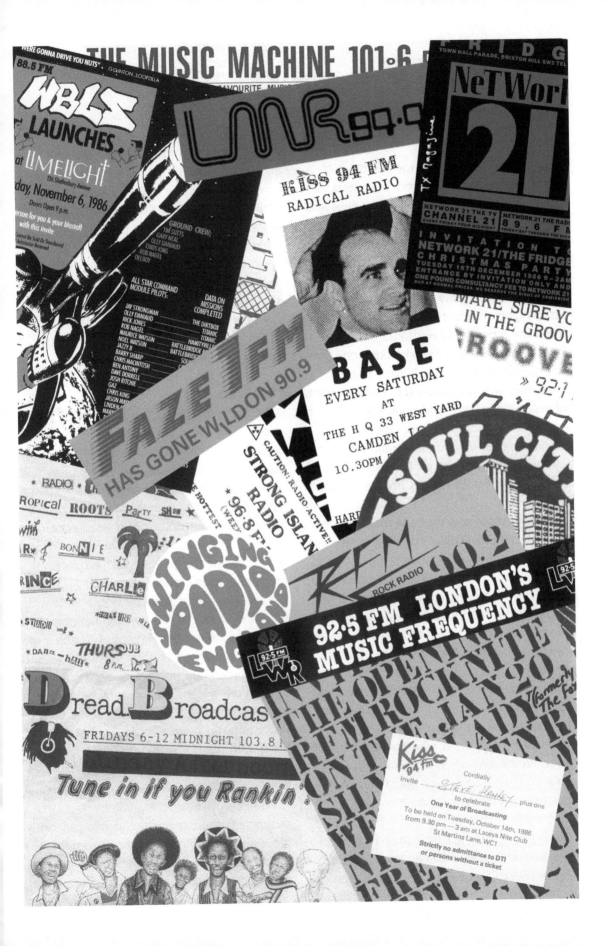

INTRODUCTION

Prehistory

In 1981 my uncle gave me his old hi-fi, a Leak Point One valve amp from the 1950s with a 1960s Pye tuner. It no longer had a case and just sat on a table in the corner of my bedroom, giving off this orange glow in the dark – with the occasional blue sparkle when the valves went weird. Despite its age, this was a big step-up from the cheap Fidelity radio that I previously had, bringing in distant stations loud and clear for the first time in rural Hertfordshire.

Not long after, I was tuning around one Saturday night when I came across pop music where there wasn't supposed to be any – right between Radio Three and Four. My very first pirate station: South London Radio. Soon I was finding others too, dotted around the band between the BBC stations. Thameside Radio, Radio Telstar South, Radio Invicta, London Music Radio...

I still remember now the huge rush of excitement at this discovery that no-one else seemed to know about. Evenings were spent tuning around listening to this strange underground culture. Presenters that were actually real people, rather than embarrassing celebrities like on Radio One. Music that wasn't played anywhere else from the new indie labels that were taking off at that time. Shows where presenters genuinely wanted to involve listeners in their broadcasts. People discovering the creative possibilities of music radio.

And of course there was that element of danger. Waiting on a frequency for a station to come on the air and never being certain that they would. Listening to a show and never being certain what would come next. Never knowing at any minute if the station would suddenly be replaced by static as the DTI struck.

When Radio Caroline came back on the air (to huge disappointment after the fun of the London pirates) I found out for the first time about the anorak magazines that existed. However, they were really for a different generation – the people who had listened to the offshore stations as young people in the sixties – and only included the land-based pirates as a token effort. Then in the summer of 1985 I was thrown out of university having narrowly failed my first year exams. I was studying to re-sit them the following year, but found myself with lots of spare time. And that's when the idea of TX Magazine was born.

TX Magazine

TX first surfaced as a supplement in the Anoraks UK Weekly Report, kind of as a way of gauging interest. AUK was a four page news bulletin covering mainly the Irish pirates and offshore stations plus a bit of land-based pirate news, put together with incredible devotion by Barrie and Ruth Johnson in Blackpool. The idea for a publication that covered the London pirates seemed to go down well, so plans were then made for a proper magazine.

I was looking for some other people to write for it and luckily the first person I approached said yes: Christopher England. I'd been a fan of Chris' shows on London Music Radio and Radio Shoestring, mixing music and listener interaction, and he agreed to write a kind of diary column to try and stir up some controversy and get people talking. Other contributors were harder to recruit and I ended up writing way more than I ever expected – though it did rapidly improve my writing skills.

With the magazine an unknown, it was a problem gathering news and information in the early days. Other sources were ruthlessly raided for pirate radio stories and there was also some occasional jumping to the wrong conclusion based on events heard on the air.

Not long after the magazine started I received a phone call one of the behind the scenes people at a station who gave me a warning about running stories unchecked, making it clear that he'd rather I called their office first to clear anything about them. I then began more scrupulously fact checking.

For the first year, the magazine was put together on a Sinclair Spectrum. This was somewhat embarrassing and never admitted at the time, but it was all I could afford. As well as writing much of the copy for the magazine, I ended up developing the software used to put it together, creating the fonts used (or sometimes hacking games to get interesting ones) and designing all the graphics and layouts. I remember at the time being heavily influenced by Neville Brody and his work on The Face (wasn't every designer), but lacked the talent or the technology to pull it off. However, despite its cheesiness and some of the roughness, people did seem to like the fact that TX at least made an attempt at a more appealing presentation. It certainly made a change from the closely typed pages of print that seemed to be the norm in anorak publications at that point.

TX did follow the anorak magazines in another way though. Thinking it was what people wanted to read, the early magazines attempted some rather tedious logging of every little event that happened during London pirate broadcasts. After a while, it became apparent that this wasn't in fact terribly interesting except to the more, umm, obsessive listeners – and they were the ones who disliked the magazine for its more light-hearted approach. Gradually this gave way to more general news coverage and an increasing emphasis on the programming the stations put out.

The first four issues were printed (well, photocopied) and distributed as little A5 magazines by Anoraks UK. By issue five, however, I was seeing a big future for TX and decided to take things into my own hands and handle printing and distribution myself. Still a teenager, I was probably guilty of a bit of naïve over enthusiasm at the time, so apologies should go to AUK for putting up with me despite all the hassle I undoubtedly caused them.

Radio Today

With subscriptions taking off, expansion plans were made. The magazine began to be available in a few shops, thanks largely to the efforts of one subscriber who kindly trudged round various West End record stores and big newsagents trying to persuade them to stock it.

Alongside the magazine was added the TX Infoline, a telephone information and recorded message service. This has the good fortune to be allocated the memorable 01 400 8282 number and was soon well known throughout the pirate community. This helped hugely in gathering stories and info for the magazine, with many of the stations feeding in news. Generally we seemed to get on okay with most stations, though LWR slagged us off in an article in The Face for revealing technical info and claimed we had been banned from the Virgin Megastore after a storm of protest. Perhaps they were still basing their views on the early issues. In hindsight it was also a bad idea to have run a reader poll where the LWR boss had been voted one of the most boring DJs.

New contributors began to write for the magazine: Clive Glover, Ken North, Lawrence Hallett and even Laser 558's Charlie Wolf. Charlie was cornered at an offshore radio convention and was amazingly easy to persuade to write – a fantastically nice guy all round. Meanwhile, legendary engineer Pyers Easton contributed most of the photographs to the magazine, although this was always tricky given the nature of the subject. We started having editorial meetings, gathering together to plan the next issue on a Sunday afternoon in the café downstairs at the Royal Festival Hall, where no-one seemed to mind us staying for hours.

The biggest change in the magazine probably came with the move to A4 size and the start of the transition to a new name, Radio Today. 'TX' had the disadvantage that only techies knew what it meant, while Radio Today was felt by everyone to be a better summary of the magazine's contents. I think it was also decided with an eye to pirates being given licences and the magazine becoming a kind of industry journal for the new radio stations. In hindsight though I wish we'd kept it as TX. Radio Today was rather bland as a name and the spirit of the pirates was what made the magazine special.

Growth pains

The changes resulted in a big growth in sales, helped also by the increasing profile of pirate radio in the press and the campaigns for licensing more stations. I found myself spending a growing amount of time dealing with journalists and even recorded a couple of TV interviews.

The first was for LWT's The London Programme, which at the time of my initial involvement was 'a sympathetic look at the world of pirate radio', but on transmission had changed focus to being an expose of pirate radio payola. Lawrence Hallett – in his capacity as a 'reformed pirate' – and myself recorded pieces one evening in the specially rented top floor of a restaurant beside the Thames. Our job over, we were then turfed out while the TV crew and some of the more famous of Kiss FM's DJs sat down to a private dinner.

In the end my piece was cut as I wasn't willing to dish any dirt on camera – and I'm rather glad it was given the angle the broadcast programme took. Oddly enough, Kiss FM was the one station that didn't come off badly in the programme, put forward as an example of the kind of station it would be good to licence, unlike the other 'corrupt' pirate broadcasters.

The second appearance was on BBC 2's Asian Eye programme, as part of a feature on the unlicensed South Asian stations broadcasting from Southall. With a somewhat lower budget than ITV, I was interviewed in a TV shop in the high street and then had to do walk shots in the street carrying a copy of the magazine, trying not to get too embarrassed by all the school kids looking on from a nearby bus shelter. It was a good segment though, put together by people with far less cynicism than my first TV experience.

The London Programme did get one part right though – pirate radio was becoming more violent. Transmitters were increasingly being taken not by the DTI but by other stations. Two people from Starpoint were threatened when a DJ from LWR took their rig. When I reported that on the Infoline, the person they named left death threats on the phoneline, which continued over the months to come.

Another time when I was round at an engineer's house, the then boss of one of the leading pirates turned up with his posse and a couple of rigs rather obviously taken from elsewhere that he wanted the engineer to get working. At one time it seemed like everyone was getting in on nicking others' transmitters and there were even tales of unscrupulous DTI operatives selling them back to stations rather than handing them in. The DTI's job was becoming harder though too. What had started out as a fun pastime had now become a serious business for many, and one that they were willing to use muscle to defend.

The end of print

After the magazine's first year I was back at university – well, a different one and on a course more appropriate to my software skills, having unsurprisingly failed my re-sits. With coursework and studying to fit in, it became progressively more difficult to find the time to run Radio Today. The increase in readership and the size of the magazine were also making it harder for our printers to produce it in a timely

manner. This was made worse by the magazine not coming out regularly so they could allocate time in advance on the presses. As a result, some issues spent more than a month at the printers. Radio Today was also costing more and more to keep running, eating into my not exactly substantial savings and student grant. What probably finally did for the magazine was when I hit the industrial placement part of my degree. It just wasn't possible to juggle two jobs anymore and combined with the other factors, Radio Today died.

It's a shame it didn't get a chance to go further as I still think the magazine had a lot of potential and ended up a pretty decent product. By the final issue, I had a much better grasp on what editing involved, the quality of articles was at its highest from a growing team of able contributors and the availability of reasonable, cheap DTP software meant it started to look like a real magazine should.

Despite the erratic publication, we were shifting nearly a thousand copies a month at the end and with some big name subscribers, like Tim Westwood and Coldcut's Jonathan More. Even the Independent Broadcasting Authority subscribed, as of course did the DTI's Radio Investigation Service, at their librarian's home address. Still, maybe it's better to have gone out on a high.

There were of course many things I would have liked to have done better had there been the chance. It would have been nice to have had more photos, though that was always a problem given the need to protect people's identities. There should also have been way more interviews with people and less reliance on second-hand information.

I think there were also problems that the magazine was really bridging a generation gap. The rest of the contributors were older than me, from a generation that was now moving into more established radio, while a lot of the pirates we reported on were of a younger age

– particularly with the big influx of stations that surrounded the whole acid house movement. Perhaps though that gap could be considered an asset – and maybe helped us fulfil the 'For today's listeners and tomorrow's broadcasters' tagline that the magazine used.

What come across as the more naïve pieces now are the ones that dealt with the political aspects of radio licensing. At that age it seemed very simple that legalising a series of stations in a range of different sizes and with a range of different formats was all that was really needed to make everyone happy. The state of commercial radio in London since is testament to the fact that it isn't.

TX often got lumped in with the offshore radio magazines, which took a more right-wing libertarian line and espoused the benefits of a total free market in radio. It was also accused of left-wing bias for featuring black music and minority ethnic stations. We didn't set out to have a fixed editorial line, contributors holding a range of political viewpoints and opinions over what kind of system would best serve listeners. Our shared motivation was a desire for interesting, creative radio of all shades.

We did go in for a fair bit of government bashing over their broadcasting policy failures and ridiculed the DTI mercilessly for their attempts at stamping out the pirates. Here the case was simpler: the authorities were taking away radio we wanted to listen to and failing to come up with an alternative.

Christopher England's columns drew criticism from some people over the provocative style inherited from talk radio. It was also a frustration to Chris that his experience of community access broadcasting was dismissed by newer arrivals because he didn't fit into their political world. Community radio as an alt-left cause had attracted some people who were motivated more by political ideals than by any real desire to make good radio of interest to ordinary people.

AM/FM

While the magazine may have died, the TX Infoline went from strength to strength, taking several hundred calls a week. By now many callers didn't even know it had originally accompanied a magazine and thought it was just a service on its own.

In 1989, with me back at university and a bit more time to spare (a final year project and some important exams coming up? yeah, so...), Chris and I hit on a new wheeze: telephone information services. Up till then you had to pay a large sum to BT and invest in a ton of expensive equipment to run your own premium service lines. However, Vodafone were now offering the ability to do so for a comparatively small sum. Through another provider, Chris had already begun running a newsline about Radio Caroline with impressive results, so we were sure we could make a go of it.

With our lines sorted, the TX Infoline was reborn as AM/FM. As well as the main news line there were also numbers for station listings, a message board with callers' comments and one for extracts from the stations. We lost a few callers who weren't prepared to pay the extra for a premium rate line, but most seemed happy to do so – or just called from work...

The DTI get nasty

By now things were doing pretty well for our new company. We quickly accumulated a number of clients, including a few that were radio or pirate related. Alongside AM/FM, we ran a Radio Caroline Newsline and also sublet lines to Kiss FM, who were using one to run a poll on people's favourite London pirates in their *Free!* magazine. All these were entirely above board, with nothing going on that was in any way illegal. Unfortunately, the Department of Trade and Industry thought otherwise, and apparently had us at the centre of a laughable plot to fund illegal radio stations.

The first we knew of this was when our Post Office box number was cancelled. A brief letter arrived from the Royal Mail informing us that it had been used in breach of the terms and conditions and was therefore being withdrawn. This was a major pain as we were using it for a promotion for a non-radio client at the time. Following this back up the chain of command, Chris got to speak to a person whose job it was to liaise between government departments and the Post Office to enable mail to be intercepted. It turned out that for two weeks previously our mail had been opened, though obviously there was nothing in any of it that showed us being involved in anything illegal. He then gave us a contact in the DTI who was responsible for instigating this particular action.

At the same time, the DTI also began putting pressure on Vodafone. They forwarded on to us several communications in which the DTI made it clear that they did not consider our services to be acceptable and requesting Vodafone to terminate them. Vodafone responded to the DTI that they did not have a role of publisher and the case would be better taken up with us. Vodafone were extremely good over this, especially given that they themselves are licensed by the DTI and could be put in a difficult position as a result of it.

As part of the DTI's investigation, which was focussing primarily on Radio Caroline, we then discovered that our telephones were being tapped, alongside those at Caroline's secret London office and some telephone boxes nearby. This was properly confirmed: not some hunch based on funny noises on the line of the sort heard by conspiracy theorists, but through a contact with appropriate access at BT.

Eventually we managed to speak to the relevant DTI person who reported that they were first alerted to us by the fact that half the pirates in London seemed to be giving out one of our numbers for the Kiss FM favourite station line. Kiss found this hilarious as they'd just got their broadcast licence. The DTI also confirmed

that they didn't consider the Caroline Newsline service legal under the Marine Offences Act. However, uncertain that they could guarantee a conviction they did not want to take us to court – a case against Time Out had recently failed – so were content just to issue veiled threats.

At this point we called in solicitors who wrote a strong letter to the DTI to protest at the action. The DTI eventually conceded that they would not stand in our way should we wish to take another Post Office box number in the future. However, we couldn't get back the original one and it would be impossible to get compensation for the problems caused by its withdrawal.

Vodafone were left alone for a few months, but eventually the DTI began complaints to them again. They responded once again that they did not consider the matter concerned them and the DTI should take it up with us instead. We were never contacted by the DTI directly for some reason...

In 1991 the problem flared up again as they started a new campaign to heavily target Radio Caroline. This time there were also problems with a new set of draconian laws concerning the reporting of unlicensed radio. After Vodafone decided they could no longer support us, the plug was finally pulled for good. We also lost a post box at the British Monomarks forwarding service, the DTI apparently deciding it didn't like letters being sent to the Newsline via that either.

Had they actually taken us to court then it's highly unlikely that they would have won as all that was being done by us was plain and simple news reporting. There wasn't even anything we were doing that would allow a complaint to ICSTIS, the body which regulates telephone information services. The DTI were just content to throw their weight around and try and bully people into giving in, relying on the "well, if a Government department says that then it must be true" factor.

AM/FM Online Edition

Since the TX Magazine days I'd been experimenting with online services. Radio Today had a fledgling news service on a small bulletin board run by Chris. Then, in 1990, access started to open up to the Internet in the UK. This was a huge inspiration to me. Here was a whole new medium that was built from the start to allow ordinary people to communicate with each other in new ways and to let them produce and publish their own content, bypassing the normal media in the same way the pirates had done.

With so much content being generated for the AM/FM Newsline it seemed a shame that it should go to waste. So in 1992 the AM/FM Online Edition was born. This gathered together all the stories from the previous month and put them out in a bulletin, delivered through an e-mail list and the most popular online services.

At that time the World Wide Web didn't exist, but when it did, we had one of the very first non-educational sites in the UK. Eventually though, the AM/FM phone lines faded away much like Radio Today had before. The new laws introduced in 1991 had made it impossible to only report pirate radio, so the emphasis on legal radio gradually increased. However, that wasn't anywhere near so fun and the calls had begun dropping off to a level where it was no longer economic to keep going.

Into the 21st century

Using all the radio material sitting on my PC, in 2001 I assembled a new amfm.org.uk website. Unfortunately though, only the files for the last few issues of Radio Today had survived and it took until 2014 before I had enough spare time to put the rest of the magazine online. Following many hours of tedious scanning, correcting and converting all the text, I was heartened by the response to the updated website and the interest many people still had in the pirates of that time.

In 2015 the Institute of Contemporary Arts in London decided to do a small exhibition on the soul music pirates of the 1980s as part of a series looking at largely forgotten areas of youth culture. Much of what was shown came from my collection of pirate memorabilia, including copies of the magazine that visitors could read. Talking about the subject with the curators encouraged me to finally bite the bullet and write the history of London's pirates I'd been thinking about for so long. Since London's Pirate Pioneers book was published that summer there has been a steady stream of interest in reading the original TX. So here in print for the first time in a quarter century is a warts-and-all slice through the magazine's three year history, taking you back to life on the illegal airwaves in eighties London. I hope you enjoy it.

Stephen Hebditch (aka Steve Hamley)
Written October 2001, revised April 2017

ABOUT WHAT IS INCLUDED

Selection

What is reproduced here is a selection of pieces from each issue chosen to illustrate what was happening on London's pirate airwaves and the changes to radio during the time that TX Magazine was published. Articles on other topics like radio production and offshore broadcasting were omitted, as were the full station listings in each issue, which would be rather repetitive over the course of a book. These can still be found at www.amfm.org.uk/tx.

For those articles that were more visually interesting the original magazine layouts are reproduced, taken from the masters where possible. For most of the longer articles just the text has been used, with minor alterations to correct spelling and grammar mistakes and to fix some style issues. There were also tiny edits to a handful of articles for space reasons.

The magazine did not always get everything right. Stories would change as they were passed along and especially early on it relied on interpreting what came through the airwaves. The more authoritative, fact-checked history can be found in London's Pirate Pioneers.

Contributors

Huge thanks should go to all the people who contributed to TX, Radio Today and AM/FM. To Christopher England especially for all his help and for putting up with me through a series of sometimes silly enterprises. To Clive Glover and Ken North for all the articles and stories and help with the listings. To Lawrence Hallett, Aleks Wright and Charlie Wolf for their contributions. To Pyers Easton for the photos and other help and his former colleague Andy Howard, now sadly departed, who also chipped in with help.

Special thanks should go to the late Barrie Johnson and to Ruth Johnson from Anoraks UK, without whose help TX would never have been able to get off the ground. To all the DJs, engineers and stations who made it all possible and for the most part were incredibly good about helping us out. And to the long-suffering subscribers, callers and online readers who for some reason wanted me to keep publishing this stuff despite all the hitches and the increasingly erratic publication schedule.

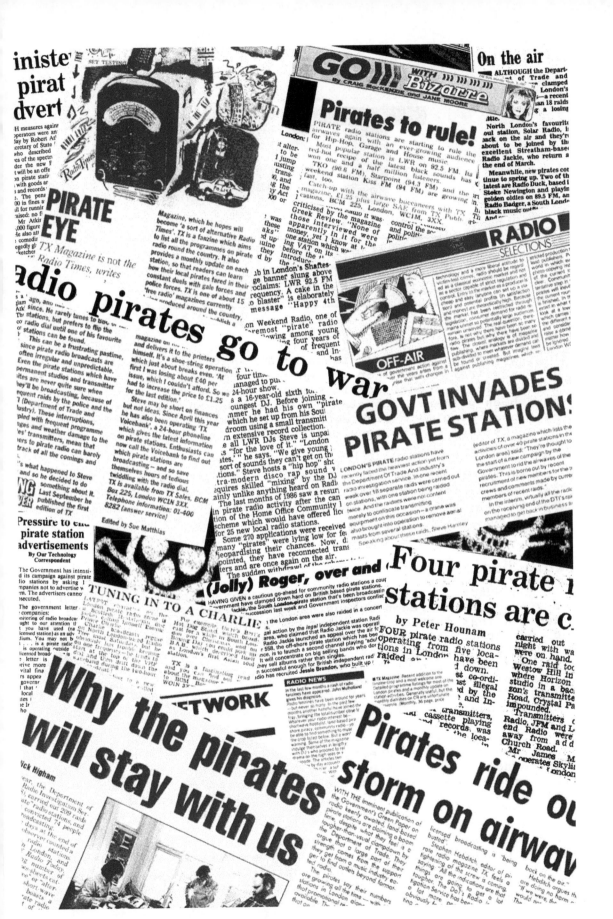

iniste'
pirat
dvert

PIRATE EYE

TX Magazine is not the Radio Times, writes

radio pirates go to war

GO))) WITH Bizarre
BY CRAIG McKENZIE and JANE MOORE

Pirates to rule!

On the air

ALTHOUGH the Depart- of Trade and clamped London's a recent g 18 raids a losing

North London's favourite out station, Solar Radio, back on the air and they' about to be joined by excellent Streatham-based Radio Jackie, who return the end of March.

Meanwhile, new pirates continue to spring up. Two of the latest are Radio Duck, based i Stoke Newington and playin golden oldies on 89.5 FM, an Radio Badger, a South London black music out

RADIO SELECTIONS

OFF-AIR

GOVT INVADES PIRATE STATION

Pressure to en pirate station advertisements
By Our Technology Correspondent

TUNING IN TO A CHARLIE

(Jolly) Roger, over and

Four pirate stations are c.

by Peter Hounam

FOUR pirate radio stations operating from five locations in London have been raided

RADIO NEWS

Why the pirates will stay with us

Pirates ride ou storm on airwav

LONDON'S FREE
RADIO MAGAZINE
OUR ADDRESS
LONDON
WC1

Issue 1, Compiled 16 September 1985

Information

Welcome to the first issue of TX, a trial issue to find out if there is the need for a newsheet dealing solely with the London pirate scene. Previously other newsheets and magazines have been primarily concerned with either the offshore or Irish stations. We aim to give you the information you want about the future of radio, the landbased pirates, rather than nostalgia for days past.

We would welcome any comments you have to make as well as any information about the London stations that you have. That way TX will become THE free radio publication for London and the Home Counties. "

Radio Horizon

On Sunday 15 September Radio Horizon closed. The station has suffered in the recent stepping up of raids by the DTI and decided that instead of trying to continue as a pirate it would do better to wait and try to get a community of interest licence. This also means that Horizon won't be seen as an illegal operation when it comes to allocating licences, possibly increasing its chances of getting one. Jackie was promised it wouldn't be discriminated against in the allocation so Horizon are obviously hoping to be similarly treated.

Chris Stewart, the station's founder and owner throughout its four year life, presented the final programme leading up to the studio close at 4.30 PM. A live broadcast from the Harrow Leisure Centre presented by the station's DJs then finally closed the station. Chris gave the usual thank yous to the station presenters who'd been with it since October 11, 1981 - quite a number in fact. Also credited (amongst others) were Radios Jackie and Skyline and Chris Miles (under his real name) who did alot of the transmitter work. He finally closed the station with the record "Thinking Of You" by Diana Ross, used by the station in its promos during the campaign before the 1984 Telecommunications Act came in.

TX: London's Free Radio Newsheet

Radio Free London

After an absence of around a year Kenny Myer's RFL is back. The station broadcasts on 92.0MHz VHF between 9PM and 12PM on a Sunday. Its format is from pre-punk type rock of the kind Caroline used to play to heavy metal. The station first appeared in the late seventies (as far as we're aware) and has since re-emerged with increasing gaps between broadcasts. The new version seems more stable than the last with presenters Mike Barnett, Steve Ego, Jenny Leather and Kenny Myres. Engineering is carried out mainly by Steve and Kenny. Letters can be sent to BCM Box 92, London, WC1N 3XX - the address last used by London Rock, a station run by Mike Barnett. Reception should be quite good across most of London.

Particularly interesting in the light of recent developments was suggestions from RFL of what the letters DTI really mean! e.g. Dead Transmitters Incorporated, Department of Terminally Insane, Department of Tragic Injustices! The station was also said to be using a special device called a "Nigel Grant Box" (remember him from RFL past and City Sound Radio) which, when installed on top of a tower block, kept the DTI away from the transmitter!!

Alice's Restaurant

Fans of Alice's Restaurant "London's Premier Rock Station" will be pleased to know that it is now back on the air after a six month absence - long by their standards. The station returned to the air on 93.0MHz VHF on Sunday 15 September after testing (we think) the week before. Unfortunately, out at the TX HQ it was only possible to just make out what the station was due to interference from Radio 4. In addition, this was not helped by low power and not tremendously good modulation quality. Now Horizon's gone from 94.5 maybe they'll move back to the better 94.4, hopefully with more power like they used to. Letters can be written to the station still at the old address of ▮ St Barnabas Road, Woodford Green, Essex, IG8 7BY.

Phoenix Radio

Phoenix Radio is now back on the air as well, though whether it's restored its links with Alice's has yet to be determined. It is now broadcasting on 90.9MHz VHF on Sunday from 4.00 PM. The station is once more field based so hours are limited and sound quality not as good as it used to be - on September 15 they were also overmodulating making reception on some receivers difficult. The format is the standard alternative music format - described as "Nightime Radio 1" by some people.

TX: London's Free Radio Newsheet

Imagine

Imagine (not called Imagine Radio) appear to be off the air currently but should be back. They broadcast to North-East London on Monday nights between 9PM and midnight with a rock format. They are a field based operation on 92MHz VHF with a power between 30W and 90W. The station is run by Steve Martin with help from Dave James and Pete Simmons. Alice's Restaurant's Dave Collins has also guested as a presenter, and Brian Marshall will probably also be appearing sometime.

Small Items

Solar will be back shortly to try and continue with their soul service, possibly now with back up help from their old rivals Horizon. LWR will also be back soon - according to Kenny Myers as soon as they can afford the rent for a new studio! South East Sound is still off the air following a raid not long ago. London Greek Radio is currently off the air. Voice of the Immigrant appear to have given up, as have Asian Peoples Radio. They all appear to be waiting to see who gets the first community licences. KJazz was featured in the Observer a few weeks ago - run by Solar's Giles Peterson, more on them next time.

Station Guide

Alice's Restaurant	93.0MHz VHF	Rock/Metal	Sunday 9AM-9PM
Contrast FM	90.0MHz VHF	Soul/Funk	Every Day 7PM+
Imagine	92.0MHz VHF	Rock	Monday 9-12PM
KJazz	94.0MHz VHF	Jazz	Sunday 10AM-10PM
London Greek Radio	104.0MHz VHF	Greek	24 Hrs
LWR	92.5MHz VHF	Soul/Funk	24 Hrs
Phoenix Radio	90.9MHz VHF	Alternative	Sunday 4PM
Radio Free London	92.0MHz VHF	Rock	Sunday 9-12PM
Solar Radio	102.5MHz VHF	Soul/Funk	24 Hrs
South East Sound	1188KHz MW	Rock/Pop	Sunday 1-5PM

Number 1

TX

October 85

TX1: OCTOBER 1985

N E W S D E S K

>>>> NUJ REJECT
>>>> COMMUNITY RADIO

* The setting up of community radio has hit a big snag - the National Union of Journalists has refused to back any stations.

They claim that current redundancies in commercial radio will worsen with the introduction of community radio and as a result they refuse to back it.

This means that stations will be unable to employ most professional journalists, having to rely instead on unexperienced staff. However, some station managers view this as an advantage...

>>>> NEW NATIONAL STATION
>>>> PLANNED

* A green light has been given for the setting up of a nationwide commercial station as well as an FM stereo network for Radio 1.

The IBA, in charge of Independant Local Radio, has long been envious of the BBC's Radio 4 which ILR is unable to match quality-wise. It's thought that many MPs and Home Office officials take the widely held view that ILR is generally mindless trash so the IBA is keen to show them that a commercial radio station can do better. The fact that the general public aren't really interested apparently doesn't matter.

The plans for the new station have not been welcomed by existing stations. ILR is worried that community radio will take their small advertisers and the new network their big advertisers leaving them with nothing.

>>>> COMMUNITY RADIO PANEL
>>>> UNFAIR CLAIM

* Community radio applicants are worried that the panel choosing the stations is not going to be fair over who it gives the licences to.

The Home Office has had to have its arm severely twisted to get this far with community radio but still doesn't appear to be too interested in it succeeding, shown by the fact that two out of the six people on the panel come from the BBC and IBA.

Many applicants feel that they might choose stations which are bound to fail in order to protect their monopolies. This is made easier by the fact that panel doesn't have to publish the stations' applications (or even a list of who applied) or say why they chose a station!

>>>> PIRATE RAIDS
>>>> INCREASE

* Up to the beginning of October this year there have been 180 raids on landbased pirates along with a total of 88 prosecutions - the highest figures since the Tories took office.

>>>> FREQUENCY
>>>> CHANGES

* Various ILR and BBC local radio stations are being shifted around the VHF band currently to "improve reception" for listeners in their areas. It's also noted that they're very carefully closing up some of the gaps used by existing pirates...

NEWSDESK

>>>> COMMUNITY RADIO
>>>> TRANSMITTERS

* Marconi have introduced a range of transmitters suitable for community radio stations.

The XE15T is suitable for the 10W neighbourhood stations and the 2501 for the 100W community of interest stations. Medium Wave transmitters are also on the way. Accurate prices are not yet known but are thought to be in the region of £5,000! Rather higher than the £250 most pirates spend on their transmitters. Service contracts will also be available on top of those prices.

>>>> ILR IN
>>>> PAY DISPUTE

* Capital, LBC and the rest of the ILR stations may be off the air for two days soon after a breakdown in pay talks. Staff are only being offered a 4.5% increase this year which they claim is unfair given that some station managers have been given 80% pay rises.

Some ILR staff, such as technical operators, get below the level of what is generally agreed as "low pay" and far less than similar staff around the world.

>>>> COMMUNITY RADIO
>>>> APPLICANTS' FIGURES

* The Home Office has received 92 applications for the 21 community radio licences.

>>>> RADIO 1
>>>> ROYALTIES

* Phonographic Performance, the company which collects money from radio & TV stations for playing records, has decided to start charging the BBC for the specially recorded sessions is uses, such as on the Janice Long and John Peel shows.

These are used to allow the station an extra hour of music a day, as they're only allowed 10 hours of records. Radio 1 is worried that this change may mean the sessions eventually get included in the time available for records which would lead to either shorter hours or yet more chat.

Radio 1 pays out around £4,500 pounds in record copyright every day and the BBC has a total bill of £11,500,000 each year!

>>>> RADIO JACKIE
>>>> IN COURT

* Radio Jackie staff have been fined a total of £3,900 over charges relating to the raid on the station in February.

The staff were also ordered to pay costs of £100 each and the equipment and records seized, valued at £20,000 new, was ordered to be confiscated.

Worst hit was the joint programme controller at Jackie, Dave Owen, who was fined £750. This was because he had been previously convicted in 1983, and at the time warned that if it happened again he would be sent to prison — but luckily for him they decided not to take this particular course of action.

THE COMMUNITY RADIO EXPERIMENT

Steve Hamley tries to find out what exactly the Government's proposals are

This feature seemed to be doomed to failure. First, the Home Office doesn't seem to be overly concerned about Community Radio and consequently has published very little about it. To further complicate things, what they have published is only available to the stations applying, definitely not magazines like TX. As a result of this we tried to get the details from another source, but unfortunately these haven't arrived with three days to co to publication date. So, we'll make do with what we've got.

What is community radio?

We start off with a difficult question to answer. Everyone has widely different views about what it community radio is, but it can be roughly split into two sections. First, are what's called "Neighbourhood" stations, similar to what Radio Jackie, Skyline or Radio Amy have broadcast – local items for local people.

Second, are "Community of Interest" stations. These can be specialist music stations, such as Solar, Alice's Restaurant and K-Jazz; ethnic stations, such as London Greek Radio and Asian People's Radio; or stations for other minority groups, such as "Our Radio", which broadcast a couple of years back with shows specifically for women, gay people and other minority groups.

The proposed stations

London has been assigned five stations: two community of interest (one in North London on MW and one in South London on VHF) and three neighbourhood (based in South-West London, South-East London and North London, with one on MW and the rest on VHF).

The stations will operate for a two year experimental period initially, controlled directly by the Home Secretary – the first time in Britain the Government's had direct power over a radio station. Following the experiment the Government will then decide whether to continue, and if it does, a bill will need to be put before Parliament.

Programme content

Essentially the stations will be allowed to broadcast whatever they want – with regard of course to the laws of libel, obscenity, etc. The only rules that have been made about programmes are to do with advertising. The stations will be free to decide how many adverts they want to carry each day, but must make sure that they keep to the "British Code of Advertising Practice", the same standards newspapers and magazines have to keep to. However, music will probably still be limited to 9 hours needle-time a day, something the Musicians' Union aren't keen to see change.

So, you could be hearing almost anything on the stations. But to give you some idea, a brief look at the basic formats that are likely to be used. First for neighbourhood radio:-

1. Music, hourly news, regular features, local info: the Radio Jackie / ILR type of format which you all know and love (hate?).

2. Speech-based, access radio: open access for anyone wanting to broadcast, such as local arts groups talking about their work, coverage of local council meetings, the residents association on problems in council houses or people talking about their hobbies.

Now it starts to get tricky: community of interest stations:-

1. Ethnic: It seems likely that no station of this kind will get a licence for one ethnic group only, so various groups have got together so that they stand a better chance. Such stations would set aside programme blocks for

different groups, for example South Asian for three hours, then Greek for three hours, then Afro-Caribbean for three hours.

2. Minority interests: like the above station but with programmes from other minorities too, all assigned different slots to broadcast in.

3. Specialist music: jazz, soul, rock or whatever. May operate like the ethnic stations with different slots for different kinds of music.

4. Other speech-based stations: The remaining category, stations like 2, but specialising in one topic only like programmes for children or poetry.

Finance

Stations will be able to raise money however they want. Most look likely to take advertising to finance the stations using one of two methods. First is "spot" advertising, like that on ILR already. Advertisers buy a 30 second spot several times a day to publicise what they've got to offer. The second kind is sponsorship, restricted to neighbourhood stations only.

You've probably heard sponsorship on the Network Chart Show "Brought to you by ILR and Nescafe", well you could soon be hearing "And now the cooking show, sponsored by Jones Grocers in Mitcham".

Stations can also raise finance without advertising, such as happens on some stations in Australia. There, once a year like Capital's Help a London Child, they have Help an Ozzie Radio Station. With the help of grants from councils, trusts etc., these manage to keep the station going through the year.

Overheads

Although running a community radio station is very much cheaper than an ILR station there are still bills to be paid. First, the station needs to build a studio, costing anywhere between £10,000 and £25,000 plus building conversion. Then, once the stations are on air, the Government wants payment for supervising them,

probably around £1 per £1,000 earned. Next, there are copyright fees if the stations are going to play records. These are not cheap, accounting for around 15% of most stations' income. However, the Performing Rights Society is considering lowering royalties for stations with small audiences.

Then there are equipment costs. Community stations will own and maintain ALL their equipment, very much cheaper than with ILR where the IBA rents transmitters tor ILR stations, at an enormous cost. Rent and Rates in London account for quite a large amount too. Finally, there are staff salaries. Most stations will employ a few full-time staff to keep the station running and part-timers or volunteers to present the programmes. But whether people will be happy to keep on working long-term for very little no-one yet knows.

Technical matters

Just about the only certain thing there is, and even then the Home Office has made several mistakes along the way. In London the VHF neighbourhood stations have been assigned powers of 10W and the South London community of interest station 100W. Put simply, this means that you can receive the small stations well for a 2-3 mile radius and the larger station for around 6 to 8 miles. For the MW stations the radii are similar – the neighbourhood station has a power of 25W, the community of interest 100W. However, at night the distance at which you can receive them will dramatically shrink, particularly in winter. The VHF stations will be able to operate in Stereo (after first being refused this), but given that they will be on small budgets this facility will probably only end up being used with adverts and records.

The start

The Home Office is choosing which stations will get the licences at this moment in time. Since the Newsdesk page was prepared the

number applying has shot up to 245 for just 21 licences. Even more amazing, 64 of them are applying for the North London community of interest licence, 31 for the South London licence and a total of 38 applicants for the neighbourhood stations.

A decision on who gets the licences will probably be made in December by the panel of six people appointed by the Home Office. The will also put forward any suggestions on whether more licences should be given out and make other suggestions to improve the stations.

Most will then finally make it to the air at the first half of next year – the start approaches...

TEKNIX: PIRATE TV

Steve Hamley discovers how easy it is for pirates to make the jump from radio to television

"I'm convinced there'll be three or four stations operating in London by the end of the year" claimed Jim Young of Channel 36, "London's First TV Pirates" back in March. So just where are they then?

Pirate TV in Europe was probably born in the Netherlands, due mainly to the rapid investment in cable TV in that country. The cable networks use high masts to receive, for example, British TV and although the picture quality isn't as good as the other cable channels there is a demand due to the better programmes in Britain. Because these signals are weak the pirates can easily block them out with their own programmes, beamed from a small, directional, transmitter nearby. However, by law, once the network notes a pirate that channel has to be switched off – due to most stations broadcasting pornography – not what you'd expect in the middle of a programme from Aunty Beeb!

The first British attempt was Telstar TV in Birmingham, who operated in early 1984. They broadcast after BBC2 closed down each Saturday, showing a mix of feature films and pop videos, generally available from home video suppliers. However, after only a few broadcasts they disappeared – reportedly "for fear of the consequences of being caught". The DTI was devoting a large effort into trying to track them, but with an unattended £300 transmitter coupled to a £200 video recorder playing 3 hour tapes the risk is much less than 24 hour a day pirate radio stations.

Later the same year in October pirate TV came to London with Channel 36. The people behind it had been waiting for eight months for a test and development licence to develop their revolutionary low-power transmitter and finally in desperation decided to put it on the air. They rented a room in London's Pirate Row and staged two test transmissions after calling in the media. Two days later the licence arrived from the Home Office and they stopped broadcasting.

Next in line was Thameside Television. This station began in late '84 but was doomed to failure from the start. The station had poor picture quality and the sound could only be received by tuning in on an FM radio. Even a diet of new pop videos and new feature films couldn't bring in an audience and the station closed shortly after.

So who's going to be next and will they be able to keep going where others have failed before. The opportunities seem too good to be true, once you've got the £8,000 Of equipment together. Given the record companies treatment of pirate radio stations programme

material won't be too hard to come by. The DTI can't trace pirate TV stations too easily at this moment in time so transmitters should stay put. Plus, an added incentive for some people, advertising rates can be higher, giving a nice large profit to buy new equipment and pay your wages.

Just how would a simple TV station on air for a few hours at the weekend (such as some in Italy) be operated. Most of this kind will probably use "Non-Real Time Editing" which, in simpler terms, means that recorded programme chunks are edited together rather like film. Stations can operate live but this pushes the cost up enormously.

For a small local station people won't be over-concerned about the picture quality so a home video format, such as VHS will probably be used. First, they need programme material. This may be recorded by the station using a home video camera and portable recorder which can be used both in a studio and outside. Other material may be purchased or contributed and included in the programmes.

Once the material has been organised the editing starts. Domestic equipment is unsuitable for this and something like two JVC BR8600 recorders (£2,500) will be used. These are fairly simple machines but sufficient for the purpose. At this point captions may be added. There are special machines to do this but these are extremely expensive so home computers are usually used. With some it's possible to overlay graphics on the screen, but with most graphics will have to be inserted between segments, rather like on "The Max Headroom Show". Extra music and speech will be added at this point too, from a simple mixer connected to the usual sources. This brings the total up to about £7,000 for the studio, and of course extra pieces of equipment will be brought in to further enhance the programmes as money allows.

Transmitters today are getting cheaper and cheaper, mainly due to the introduction of new transistors to replace the expensive valves used up till recently. There are still a number of problems, though, which means that very few stations build and maintain their transmitters themselves.

First, TV signals are not symmetrical like radio. One side of the signal is sharply cut off while the other is not. Stations can ignore this but may cause interference to neighbouring channels as well as reducing the power

Second, the very high frequency and large bandwidth make design of the power amplifier more difficult for amateur builders, but this is getting progressively easier. The main difficulty is the lack of up-to-date information – most published designs use £5,000 valves which are now unobtainable. It's possible to get away with just connecting a UHF amplifier to the back of a video recorder for very low power (1 mile radius) but not without putting out harmonics all up the band!

Altogether, a transmitter and a suitable specialist aerial would cost around £1,000 for a high quality system, around £500 with lower power and picture quality.

Most stations would use a separate studio and transmitter site for two reasons. First, the ideal location for a studio is not the ideal location for a transmitter aerial. Second, a transmitter may have adverse effects on some of the studio equipment. A single VCR can be easily screened, a whole studio can't.

ON-AIR: PIRATE RADIO

LWR

Easily London's number one station at this moment in time and sounding it's most professional for some time. LWR began as London Weekend Radio on 1 January 1983 and despite being hit hard by the DTI, even on its very first broadcast it's kept on coming back. Originally the station had a more general pop format, although with a soul bias, and operated only on Saturdays. At this time it was run by John Dawson and Johnny Heyward.

Then on 10 March 1984, the station went 24 hours a day. They'd been hit hard by the DTI the previous few weeks and decided that this was the only way to survive. The station quickly established itself with its new operation but closed down in August when the new telecom act came in.

However, John Dawson couldn't keep away from radio for long, and seeing as Horizon was still on the air he decided to restart the station on his own. This time the station changed to a black music format and has continued with this ever since.

LWR has been more adventurous than many of the other stations, both in the style of the presenters and the records chosen. Continuous listening is less irritating than on many with a good varied choice of music in the different shows.

NEWS

LWR was one of the rare stations actually broadcasting at the beginning of October, but it wasn't to last. On 2 October during JJ's programme between 2 and 4 in the afternoon they were raided by the DTI.

This was apparently prompted by Capital Radio who claimed that their programmes were being jammed by LWR in the Crystal Palace region. Eric and Co had found the transmitter in a room in Westow Hill, Upper Norwood and traced leads going up the chimney some 200 - 300 yards over the roofs of surrounding buildings. At the other end in a house in Church Road they found the studio and JJ.

He was fined £200 plus £60 costs and all the station's equipment was confiscated. They were kind enough to let him have his bag back, but not his cassettes containing various jingles and mixes.

Back came LWR on Monday 14 of October, resuming normal transmissions immediately with very little testing. Very few problems have been heard since, with the station starting stereo broadcasts in the last week of October. This time it's REAL stereo - last time there was simply the pilot tone to turn the stereo light on and good old mono still. Although this trick looks good this simply makes reception more difficult in outlying regions...

To finish on the news side, with the setting up of their sales office in Covent Garden to handle advertising and gigs it seems that there'll be no shortage of finance to keep them on the air for a good few years to come.

ON-AIR: PIRATE RADIO

Unfortunately we don't have a full programme schedule for LWR at present so instead a look at some of the presenters and their programmes.

John Dawson: Already mentioned on the previous page, but I should point out that he also presents programmes on a Friday and Saturday night between 10PM and 1AM. A mixture of some of the best soul tracks around with some soft soul to send you to sleep. He's come a long way since RFL!

Mark Mason: Presents the breakfast show every morning between 7 and 10 with a mixture of soul, travel and some news. Mark started off with John's previous station, South London Radio (the very first pirate I ever received when I was just 14!). Back then he was playing stuff from indie labels before moving on th indie dance music and eventually soul.

Zac: Presents the 10 to 12 spot each weekday morning. Predominantly reggae but some soul and lovers' rock. Also each week includes the charts from several specialist shops around town and listeners on the phone.

Ron Tom: Soul for the weekday lunchtime 12 to 2 spot.

J.J.: Still on the station and presenting 2 till 4 each weekday with mainly reggae.

Tim Westwood: LWR's Hip-Hop and electro man. More soul biased with his afternoon show (4 - 6) these days but now doing a couple of specialist shows on Tuesday and Sunday evenings.

Jasper: Drivetime 6 - 8 on Monday, Wednesday and Friday. Another member of the reggae squad.

Mike Steel: Drivetime on Tuesday and Thursday plus Sunday morning 9 till 12. Mainly soul and including the jam session and some traffic news on drivetime.

That covers most of the main weekday programmes, next month we'll try and give a full round-up along with details of those jocks we've missed, out this time, including James, Barry B, Barry Gibbs and Eddy James.

You might also like to know that LWR has available a newsletter and car stickers, sent out on receipt of an SAE to their mailing address below.

```
FAX.FAX.FAX.FAX.

ADDRESS: ████ New Cavendish St.
         London
         W1

FREQUENCY: 92.5MHz VHF
POWER: 250W
LOCATION: Crystal Palace
PRESENTATION: Live
TIMES: 24 hours a day
FORMAT: Soul/Reggae/Electro
```

ON-AIR: PIRATE RADIO

RADIO FREE LONDON

Back once more on London's airwaves is RFL, the first ever pirate station to make regular use of the VHF band in London. Since its beginnings in the mid-seventies it's gone through many incarnations, with many of its staff moving onto other stations. Examples include John Dawson, the man behind both South London Radio and the successful LWR; Mark Ashton and Andy Mason who've both worked for Skyline; and Nigel Grant who runs the occasionally appearing City Sounds Radio (quite when his tastes changed from Heavy Metal to Soul we're not too sure!).

The station last appeared in 1983 running from 6-9PM on a Sunday for several weeks until Nigel Grant was twice caught minding the transmitter on top of a tower block. As far as we know, he then left the station and Kenny Myers and Mark Ashton weren't willing to continue on their own.

RFL re-emerged this year in September broadcasting between 9 and 12PM on a Sunday with Kenny Myers, Steve Ego, Jenny Leather and Mike Barnet (who was last heard back in '83 running London Rock single handed). The station continues with its soft / progressive rock format sounding even more like the seventies Caroline than Imagine (these comparisons are getting out of hand, next we'll have "Caroline sounds even more like RFL sounds like Imagine sounds like Caroline"!... Confused?)

NEWS

October doesn't have much news as RFL was another of the stations got by Eric and the boys on 6 of the month. Whether that's it from RFL for another year time will only tell.

The station had changed hours to 6-9PM the previous week as the nights were getting longer and spotting a DTI van in the dark is even more difficult than in the light. After coming on the air normally with the Mike Barnet show the station then dissappeared when it was time to change over the tapes at 7PM. Apparently the crew managed to get away.

```
FAX.FAX.FAX.FAX.

ADDRESS: BCM Box ██
         London
         WC1N 3XX

FREQUENCY: 92MHz VHF FM
POWER: 50W
LOCATION: Crystal Palace
PRESENTATION: Taped
TIMES: Sunday 6-9PM
FORMAT: Rock/Metal/Progressive
```

□ NUMBER 2: DECEMBER 1985 □ 90P

▶COMMUNITY RADIO
 THE LONDON APPLICANTS
▶CHRIS ENGLAND
 CAROLINE'S NEW YEAR RESOLUTIONS
▶THE ERIC FILE
 THE DTI RAID KISS-FM
▶TX SURVEY
 VOTE FOR THE BEST OF '85
▶ON-AIR
 THE COMPLETE LONDON GUIDE

TX2: DECEMBER 1985

THE COMMUNITY RADIO EXPERIMENT APPLICANTS

We look at who wants a licence and how the winners will be chosen

There have been 245 applicants for the 21 community radio licences in the UK as a whole. For London there have been 82 applicants for the three neighbourhood radio licences, 33 for the South London and 69 for the North London community interest licences. With figures like that, how on earth do you decide who to choose?

As this is an experiment you obviously need to have as much variety as possible, so that at the end you can see what works and what doesn't. As a result the best won't necessarily win, but the most different will.

First in the factors they'll take into account is geography. No, you don't have to have an "O" level in it to run a station, but the stations need to be spread out over London, not all cluttered together in one bunch. Obviously certain parts of London are wealthier than others so they'll want to see if a neighbourhood station in Hackney would work as well as one in well-off Hampstead.

Next comes the all important money. The station must have sufficient finance to be able to start, and then be properly organised so as to be able to support itself once on the air. As mentioned last month the stations can raise money how they wish: spot-ads, sponsorship, subscription and local grants. Again, they'll want the widest possible choice. Most applications I've seen have been expecting to have advertising, so a station with other fund-raising methods possibly stands a better chance.

For the pirates going straight there's another hurdle. Although the Home Office has said they won't bar any stations or staff that have operated illegally, they can't be seen to be licensing too many. This would lead to complaints that all people have to do is set up a pirate and they'll be given a licence – something the Home Office is keen to avoid.

Finally, comes the actual programmes (always last). Here again they're after variety, and nothing that's already done by existing stations – no mini-Capitals. Access is the keyword at the moment – stations are all after involving the community as much as possible. This will probably take a while to work, given that communities have never had the chance before so won't know what to do.

For details of the sorts of programming that are being offered see the last issue's feature on the community radio proposals – back copies are still available.

Neighbourhood radio applicants

VOICE OF THE PEOPLE: Based in the Production Village, Cricklewood – who provide facilities for TV and video. Running costs paid for by sponsorship, programmes a mix of local music, news and access.

TW SOUND: Ex-Border Radio from their pirate days, operating in the Twickenham area. Providing programmes produced by local interested parties, trained by the station. Run as a non-profit-making co-operative with a 12 strong management team and listeners' advisory committee.

RADIO JACKIE: Extending its ideas from its illegal days. Mixture of local content in with mainstream music, plus some feature programmes and public access. Panel of 15 community representatives advising the stations on its programmes.

CROYDON 104: Run by ex-Sovereign staff Andy Millard and Simon Parry (of Free Radio

Waves fame). Structured clock format giving continual flow of top forty music and local information.

RADIO CROYDON: An expansion of Whitgift Radio, currently providing music for shops in the Whitgift shopping centre. Some of its staff previously involved in Skyline Radio. Music. Phone-ins and community news.

SKYLINE RADIO: Camberwell-based ex-pirates with similar sort of format to Jackie.

SINA RADIO: Asian community radio, from pirate offshoot of Asian People's Radio. Mainly music based with some features.

RADIO THAMESMEAD: The cable station staffed by 15 volunteers. Currently vastly underfunded as can't take advertising. Hoping for a licence to enable them to continue more easily. Mixture of music, local news and information and specialist programmes in the evenings.

HACKNEY RADIO: a co-operative aiming to serve minority community groups. Programmes, including music, produced by local groups in studio workshops.

RADIO TCU: Operating from the City University's School of Journalism with input from students and local community.

URBAN CITY RADIO: Group of 10 people involved in community work and journalism. Programmes include community news, independent arts and access slots. Sort of City Limits on the Radio.

RIVERSIDE RADIO: Main opposition to TW Sound, run by David Dimbleby, broadcaster and local newspaper owner. Going for more commercial, entertainment-led programming.

TOWER RADIO: Broadcasting to the city workers by day, local residents by night from the top of Guy's Hospital.

Also, amongst many others: Greek Community Radio, Meridian Broadcasting, Arabic Community Radio, Central London Radio, W.H.I.C.H. Voice Radio, Radio Friendship, Tower Hamlets Radio Project, Inner City Radio, The Sound of London, South Side Radio, Latin Radio Company, Link Radio, Radio Simplicity, Radio Harmony, Docklands Community Radio and Crystal Radio.

South London community of interest applicants

FORMAT RADIO: Providing three sections of programming: jazz, album rock and folk music. Run by a management committee of 20, including a few who'll be familiar to quite a few of you. Nuff said...

SOUTH LONDON COMMUNITY RADIO: Better known as JFM and less of a mouthful. Aiming more at being an ethnic station than its pirate opposition, with half its airtime devoted to community news and information and greater emphasis on black music other than soul.

SOUTH LONDON RADIO: Solar Radio going for a specialist music licence. Predominantly soul / commercial black music with specialist programmes, both music and speech, in the evenings and at weekends. Links with local press for news. Management structure ensures good community representation.

LONDON MUSIC AND COMMUNITY RADIO: Horizon Radio we think, but could be wrong. Promising 24 hours a day laid-back soul music with some news and community features.

BLACK COMMUNITY RADIO: Probably one of the most commercial of the stations. Planning to broadcast a variety of black music, local news, current affairs, phone-ins and national news.

AFRO-CARIBBEAN COMMUNITY RADIO PROJECT: GLC funded and baaed at their Brixton Enterprise Centre. Supported by 10 black community organisations around London and with a management drawn from many of them. Mainly speech based and proposing to set up a black radio school to train people for the station and elsewhere.

RADIO SELF-HELP: Serving mainly Afro-Caribbean people but with occasional programmes for Asian, Chinese and Irish people. Run by the National Federation of Self-Help Organisation, which promotes self-help within the black communities and designed to be the focus of such activities.

APNA RADIO: The longest established of all the South London applicants. Proposing a multi-ethnic station, providing programme segments for African, West Indian, Gujariti, Punjabi, Banglandeshi, Chinese, Italian and Greek people. Providing news, educative and cultural programmes and information about services.

Also, amongst many others: Root FM, Arabic Community Radio, Live-Wire FM, Dar Associated Radio, Radio Aljalia, London International Radio, Thames Community Broadcasting, London Rock Radio and Radio Limehouse.

North London community of interest applicants

ICA RADIO: A joint venture between the Institute of Contemporary Arts and Time-Out magazine for an arts station. Also involved are former Capital executives Tim Blackmore and Aidan Day. Would operate with a small team of editors commissioning projects and a small training team. Looking for £1 million in advertising a year provide all this!

SPECTRUM RADIO: Another ambitious plan for a shared access community station, based in Kentish Town. Slots taken each day by ethnic and other minorities along with alternative music groups. Also providing training facilities for potential broadcasting groups. Funded by both advertising and listener subscription. More details in the mega-enormous application.

NORTH LONDON RADIO: Multicultural radio group providing daily programmes for Afro-Caribbean, Asian, Greek / Cypriot and Turkish people along with weekly Italian and Irish programmes and community access time. Using a local community centre as a training base for people wishing to make programmes. Monitoring committees providing feedback about programming.

INTERNATIONAL JAZZ CLUB RADIO: Hoping to bring jazz from around the world to the communities of North London along with local news, events and features. Backed by Virgin and with Sidney Gross, Ronnie Scott and Spike Milligan amongst its committee members.

LONDON GREEK RADIO: Ex-pirates backed by prominent Greek businesses and with strong links with both Cypriot and Greek radio stations. Programmes will be in both Greek and English, including Greek music, news, information, educational and cultural programmes and religious services.

RADIO NEW COMMONWEALTH AND PAKISTAN: Run by a group of Asian people planning a multicultural station with Afro-Caribbean, Greek, Turkish, Chinese and African groups taking daily programmes. Also a weekly access slot.

RADIO AMANDA: Another ex-pirate, planning to broadcast a mixture of album rock, interviews, local bands' demo tapes and local information.

LONDON ASIAN RADIO: Aiming to carry cultural, educational and current affairs programmes of interest to London's Asian communities. Training for broadcasters provided by the Asian Radio Studio Project.

IRISH COMMUNITY RADIO: Programmes for London's longest-established and also largest ethnic group.

Also, amongst many others: Radio Krishna, Ruby Radio, Alasia Radio, Orbit Radio, Radio Vox, Arab Broadcasting Company, Radio Harmony, Radio Italia and Greek Community Radio.

O·N - A·I·R : N·O·V·E·M·B·E·R

KISS-FM

Kiss-FM is London's newest black music station, broadcasting 24 hours a day to with one of the strongest signals from a pirate ever.

> NEWS

November didn't begin too well for Kiss-FM. The station's original transmitter site had been raided several times the previous month so they decided to try a non-permanant one, changing regularly. This tactic didn't work too well however.

They were raided on the 3rd, returned on the 5th, raided on the 6th, moved to 94.2MHz, disappeared in the afternoon, came back the next day on 94.4MHz in the morning and evening running through till the 11th when they were raided again.

Exhausted by these activities, both physically and financially, the station then took a couple of weeks off. Kiss-FM returned on the 27th at around 8PM with a superb signal once the transmitter was set up.

Apart from a few small problems they then made it through to the end of November without too many difficulties.

> PROGRAMMES

Kiss-FM plays mainly upfront dance music, with alternative mixes where available.

We still haven't got a full programme shedule yet, but we're working on it...

Weekdays:-
1.00AM: Greeny
7.00AM: Dean Savon
10.00AM: Gordon Mack
12.00PM: Nicky Holloway
2.30PM: Max-LX
5.00PM: Toshka
7.30PM: DJD/Desmond D/NormanJ
9.00PM: DJT
11.00PM: Danny

Weekend:-
1.00AM: Unknown
7.00AM: Unknown
10.00AM: Dennis O'Brian
12.00PM: Norman J
2.30PM: George Power
5.00PM: Paul Anderson
7.30PM: Pepe
10.30PM: Richie Rich

Compiled during late November, early December.

FAX.FAX.FAX.FAX.

ADDRESS: ███ Dysons Road
London
N18 2DJ

FREQUENCY: 90.0MHz VHF
POWER: 250W
LOCATION: South London
PRESENTATION: Live
TIMES: 24 hours a day
FORMAT: Soul/Jazz/Funk/Reggae

O·N - A·I·R : N·O·V·E·M·B·E·R

KJAZZ

Kjazz is the first specialist jazz station in London, starting at a time when there's increased interest in jazz which has helped its popularity.

Unfortunately, its future is now in doubt. Following the close of the LAB network (see Radio Activity) the station may either combine with Starpoint or try and continue on its own, which would probably give it a larger, and more loyal, audience.

> NEWS

November was rather unsucessful for Kjazz, only making it to the air for two broadcasts - and then with reduced hours.

At the start of the month they came on air as usual at 10.00 with Chris Phillips, but then were off between 11.30 and 1PM while they sorted out some transmitter problems. Giles Peterson then took over with his programme, only to have Kjazz keep on going off air intermittantly. The problems were solved for Kevin Beadle's programme at 3.30, but unfortunately they were

raided at 5 by the DTI.

Back they came the following week at 12PM for 8 hours of programmes, reduced due to a shortage of staff. Chris Phillips began the proceedings followed by Kevin at 2, Baz at 4 and then Tomik at 6.

Because of Radio Activity being raided the next week and subsequently closing the station has not yet made any more transmissions.

> PROGRAMMES

The approximate programme schedule is as follows:-

10AM: Chris Phillips
 - Latin / soft jazz
12PM: Giles Peterson
 - Newer soul tinged jazz
 3PM: Kevin Beadle
 - Fusion & Salsa
 6PM: Baz
 - Modern jazz
 8PM: Tomik
 - Samba

We'd appreciate it if any jazz fans could verify this for us - we're not too well up on jazz terminology here at TX.

FAX.FAX.FAX.FAX.

ADDRESS: ▆▆▆ The Piazza
 Covent Garden
 London
 WC2

FREQUENCY: 88.6MHz VHF

POWER: 100W

LOCATION: Crystal Palace

PRESENTATION: Live

TIMES: Sunday 10AM-10PM

FORMAT: Jazz

O·N - A·I·R : N·O·V·E·M·B·E·R

PHOENIX RADIO

Phoenix Radio in roughly its current form began back in January 1982 when Alice's Restaurant decided to split its service into two, Alice's carrying the rock end of the spectrum and Phoenix with the "Alternative Music" side.

The station broadcast every Saturday (or tried to), beginning with 2 hours only and extending to 11 in early '84. Unfortunately this was not to last. One of the Phoenix crew was caught by the DTI in July whilst setting up the transmitter and then the station split with Alice's Restaurant who they shared transmitters with. They made one final broadcast to try and get new support but unfortunately were forced to close.

Phoenix then re-appeared with a test transmission on September 8th and programmes commenced the following week. The station is now operating with tapes (not much fun in this weather) which along with several raids has caused the station to be off the air fairly frequently.

> NEWS

The station returned on the 3rd after being off during October and was raided at the start of the final programme. They returned the following week slotting in the show that didn't go out before. On the 24th they weren't on again, thought to be due to a lack of site staff, but returned on the 24th, disappearing at around 8.30, probably because of the weather rather than a raid.

> PROGRAMMES

Programmes last one and a half hours with a rota of presenters as follows:-

John Scott: Variety of mainly new material including demo tapes from bands.

Gill Black: The most varied show on the station. Expect to hear what you wouldn't expect!

Mark Welsh: The noisier side, industrial, post punk and some pop.

Nick & Tips: Vintage rock and roll - 50s and earlier.

Also Sue Scott & Bruce B.

FAX.FAX.FAX.FAX.

ADDRESS: Not Yet Available

FREQUENCY: 90.9MHz VHF
POWER: 50W
LOCATION: East London
PRESENTATION: Taped
TIMES: Sunday 9-10PM
FORMAT: Alternative Music

──────────── R·A·I·D·S ────────────

THE **ERIC** FILE
Raid's

File Number TX/2/KISS

This time, a report about a raid on Kiss-FM in October:-

If you live in South-East London you may remember a large traffic hold-up on the A2 near the centre of town back at the beginning of October. It was large enough to get on Capital, LBC and Radio London, being reported as caused by an obstruction blocking one lane of the road. Want to know who caused it?

The station had its FM transmitter located on a building alongside the A2 — strapped to the outside of a chimney along with its aerials. The roof was fairly steep making it impossible to get at the transmitter without using specialist ladders and boards.

Eric had spent the afternoon tracking the transmitter in the usual way before finally spotting it on the chimney. He'd decided it was too dangerous to climb onto the roof and get it, so chose instead to call in the Fire-Brigade. They arrived first in a control vehicle to see what was needed before calling in a fire-engine with an mechanical lift and rotating turntable. By now the evening rush hour was

beginning to approach...

To get at the transmitter (which was still operating) the fire engine had to park on the edge of the main A2. And if you've ever seen the size of those machines you'll know what sort of a hold-up they can cause.

Eric got into the bucket along with a fireman and up they went to the transmitter. With great difficulty they managed to disconnect it, remove the aerial and then descend. Meanwhile a small crowd had gathered down below wondering what on earth was going on. Cars that were passing slowed down to watch the action, causing even greater delays than there were already and bringing the police in to deal with the hold-up. Even when Eric had gone, transmitter in hand, the traffic was still delayed for much of the evening.

So next time you're stuck in a traffic jam it might just be Eric and Co. removing a transmitter. And if the station you're listening to suddenly disappears then it probably is!

If you work for a station and have a story suitable for inclusion in The Eric File then send it in (station and staff names may be omitted) to The Eric File, TX Magazine, BCM Box 225, London, WC1N 3XX.

TX3: JANUARY 1986

Plus On-Air: London's Only Radio Guide 90P

TX

LONDON'S ALTERNATIVE RADIO MAGAZINE

The Pirates And the Law

TX takes the lid off the pirate broadcasting laws

▸ THE ERIC FILE Horizon in court
▸ LISTENING IN Your first comments
▸ BOOK REVIEW
▸ TX SURVEY Rebel Radio
▸ PLUS Your last chance to vote
 Rumblings and NewsDesk

TX3: JANUARY 1986

PIRATES AND THE LAW

Part one of our series looking at how the laws and their implementation affect the pirates

In the beginning, the only way that man could set the music he wanted was by sitting in a boat three miles off Frinton-on-Sea and getting sick. This angered the government (and the cleaners) and so they brought in the 1967 Marine Etc. Etc. Doing Things With Strange Looking Boats In The North Sea Act.

Then one day an electronics freak came along and decided that if people could broadcast from a boat, then why couldn't they broadcast from a bedroom. You didn't get seasick, it was much cheaper and you didn't have to feed your staff, just buy them the occasional pint down the pub.

However, the government in their infinite wisdom had come along some time previously and brought in a law called the 1949 Wireless Telegraphy Act; anticipating that if they weren't careful, everyone and their dog would try and start up a station leading to potential anarchy on the airwaves. Even worse, some people might use radio to put across their own political views and bring about the downfall of the government and possibly the end or civilisation as we know it.

So, after a little debating, the 1949 Act was introduced. It set out plainly that: "No person shall establish or use any station for wireless telegraphy except by the authority of a licence granted by the Secretary of State, and any person who establishes or uses any station or installs or uses any station for wireless telegraphy, except under and in accordance with such a licence, shall be guilty of an offence under this Act".

In other words, if you've not got a licence you've 'ad it mate!

Now unfortunately for the government there were several problems with this act. "Apparatus" was defined as that "for the sending or receiving, over paths which are not provided by any material substance constructed or arranged for that purpose, of electromagnetic energy of a frequency not exceeding 3 million MHz, for the purpose of conveying messages, sound or visual images". Because of this wording, it was generally taken that only the radio frequency side (i.e. modulator and RF amplifiers) could be confiscated by the courts, not the studio equipment or signal processors – a great advantage.

There was also some vagueness over how large the "Station" is. Is it just the room containing transmitter, the whole building or what?

The most difficult part, however, is over the term "using" the equipment. The first thing to make clear is that it is not an offence to contribute recorded material, letters, etc. to a pirate station. Being on a live phone-in probably is. Now, courts in the UK do not usually at present accept evidence in the form of recorded tapes, primarily because it's difficult to tell if they've been tampered with. With pirate radio, it'd also be difficult to prove that a presenter was actually there, live in the studio, not just on a piece of tape. As a result, the DTI actually have to catch someone at a station, and prove that it is a pirate radio station to the courts, usually by the presence of a transmitter, but not necessarily so.

However, THE main loophole of the 1949 act, and only discovered in 1983, was that "any apparatus manufactured in this country cannot be seized until the case goes to court and an order made". This meant that providing someone claimed the transmitter as belonging to them it could only be inspected and tested by the then enforcers, British Telecom. As it normally takes some time for cases to come to court, the stations could continue operat-

ing right up until the court appearance. Some even swapped dud components for the expensive ones on their transmitters. Because of all these problems, amendments were made to the 1984 Telecommunications Act, which also switched the responsibility for finding pirates from British Telecom to the DTI. Most importantly the authorities were given new powers to search premises and make arrests.

Under the 1949 Act, you could only be arrested for radio piracy with a warrant and during an "inspection" could not be compelled to give your name. Now the police have the power to arrest anyone who's committed, or is suspected to have committed, an offence without a warrant; for example if they suspect that the person is lying about their name or address.

When it comes to searching private premises, a warrant is still needed. A local magistrate has to be convinced that there is reasonable grounds for suspecting an offence has been committed and will then issue one, valid for a month. The warrant will specify the premises to be searched, and the searching officers – both police and DTI. The roofs of council tower blocks are not apparently considered private premises.

Under the 1984 Act these powers are then extended to allowing the searching officers to seize and detain any apparatus relevant to the offences found during the search, regardless of who owns the equipment. This can be anything they think is needed to run a pirate station.

If you're caught you can now expect to be fined up to £2,000 or up to a 3 month prison sentence. Fines are usually much lower, however.

All equipment seized must go before the courts for a confiscation order, whether or not someone is charged – if not done so within 6 months then it must be returned.

It is also an offence to possess, manufacture or offer for sale transmission equipment, even in component parts, maximum fine £2,000, no prison sentence.

It is a serious offence to deliberately interfere with licensed stations (only) maximum fine £2,000 or 6 month prison sentence, or if you elect to be tried in a crown court, an unlimited fine and / or a maximum of 2 years in prison.

Finally listening to an unauthorised station is also an offence.

THE ERIC FILE: HORIZON RADIO

Christopher England describes Horizon Radio's recent court appearance

On Monday 6th January, the case of the missing link finally came to Wells Magistrates Court in the West End. Ex-Radio Horizon DJs Chris Stewart and C.J. Carlos had to face Brian Holder and Eric Gotts Of the DTI. They had previously met on Thursday 11th October, 1984 during a raid on Chris Stewart's studio in South-East London, and were now answering charges that they were running a pirate station on that occasion.

In an entertaining case that took up the whole day in Court No. 4, we heard the DTI's version of events that led up to them seizing over £20,000 worth of studio equipment. They had to individually itemise and stick numbered labels onto each piece before it was carried out to a waiting police van.

Helping to present the facts was Edward Bull, not seen so much on raids nowadays, and Messrs Clayton and Bywater who'd been

drafted down from Lancashire to help Eric and Brian back in '84.

There was some confusion in the case for the prosecution, including Mr Bull nervously referring to Brian as Mr "Golder". According to Mr Holder, C.J. Carlos was arrested for not giving his name and address. Mr Gotts, on the other hand, said it was because he was causing a breach of the peace by not letting go of his box of records.

They also told us they were sure they'd packed away the link transmitter (which gets the signal from the studio to the main transmitter) found in the studio. How embarrassing to find it wasn't in the van when they checked the items of equipment against the inventory back at base. Had there ever been one? If there had, where was it now?

Eric admitted he wasn't a musical connoisseur, and didn't quite know what soul music was. His boss, Derek Jerman, answering the magistrate's questions about the DTI's work, mentioned that in 1985 they'd prosecuted three times as many pirates as in 1984, which was why 1985 was slightly more "pirate-free". He said that pirate activity in the last three months had increased due to a growing disbelief that music stations would be granted licences under the community radio experiment, although he admitted that pirates had made a major contribution towards the decision to introduce Community Radio.

But, back to the case for the defence. Maybe it wasn't helped by Eric's tale of the neighbour calling round during the raid to return the stereo encoder someone had thrown into the back garden from the studio window. Nevertheless, an impressive string of disc-jockeys testified that the studio the DTI had found was not anything other than a DJ training school, called Horizon Productions. None of them had ever seen a transmitter before, or noticed anything suspicious when they'd been in the studio doing their programmes, er, I mean, training

work. To their knowledge, it had never been connected with any set-up of a pirate station.

"Fire station? Sorry? What's that about setting up a fire station?" the magistrate suddenly barked, waking from a self-induced trance. He'd temporarily lost his concentration whilst trying to read the small print on a Laser 558 sweatshirt being worn in the public gallery. Roars of laughter from absolutely everyone helped break what was fast becoming a very tense atmosphere.

Sadly, the Magistrate, who just happened to by Richard "Virgin Records" Branson's dad, decided that the DTI were the ones telling the truth. He fined C.J. Carlos £200, and ordered the forfeiture of the studio equipment. Because this meant that Chris Stewart was effectively losing the £20,000 this was worth, he decided to conditionally discharge him for eighteen months, rather than inflict a fine. However, as the case had dragged on for 15 months before coming to court, and over 65 letters had travelled back and forth between Horizon's solicitors and the DTI, Chris Stewart was ordered to pay £1,000 costs, whilst C.J. Carlos had to pay £300 (on top of the £200 fine).

So, the lesson learnt from this story: Watch out! You can still get done even if the DTI haven't got your transmitter.

O·N - A·I·R : S·E·L·E·C·T·I·O·N·S

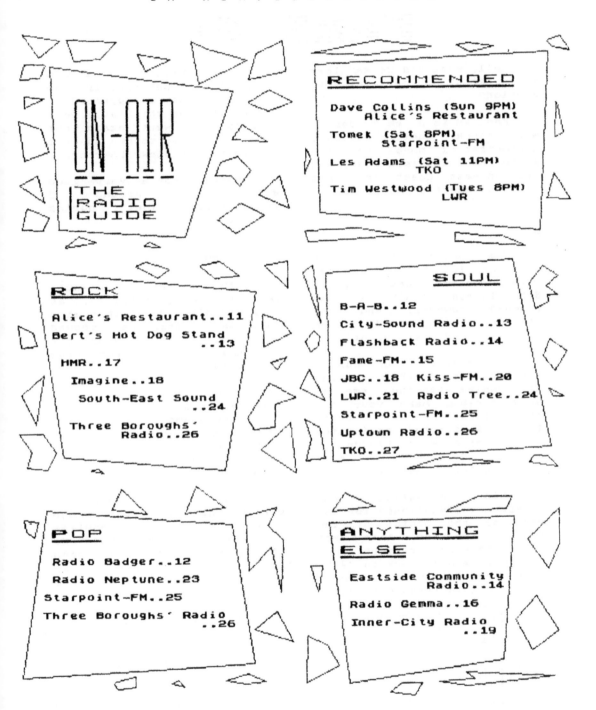

ON-AIR
THE RADIO GUIDE

RECOMMENDED

Dave Collins (Sun 9PM)
　Alice's Restaurant

Tomek (Sat 8PM)
　　Starpoint-FM

Les Adams (Sat 11PM)
　　　TKO

Tim Westwood (Tues 8PM)
　　　LWR

ROCK

Alice's Restaurant..11

Bert's Hot Dog Stand
　　　　　　　..13

HMR..17

　Imagine..18

　　South-East Sound
　　　　　　..24

Three Boroughs'
　Radio..26

SOUL

B-A-B..12

City-Sound Radio..13

Flashback Radio..14

Fame-FM..15

JBC..18　Kiss-FM..20

LWR..21　Radio Tree..24

Starpoint-FM..25

Uptown Radio..26

TKO..27

POP

Radio Badger..12

Radio Neptune..23

Starpoint-FM..25

Three Boroughs' Radio
　　　　　　　..26

ANYTHING ELSE

Eastside Community
　　　　Radio..14

Radio Gemma..16

Inner-City Radio
　　　　　..19

We try to make the On-Air section as accurate as possible, however errors do occur sometimes. If you spot one, or can provide further information about a station then please do get in touch with us at TX Magazine, BCM Box 225, London, WC1N 3XX.

O·N - A·I·R : D·E·C·E·M·B·E·R

FAME-FM

Well, what did we say last month about a certain soul station?

Fame FM is a new 7 day a week black music station, concentrating more on the softer soul and jazz funk, and less on East Coast (no, not Clacton) electro and go-go.

NEWS

Fame began testing on December 12th mid-afternoon, with programmes beginning at 8PM. Things didn't go as planned, however, and the station disappeared the following day over lunchtime.

Back they came on Sunday 15th at around 7PM, testing all evening with the same Al Stewart album. Make your own conclusions about that. Programmes started again the next morning with Linden T, but Fame was gone once more at 12PM the following day.

This appearing and disappearing continued for the rest of the month: started again on the 22nd, then went again, back on Christmas Day, then went again, back on 29th, then the following morning suffered interference from TKO who were setting up a new transmitter. Then finally for the month, they disappeared at around 10AM on the 31st, were back by 9PM, went again but finally managed to see in the New Year with Nicky Lawrence.

Overall, not a very good start with around 3 transmitters lost during December.

PROGRAMMES

A full programme schedule is still being compiled, as they haven't made it through a full week, this has proved rather difficult. However, for weekdays it looks something like this:-

```
 7AM: Linden T
10AM: Simon G
 1PM: Ray Adams
 4PM: Gary Johns
 7PM: Greg C
10PM: Various
 2PM: Close
```

Presentation has been of a variable standard, partly due to all the technical problems that the station has had. No specialist shows have been noted so far, but are likely to be appearing soon, if they haven't done so already.

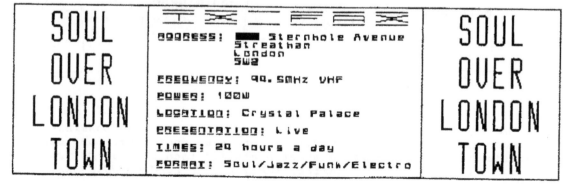

SOUL OVER LONDON TOWN

TX FAX

ADDRESS: ███ Sternhole Avenue Streatham London SW2

FREQUENCY: 90.5MHz VHF

POWER: 100W

LOCATION: Crystal Palace

PRESENTATION: Live

TIMES: 24 hours a day

FORMAT: Soul/Jazz/Funk/Electro

SOUL OVER LONDON TOWN

O·N - A·I·R : D·E·C·E·M·B·E·R

INNER-CITY RADIO

Inner-City Radio is a new soul station, and before you say not another, this one broadcasts to the South Essex area rather than London. ICR first began operating at the tail-end of November, but due to lack of details at the time didn't get in that issue.

ICR is one of the more professional soul stations around, sounding rather like JFM before they went to daily operation, not surprising as a couple of the staff have worked on that station.

Sound wise, the station is pretty good, with an excellent stereo signal, easily received here in Hertfordshire.

Overall, the station looks fairly promising. Specialist shows are planned to start soon and broadcasting hours to be extended.

NEWS

The station has made it to the air each Sunday during December with no raids known of. Maybe we'll see a migration of pirates from London to the Home Counties...

As far as is known, there were no special Christmas or New Year's broadcasts by the station. But then if there were, you've got to have a break from soul music sometimes and there were other interesting things on the airwaves over Xmas.

PROGRAMMES

8.00AM: Grumpy Graham (?)

10.00AM: Martin John

12.00PM: Darren Fogle

2.00PM: Mark Roman

4.00PM: Daryll Barker

6.00PM: Nick Jones

8.00PM: Close

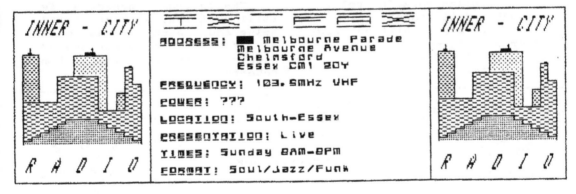

TECH

ADDRESS: ▓▓▓ Melbourne Parade
Melbourne Avenue
Chelmsford
Essex CM1 2QY

FREQUENCY: 103.5MHz UHF

POWER: ???

LOCATION: South-Essex

PRESENTATION: Live

TIMES: Sunday 8AM-8PM

FORMAT: Soul/Jazz/Funk

On Air - The invaluable guide to London's pirates
Keep it by your radio

·O·N· - ·A·I·R· : D·E·C·E·M·B·E·R

STARPOINT-FM

Starpoint-FM broadcasts a range of specialist interest music over the weekend.

NEWS

Starpoint first appeared on the 1st, with just Chris Phillips, Mix Master Mac, Ben West and Stephen Bishop presenting. The following week Tomek reappeared presenting R+B, along with Pat French with Reggae and Tim Roberts hosting a pop and phone in programme at midnight.

Mark Summers was added on the fifteenth with a top forty programme. The hours were then extended still further on the 21st, starting at 6PM with Johnny C. Unfortunately the DTI got them that night, sometime after 12, but they made a return the following week with full programmes.

PROGRAMMES

2.00PM: Tom Ingram
 - Vintage rock 'n' roll.
4.00PM: Neil Francis
 - Primarily sixties soul from a Caroline jock.
6.00PM: Pat French
 - Gospel.
8.00PM: Tomek
 - R+B.
10.00PM: John Dawson
 - Soul and Reggae from the now ex-LWR jock.
1.00AM: DJC
 - Soul and electro.
3.00AM: Jerry King
 - The Nostalgia Show.
6.00AM: Ray Thompson
 - Breakfast with SkyLine's old breakfast jock.
8.00AM: Barry J
 - 60s and 70s classics.
10.00AM: DJ Dorsky
 - Electro.
12.00PM: Mix Master Mac
 - Electro.
2.00PM: Chris Phillips
 - Jazz.
4.00PM: Ben West
 - Europop and Soul.
6.00PM: Mark Summers
 - Top Forty.
8.00PM: Pat French
 - Reggae from Skyline's old reggae jock.
10.00PM: Tomek
 - Salsa.
12.00PM: Jerry King.
2.00PM: Ray Thompson.
4.00PM: Close

The programme schedule is still evolving, with new staff being added each week as well as, it seems, the departure of Stephen Bishop and Tim Roberts.

TX - FAX

ADDRESS: ███ Stockwell Road
London
SW9

FREQUENCY: 88.6MHz VHF

POWER: 100W

LOCATION: Crystal Palace

PRESENTATION: Live

TIMES: Saturday 12PM-Monday 6AM

FORMAT: Specialist Music

► TX4: FEBRUARY 1986

Plus On-Air: London's Only Radio Guide ►► SOP

TX

LONDON'S ALTERNATIVE RADIO MAGAZINE

THE BEST OF 85

10

SURVEY RESULTS

TX4: FEBRUARY 1986

NEWSDESK

London Greek Radio fined £1,000

London Greek Radio were in court again recently, one of their presenters being fined £1,000 with £135 costs as well as having his personal record collection and all the station's studio equipment confiscated.

In the past 2 years the station has lost over 100 transmitters to the DTI with several staff ending up in court, and all of them being fined harshly. The latest appearance related back to October 25th 1985 when at 9.30pm the Radio Interference Service forced their way into the studio in Muswell Hill.

The prosecutor for the DTI claimed in court that there had been complaints that the station had been interfering with BBC transmissions. When they raided the premises they found a solitary DJ operating the equipment. LGR is currently off the air following another raid, but hopes to be back soon.

TV pirates at it again

If you live in South London and North London stand by your TV sets for the transmissions from two pirate TV stations scheduled to begin operations in March.

Interference

There seems to be increasing interference to pirate links from taxis and other communication signals. LWR spent ages trying to eliminate mobile system interference and Expansion have also been picking up taxis recently. Car 4 to Wham Square please!

PIRATES AND THE LAW

Part two of our series looking at how the laws and their implementation affect the pirates

Last month we looked at the laws that affect pirate radio stations in Britain, this month we turn our attention to how the DTI carry them out. To do this we've used various bits of information from a number of sources to try and build up a picture of their operation. Obviously we can't be exactly sure of how they work and the methods they use, but this article should hopefully give you some idea of what pirate stations are up against.

With the introduction or the 1984 Telecommunications Act, the responsibility tor prosecuting illegal users of the airwaves shifted from British Telecom to the Department of Trade and Industry. This shift took some time to organise, which is one of the reasons why there was a lessening of activity against the pirates at the end or '84 (there were others reasons too).

Under the DTI there was a major change to the operation of the Radio Interference Service (RIS), which BT and the Post Office before it didn't really devote to much time or money to. One of the first steps was to streamline the organisation and cut out "unnecessary" jobs, such as solving listeners' reception problems. With the cash saved they could then devote time to tracing pirate stations, seen as the greater nuisance.

Up till this change, the RIS had simply traced stations' transmitters and removed them without really bothering about finding studios or who the people behind the stations were. This was all to change with the start of an information gathering campaign.

Before we go on to this there needs to be a small explanation. If you want to stop a station from returning to the air then you want to inflict as much damage as possible on them when they're raided. If there's evidence that a person has repeatedly broken the law then the fines will be very much greater and there's less chance or them returning.

Therefore, the RIS now collect information on all the people working on pirate stations, so that if (when?) they're finally caught they will be able to secure a large fine. These details come from a large variety of sources, including what the stations put out. Members of the RIS will make notes about pirate staff from the radio – it's been reported that on some or the large stations DJs have been followed by private investigators working for the DTI.

Promotional material produced by the stations, including flyers for club nights, will be collected, along with free radio magazines, such as TX (hi guys – this is why there are some details you won't find printed by us!). The most important source of information is probably the national and local press. A station looking for publicity won't always be too careful about what it says, and this may cause problems for it later.

Recent prosecutions have all featured such sources, including a television report about a Manchester station being used to identify staff. It should be mentioned that as information is also collected about the offshore stations, then any North Sea DJs found at the controls of landbased pirates face extra charges especially as identifying them is much easier.

At this point we move onto tracking the stations, and the jobs of Messrs John Garlic, Brian Holder and Eric Gotts. These are the guys in London who go out in all weather, rain or shine, Bank Holiday or New Year's Day, simply with the intention of finding transmitters and removing them. It should be made clear that it is not their job to decide who's raided, those orders come from higher up (which explains the rather odd way some stations get persistent raids and others only rarely).

There are two kinds of raid: get out quick and remove the transmitter, or spend some more time and try and catch someone. The vast majority are in the first category, though every now and again the RIS decides to have a go at the second – which is much more difficult. The method of doing this obviously depends on the station. To catch the staff at a MW taped station operating from a field, the RIS will often hide behind bushes and wait for pirate staff to appear from behind other bushes to change the tapes. This isn't much fun for them so they usually just collect the transmitter and go.

Most VHF stations these days operate live, with a studio in one location and a secret radio link to the transmitter at another. The RIS were unable to trace the UHF links used for a long time, which meant they rarely found any studios.

Unfortunately they are now able to, which means that stations have to resort to other devious means to avoid detection (and which we won't so into here for obvious reasons).

To try and find the studios another way, the DTI have been employing people to follow known DJs to see where they go, and then once they're sure of the location of a studio, raiding it. This has its problems still as stations regularly change their studios. There've also been many accusations of rival stations tipping the DTI off about the location of studios. Whilst some of these are true, many arise because studios are traced when they're mistakenly thought to be secret.

Overall, radio piracy today is a much more risky business than it was even just a couple of years ago. Currently the pirates are one-up on the DTI in terms of their technology, but for how much longer? 24 hour a day stations may well die out, but in some form pirate radio is certainly here to stay.

—————————————— Y·O·U·R V·O·T·E·S ——————————————

```
TTTTT X   X     TTTTT  OOO  PPPP      1    OOO
  T    X X        T    O    O P   P   11   O  OO
  T     X         T    O    O PPPP    1    O   O
  T    X X        T    O    O P       1    OO  O
  T   X   X       T    OOO  P         111  OOO
```

TOP STATION OF 1985

> 1 Alice's Restaurant +
> 2 Laser 558 +
> 3 Solar Radio +
> 4 Horizon Radio +
> 5 Radio Activity +
> 6 Starpoint-FM +
> 7 Imagine +
> 8 Radio Free London +
> 9 Kiss-FM +
> 10 TKO +

ALL-TIME FAVOURITE STATION

> 1 Thameside Radio +
> 2 Alice's Restaurant +
> 3 Laser 558 +
> 4 Solar Radio +
> 5 Horizon Radio +
> 6 Capital Radio +
> 7 London Music Radio +
> 8 JFM +
> 9 Radio Caroline +
> 10 Radio Activity +

PERSONALITY DJ OF 1985

> 1 Charlie Wolf (Laser 558) +
> 2 C.J. Carlos (Horizon Radio, Solar Radio, TKO, Fame-FM) +
> 3 Chris England (Radio Shoestring) +
> 4 Kenny Myers (Radio Free London) +
> 5 Colin Noble (Alice's Restaurant) +
> 6 Paul Buick (Horizon Radio, Solar Radio, TKO) +
> 7 Steve Price (Alice's Restaurant) +
> 8 Tim Allen (Three Boroughs' Radio) +
> 9 Dave Windsor (South East Sound) +
> 10 Marc Damon (JFM, Solar Radio) +

SPECIALIST MUSIC DJ OF 1985

> 1 Steve Price (Alice's Restaurant) +
> 2 Louie St. Clair (Solar Radio, TKO) +
> 3 Ben West (Radio Activity, Starpoint-FM) +
> 4 Bear (Alice's Restaurant) +
> 5 Tim Westwood (LWR) +
> 6 Brian Marshall (Alice's Restaurant) +
> 7 To'Mek (Kjazz, Starpoint-FM) +
> 8 Princess Asher (JBC) +
> 9 Steve Ego (Radio Free London) +
> 10 Steve Martin (Imagine) +

Y·O·U·R V·O·T·E·S

MOST BORING DJ OF 1985

```
>  1  Jimmy Saville  (Radio 1)               +
>  2  Neil Francis   (Radio Caroline)        +
>  3  Zac            (LWR)                    +
>  4  Tom Anderson   (Radio Caroline)        +
>  5  Dave Collins   (Alice's Restaurant)    +
>  6  Steve Wright   (Radio 1)               +
>  7  Jasper         (LWR)                    +
>  8  Mike Read      (Radio 1)               +
>  9  Gary Davies    (Radio 1)               +
> 10  John Sachs     (Capital Radio)         +
```

MOST INCOMPITANT DJ OF 1985

```
>  1  Mike Read      (Radio 1)               +
>  2  Jimmy Saville  (Radio 1)               +
>  3  Chris Tarrant  (Capital Radio)         +
>  4  Tim Roberts    (Starpoint-FM)          +
>  5  Gary Davies    (Radio 1)               +
>  6  Dennis O'Brian (Kiss-FM)               +
>  7  Steve Wright   (Radio 1)               +
>  8  Janice Long    (Radio 1)               +
>  9  Iain Johnston  (South East Sound)      +
> 10  Phil Thomas    (Forestside Radio)      +
```

BEST ADVERT OF 1985

```
>  1  Spin-Off's Records   (Various)             +
>  2  Maxell Tapes         (Alice's Restaurant)  +
>  3  Kiss-FM Sales        (Kiss-FM)             +
>  4  Hawiian Tropic       (Radio Caroline)      +
>  5  Jif's Records        (Various)             +
>  6  Marlborough R.A.A.   (Laser 558)           +
>  7  Alice's T-Shirts     (Alice's Restaurant)  +
>  8  Windjammer Cruises   (Radio Caroline)      +
>  9  Kiss-FM at Kisses    (Kiss-FM)             +
> 10  Sancho's Pizza       (TKO)                 +
```

BEST GIG OF BY A RADIO STATION

> Not possible to give a top ten, but particularly recommended were Alice's Restaurant at the Wellington, Shepherd's Bush; The Floss Roadshow; Kiss-FM at Kisses and the Skyline roadshow.

Many thanks to everyone who completed the entry form in the back of TX and sent it off to us. £10 record tokens go to Andrew Williams of Walthamstow and Mr R. Griggs of Hythe in Kent who were lucky enough to get pulled out of the rubbish bin!

Although the response wasn't tremendous, we were able to get a reasonable chart out of the entries, though there are a few oddities. With regard to the Boring and Incompitant DJ entries, these certainly didn't match up with what I considered the worst in '85 - all my entries came from the legal stations (so don't hit ME). If you want to comment on the results, then write in to Listening In.

-O·N - A·I·R : J·A·N·U·A·R·Y

ALICE'S RESTAURANT

Alice's Restaurant broadcasts rock music to London every Sunday on 93FM.

> NEWS

The Restaurant saw in the new year with a live party at the studio (what's a dead party?) with Steve Price, Colin Noble, Dave Lane, Brian Marshall, Dave Collins, Chris Miles and Phil Thomas in varying states of merryness.

Back to sobriety the next Sunday, with a normal broadcast, except for a live concert from someone during Steve Price's show - it wasn't that noisy, I just can't remember! For completeness, Alice's made a test the previous evening, emitting various non musical noises for a few hours.

The 12th began as usual with Colin Noble, including the start of his competition to name all the members of the Woodentops family (which at the time of writing is still running) and the usual album side at 10.30. Dave Lane then began his show, but didn't get too far with it - the transmitter site was raided by

the DTI at 12.43PM.

Back they came the next week with the usual start time and programmes. Brian Marshall introduced a new feature to his show this week called "Connections" (now where have I heard that before...?), the idea being to send in 4 or 5 tracks with a common link. Dave Collins included several of the more interesting top fives from the Xmas Top 100 in his show as well as the usual features.

The final broadcast of the month was again fairly normal, though Steve Price and Cliff Brooks swapped programmes and Steve was joined by Lisa. Cliff's show was also noticeably more mellow than usual, due to the number of requests played, still managed to get in the usual material though.

> PROGRAMMES

```
 9.00AM:    Colin Noble
12.00PM:    Dave Lane
 2.00PM:    Cliff Brooks
 4.00PM:    Brian Marshall
 7.00PM:    Steve Price
 9.00PM:    Dave Collins
12.00AMish: Close
```

LONDONS PREMIER ROCK STATION

T·X - F·A·X

ADDRESS: ▆▆▆▆ Heathway
Dagenham
Essex
RM9 5AQ

FREQUENCY: 93.0MHz UHF

POWER: 50W

LOCATION: South-East London

PRESENTATION: Live

TIMES: Sunday 9am-12pm

FORMAT: Rock/Metal/Progressive

LONDONS PREMIER ROCK STATION

·O·N – A·I·R : J·A·N·U·A·R·Y

TKO

TKO broadcasts black music to London 24 hours a day, with a mixture of live shows and taped, continuous music.

> NEWS

There's quite a bit of controversy over TKO's operation. Shortly after they started transmissions back in November TKO were left without any engineering staff. This meant that there were several breakdowns which took some time to be repaired as they had to rely on engineering services from outside.

To make matters worse, several ex-Solar staff made it clear that they did not support TKO, fearing it might cause problems with Solar's community radio licence application which they'd put a lot of effort into. Not put off, TKO's management still felt it was worth continuing – particularly with the emergence of Fame-FM as a new contender for London's soul fans.

Therefore, sometime during the evening of the 27th January a new transmitter appeared on the 102.45' frequency. By the following morning it was carrying the tapes of continuous music interspersed with jingles, thought to be repeated every 12 hours. There were occasional technical problems during this time, but they were generally sorted out fairly quickly.

The tapes were changed a couple of times during the week, and the number of adverts that were carried grew fairly quickly. Programmes then began at the weekend – but you'll have to read the next issue of TX to find out about them!

Overall, the future of TKO still isn't certain. The DJs seem to all want to do proper programmes live, but the management seems to be unsure of doing this - not wanting to annoy the Solar group? The presence of programmes for just one day recently suggests that maybe programmes will be run only at weekends – when the audience is much larger. TKO's intentions don't seem to be too clear, we'll just have to wait and see!

> PROGRAMMES

A full programme schedule is unavailable, though we hope to provide selected details in next month's issue.

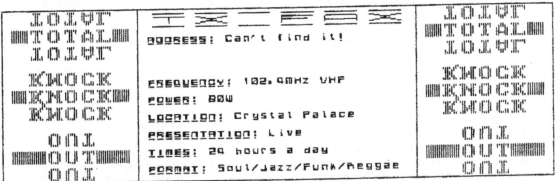

JOINT TOTAL JOINT T X — F A X JOINT TOTAL JOINT

ADDRESS: Can't find it!

FREQUENCY: 102.4MHz VHF

POWER: 80W

LOCATION: Crystal Palace

PRESENTATION: Live

TIMES: 24 hours a day

FORMAT: Soul/Jazz/Funk/Reggae

KNOCK KNOCK KNOCK

ONE OUT ONE

Welcome to another Listening In. To start things off this month, the Metal Android thinks that Dave Humphrey's got it all wrong:-

I had the bad luck to hear Dave Humphrey's top five on Alice's Restaurant recently, and if he wants Caroline to sound like that then HE must want his head examined. I'm sick of all this boring "alternative" stuff that keeps on being called rock as it isn't. It's nearly as bad as calling Wham a rock duo as the papers do!

What London BADLY needs is a 24 hour metal station, playing the likes of Ratt, Bon Jovi, Deep Purple, Iron Maiden, Rush etc. without all the post punk dirges - and no trash-metal either. Why hasn't anyone started a station on Land doing this instead of all the pathetic soul music drivel that others put out. Metal lives - but only just!

So why hasn't London had a 7 day a week rock station? Not enough money to be made?

We now turn our attention to what's happened to Kjazz which a number of people have enquired about. Well it seems that Kjazz is sadly no more (having said that they'll no doubt reappear). To give the full story, it goes something as follows.

Kjazz was originally started by Gilles Peterson with Baz Fe Jazz, Kevin Beadle, Jez Nelson, Paul Murphy, To'Mek and Chris Bangs; many of whom came had worked on Solar, where they felt not enough jazz was being played. The station started off on 94FM, but with the arrival of Chris Phillips, they decided to timeshare a transmitter with Radio Activity. Another group called Liberty-FM then also wanted to join so they formed the LAB network.

This didn't last for long, however, due to various technical and staff problems and it ended up with Starpoint-FM being formed, Chris Phillips and To'Mek joining from Kjazz, whilst the original group departed. This is then thought to have been the end of Kjazz.

As far as is known this is what happened, though we may be wrong as some of this has been reported second-hand. If any different details or corrections crop up, then we'll print them.

That's it for this month. Don't forget that we'd love to have your comments about what you like and dislike on the radio, including your views on the black music pirates which haven't featured much so far. We'd like to hear your views about which station you currently prefer, and whether you like the increased amount of reggae that stations such as Fame, LWR and TKO are putting out. Is it just because of a major record company push or is it because JBC's become so popular? Letters to...

Listening In,
TX Magazine,
BCM Box 225,
London,
WC1N 3XX.

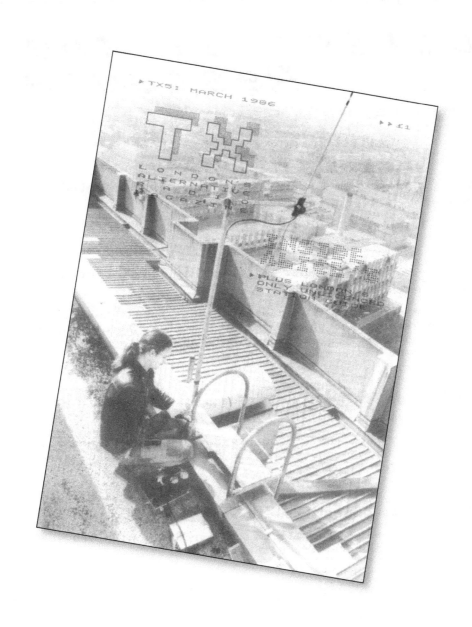

TX5: MARCH 1986

— F·E·A·T·U·R·E —————————————————————————————

Rockin' at the Restaurant

COMMENTS BY &DAVE LANE
FEATURE BY &BRIAN MARSHALL
 &CHRIS ENGLAND
 &STEVE HAMLEY

▶ Dave, How do you feel about Alice's being voted Number 1 Station in 1985?

> Well, We're all absolutely delighted!

▶ And it was also Number 2 in the All-Time section, second only to Thameside Radio...

> I was surprised that a station that hasn't been on the air for two years or so should get to number 1. It obviously shows what a good job Thameside did, well some of the time, and how far ahead of their time they were.

▶ What do you think Steve Price would say about being voted Specialist Music DJ of 1985?

> I don't know, he'd probably be very embarrassed actually. He deserved it though, he really did deserve it. I think Steve is very professional.

▶ Phil Thomas was voted 10th most incompitant DJ...

> I think that's a position HE thoroughly deserved - and I don't mind being quoted on that!

▶ Brian, what's your reaction to Alice's being Number 1?

> I'm very pleased, but we've still got a long way to go. We'd rather be a licenced rock music station, then we'd spend more effort in getting our programmes right, and less in anti-DTI trivia to avoid getting caught.

▶ What about being voted sixth in the Specialist Music DJ section?

> Well, it was nice to see 3 Alice's presenters in there, not just myself. There are others from Alice's who deserved to be in there rather than me. For example, Dave Collins plays the same music as me, but better and more up to date. To vote him the 5th most boring DJ shows the remarkable lack of taste some TX readers have got!!!

F·E·A·T·U·R·E —

▶ **Dave, tell us about the charity gig you held recently?**

It was a charity bash in aid of the Kings Cross Scanner
Appeal. It was a great success, we sold 400 odd tickets, which
was the capacity of the place - though it's possible some extra
people were let in - so we definately sold out. I'm not totally
sure of the amount we raised, I think it's in the region of
£750. Special congratulations must go to Steve Price and Colin
Noble who organised it and put up quite a lot of the money to
get it on the road.

There were quite a lot of Alice's people there - like Bear,
Tony Warren and Phil Thomas. It was a very good night. We had
two bands on stage - Chariot and Elixir - and they both went
down very well - particularly Chariot - and a very good time was
had by all.

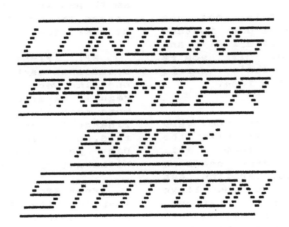

▶ **What about the future?**

First, we've got a special broadcast coming up at Easter for
3 days - Friday, Saturday and Sunday - when we're doing our Best
Albums of '85 chart. Then we're going to have a major reshuffle
of the programme schedule after Easter, basically to accommodate
our new female presenter Debby Smith [See Chains for details of
her past] and maybe some old names from the past [And maybe
operate an extra broadcast each week].

Musically, we're going to try not to make things
significantly different - we'll try and keep the metal and
alternative programmes in approximately the same place, though
there may have to be one or two swap rounds. The idea of the
format is that we cover a broad range of material mixed up a bit
- say a heavy programme followed by an alternative programme
followed by a seventies programme [This idea was originally
rejected as too confusing for the listener and Phoenix was
formed to take the alternative content, Alice's carrying the
more mainstream metal and rock]. We'll try and stick to that
rather than do what we used to do ages ago which was to start at
one end of the rock spectrum and move to the other. We've
decided that idea didn't work and we're going to keep going with
the same sort of idea as at present.

Many years ago, when Capital occasionally came up with innovative ideas there existed a programme called Chains, part of Nicky Horne's rock show on a Friday (or was it a Monday?). Listeners would make up a chain of records starting and ending at the same point, with each record having a connection with the one previously.

We're taking this idea one step further, using DJs instead of records (just like ILR!) and without an end. If you're confused then don't worry, you'll soon get the idea.

We start off on the very first leg of the chain with the forerunner of them all, Caroline, whose history needs no explanation by us. Caroline has always had quite a few links with London's pirate stations, but the one we're going to choose is afternoon DJ Neil Francis.

Neil joined Caroline on March 4th, 1985 to present the afternoon programme, to which he added various features, including the Teatime Teaser, carried on by the station for some time. Now, before he joined Caroline Neil was working on London station Skyline Radio where he presented the breakfast show most weekday mornings.

Skyline started with the intention of being a "Radio Jackie" for South-East London. It started back in October 1983 and resurrected the "simulcast" on pirate radio – broadcasting on both medium wave and VHF. This wasn't too popular with the DTI unfortunately, who kept their medium wave frequency more off than on for most of their life.

There were quite a large number of DJs on Skyline, almost all recruited from previous stations. The largest number came from one of London's first stations on the VHF band – Radio Free London. Mark Ashton, who presented the drivetime show, along with rock show DJs Debbie Smith and Andy Mason have all passed through Radio Free London at some time.

RFL first began their broadcasts back in 1977 and at one time were one of the most regular stations on the air. More recently they've lacked the finance to continue on after a raid, only appearing when the DJs get particularly bad withdrawl symptoms.

From RFL we take a short leap to City Sound Radio via Nigel Grant. When Nigel got tired of headbanging on RFL he moved to City Sound Radio where he's been ever since. Like RFL this station only appears occasionally for a short series of broadcasts until they lose their transmitter – at one time said to be situated on top of a mosque!

CSR has had quite a few DJs from other stations on it, including LWR's Debbie Gopie, Kiss-FM's George Power and Starpoint's Ben West – who it's thought both made their radio debuts on this station.

And so this is where we leave the chain this month. If you've got any suggestions as to possible routes we can merge in during future chain segments then send them in. If we include them then you'll get a TX pen for your trouble.

— O·N - A·I·R : S·T·A·T·I·O·N·S

FAME FM
94.5 FM

BLACK MUSIC

Fame-FM
Mainstream Records
Dartmouth Road
Forest Hill
London
SE23

POWER: 100W
SITE: Lambeth
TIMES: 24 hours

Deep breath, cos there's been one helluvalot of action on this station during February! Fame returned on the 1st at around 5PM, though their new studio and transmission equipment took some time to set up, making it the 3rd before programmes were running smoothly. Then the VHF aerial blew down in the wind, so they were off till the 6th, when programmes resumed at 1PM.

The windy weather continued and another aerial blew down on the 10th, this time losing the signal from the studio to the transmitter. Back they came on the afternoon of the 12th continuing until the 14th when the same aerial blew down again at 5.30PM. Forestside Radio put in an appearance on Fame's transmitter for half an hour that evening too. Fame came back normally the next morning and operated normally till the 16th when it's thought the transmitter site was raided.

Back they came once more on the 19th, only to disappear in the afternoon with technical problems. Back yet again on the 21st in the evening only to disappear once more on the 24th when the transmitter site was raided again. Having thoroughly exhausted their engineering dept. that was all (!) they could manage for February. 10 out of 10 for perseverance and a gold star to the engineers!

RADIO FUNK
90 FM

BLACK MUSIC

Address Unknown

POWER: ???
SITE: East London?
TIMES: ???

Another new soul station (cries of oh no from certain quarters) noted on the 4th, 8th and 9th of February. The station is thought to come from the East End of London, trying to keep up a 7 day a week schedule with a small number of DJs.

Reception has been described as pretty crummy, with only the immediate vicinity of the transmitter site (wherever that may be) able to receive the station with any success. What with the mass of Radio 2 relays around 90 megs this is hardly surprising.

O·N - A·I·R : S·T·A·T·I·O·N·S —

RADIO TREE 105 FM

BLACK MUSIC

Radio Tree
P.O. BOX ████
SUNNINGDALE
Berkshire
SL5 0QU

POWER: 20W
SITE: Lambeth
TIMES: Thursday
8PM-10PM

Since the piece in The Standard taken from TX, we've been informed of a few errors in our report (well our information was taken from another source so that's our excuse). The show is now on Thursday between 8 and 10PM, they no longer wander along the waveband and BPC comes from North Clapham.

To quote Bonnie Price Charlie, "I rap / toast inna reggae style, Mac Macgregor, a red-dread-locked Scots Rasta, spins the discs and Bernadette makes tea and gives Afro vibes inna Caribbean black-gal style!" Charlie's also been protesting recently at the lack of reggae on the airwaves: on Channel 4's Videobox and also outside Radio 1 with placards and wearing his "huge red-gold- green scarf to ensure maximum publicity".

Transmitter power is soon to be increased to 80W, so the whole of London can hear Radio Tree's broadcasts. Capital and London should tune in to hear how reggae SHOULD be presented.

TWILIGHT RADIO 94.4 FM

BLACK MUSIC

Address
Unknown

POWER: 20W?
SITE: North London
TIMES: Sat+Sun
2PM-6PM

After being noted in November by TX, Twilight Radio weren't heard again till the 16th of February. It's uncertain whether the station was on air in December and January.

Since then, Twilight has been heard every weekend, generally between 2PM and around 6PM on both Saturday and Sunday. A station called Radio Infinity also cropped up on the same channel as TFM last time they were on and were thought to use the same transmitter, but haven't appeared since.

Twilight Radio still appears to have only two DJs - Del Brisco who presents a soul show and an unidentified DJ who does a reggae show afterwards. The station seems to have a fairly healthy supply of advertisers, and as far as we could tell has also been running a number of competitions each week, along with a phone-line for requests and dedications. We hope to have more infomation about Twilight for you next month.

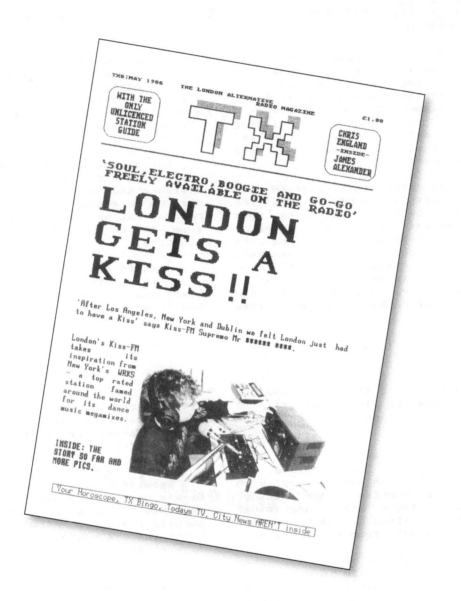

TX6:MAY 1986

THE LONDON ALTERNATIVE RADIO MAGAZINE

WITH THE ONLY UNLICENCED STATION GUIDE

£1.00

CHRIS ENGLAND
-INSIDE-
JAMES ALEXANDER

'SOUL, ELECTRO, BOOGIE AND GO-GO FREELY AVAILABLE ON THE RADIO'

LONDON GETS A KISS !!

'After Los Angeles, New York and Dublin we felt London just had to have a Kiss' says Kiss-FM Supremo Mr ###### ####.

London's Kiss-FM takes its inspiration from New York's WRKS - a top rated station famed around the world for its dance music megamixes.

INSIDE: THE STORY SO FAR AND MORE PICS.

Your Horoscope, TX Bingo, Todays TV, City News AREN'T inside

TX6: MAY 1986

HOLD IT NOW

Kiss-FM began back in October 1985, with the idea of being the first station to incorporate live mixing in their programmes. Many of its DJs were new to radio, including Grandmaster Richie Rich and Max-LX of the Hard Rock Soul Movement.

From the start, Kiss-FM has been hit fairly heavily by the DTI. They began operating from permanant sites, but after a while decided to try using the tower blocks favoured by weekend pirates, changing regularly from one site to another. This tactic wasn't very successful so they went back to permanant sites

Programmes would now be going out over weekends only, and shortly after Fame-FM followed suit. Two weeks later they made a move to 95.3MHz, a slightly clearer channel for most of London.

Unfortunately, it seems that the DTI have followed the soul stations and are concentrating more on weekend stations than before, making life harder for some of the non-profit making stations.

Kiss-FM has also had to cope with the DTI's surveillance staff who go around following DJs in an attempt to try and

K I S S - F M

again. During this time they put out one of the best signals ever, reaching a very large audience.

By now, the DJs were also beginning to get settled in, although there wasn't very much of the promised live mixing. Even so there were many other mixes aired each day, particularly from Richie Rich.

As December moved in, they continued their 24 hour a day broadcasts. This came to a halt on the 11th when DTI activity forced them off the air for a couple of months. Kiss had lost a very substantial amount of equipment during the time they'd been on, which had caused financial problems.

The return to the airwaves came on the 22nd, back on their old frequency of 94FM.

find out where stations' secret studios are. The main reason why this issue is so late is because of the danger of getting the photos of the Kiss studio without being caught by the DTI!

Because of these pressures, Kiss's programming has suffered at times - it's not easy to happily present a show if you think the DTI could knock on the door at any minute...

Even so, Kiss-FM has managed to get out every weekend since their return. Musically, there've been few changes to their blend of some of the more upfront soul, hip-hop, go-go and boogie as well as regular doses of fusion, particularly in the nightime programmes. Watch out for their excellent version of Prince's "Kiss" too.

Tune in this weekend!

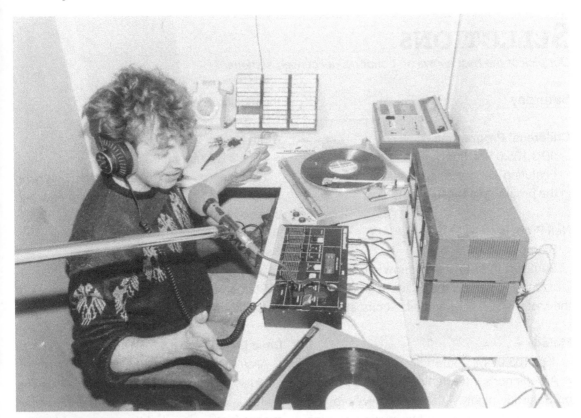

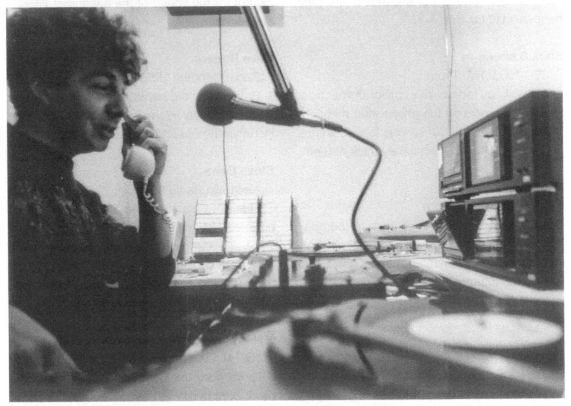

Gordon Mac in the Kiss FM studio

SELECTIONS

Our pick of the best shows on London's unlicensed stations

Saturday

Childrens' Programme

JBC 105.0 FM, 9am

Featuring JBC's younger listeners taking part in the programme live in the studio.

Neil Francis

Starpoint 88.6 FM, 5pm

Subtitled the REAL soul show – less of the jazz funk and more of the sixties soul, including the Motown half hour and prize competitions.

Melody

JBC 105.0 FM, 9pm

A beginner's introduction to African music on Saturday night, with details of where you can find out more about the music and gigs happening in London.

Soca B phone-in

JBC 105.0 FM, 11pm

As well as soca, this programme now includes listeners on the phone after midnight giving their views about various topical stories and letting JBC know what they think of them.

Peter Wally

QMR 105.1 FM, 11pm

Lively at first, softer later on, with competitions for "a really wonderful prize" and an instant-request phoneline, manned as usual by Uncle Schtum.

Sunday

Steve Davies

QMR 105.1 FM, 2am

Second part of the QMR (ex-Expansion) broadcast, with Steve Davies playing more of the rockier side of their output.

Colin Noble

Alice's Restaurant 93 FM, 8am

Featuring many excellent demos by young bands in the London area along with new and classic rock tracks.

Barry J

Starpoint 88.6 FM, 8am

Starpoint's contribution to the resurgence of Seventies' soul.

Dave Lane

Alice's Restaurant 93FM, 11am

Music mainly from '70 to '75 bands plus The Plates – a half-hour of music uninterrupted except for the sound of the restaurant kitchen in operation.

Dave Rogers

Radio Neptune 1566 AM, 11am

Back to his old name again with more pop tracks and local information for the North-East Herts area, including a cinema guide.

Steve Dene

Newtown Radio 90.6 FM, 12pm

First programme of the day from the newly returned Newtown Radio in Stevenage. Steve Dene recently joined the station shortly before they were subjected to a couple of raids from the DTI and were forced to give up broadcasting until things quietened down again.

Melita Ray – Caribbean Connection

JBC 105.0, 2pm

News from the Caribbean islands and the black community in London and JBC's home borough of Brent.

Phil Raven

Radio Gemma 90.3 FM, 4pm

Radio Gemma's rock programme – which started out with fairly soft tracks and seems to get heavier and heavier every week.

Smokey T

JBC 105.0, 5pm

The second Gospel show of the day from JBC, Smokey T hosts along with the Rev Michael and listeners on the phone.

Spencer

Fame-FM 94.5, 7pm

As you'd expect from Fame, playing the more danceable reggae tracks and the slower lovers rock side.

D.D.

People's Choice Radio 103.5, 8pm

Normally the last programme to go out from People's Choice each week. They're a new soul station broadcasting to the North London / Far South London area each weekend.

Dave Collins

Alice's Restaurant 93.0 FM, 9pm

A wide range of music features on this programme – starting off with a couple of hours of alternative tracks plus progressive and folky stuff later.

Barry B

LWR 92.5 FM, 10pm

Often now taking the form of a live broadcast from Sinatra's nightclub with Barry B and other LWR jocks.

Tomek

Starpoint 88.6 FM, 10pm

A breather from the rest of the jazz funk Starpoint has now filled most of its broadcasts with. Described by the Observer as "a late-night show where the DJ takes great pains to get his Spanish pronunciation correct".

Monday

Keith James

Fame-FM 94.5 FM, 7pm

The 120 minute Cosmopolitan Show – mainly soul plus some gig news.

Steve Martin

Imagine 92.0 FM, 10pm

A mixture of past classics and new material from the softer side of the rock spectrum – somewhere between QMR and Alice's Restaurant.

Tuesday

The Wicked Uncle

JBC 105.0 FM, 8pm

Second programme of the week for Asian soul fans – JBC have now added another Sunday lunchtime programme because of the popularity of this one. They're also considering covering other Asian music too.

Thursday

Lyndon T

Fame-FM 94.5 FM, 7am

More laid-back soul for the early risers. Doesn't anyone believe in shaking people out of their beds these days?

Bonnie Prince Charlie

Radio Tree 106 FM, 8pm

More from the legendary Radio Tree. "Bonnie Prince Charlie spreading truth, rights and reggae" according to City Limits. Should be back soon after a recent raid.

— O·N - A·I·R : M·A·R·C·H

LONDON GREEK RADIO
105.1 FM

GREEK MUSIC	London Greek Radio PO Box ▮▮▮ London N19 5QN
POWER: 200W SITE: Haringey TIMES: Every day 6AM-12AM	TX FAX

LGR returned to the air on the 13th March, after a break of a couple of weeks. They'd tried using tapes the last time they were on but found this unsatisfactory so they then went back to live broadcasts once more, even though the risk of staff getting caught is greater. Hours have been shortened with the station closing at 10PM most nights rather than midnight as previously.

LGR only missed two days of broadcasts for the rest of the month when LGR staff appeared in court. The first case was particularly interesting as they tried to pin six offences of illegally broadcasting on the presenter, four of which were on successive days up till the day he was caught. They withdraw those four charges though and he was eventually fined £500 plus £250 costs. In the second case the presenter was fined £250 plus £75 costs. Given the amount of effort the DTI had gone to these prosecutions weren't very successful.

LWR
92.5 FM

BLACK MUSIC	LWR ▮▮▮ New Cavendish Street London W1
POWER: 200W SITE: Croydon TIMES: 24 hours	TX FAX

Yet another return to the airwaves after a couple of weeks off for LWR. The first broadcast in March was on the 14th with a live transmission from Cammie's nightclub. Late the following day they returned to the tapes, some of which included adverts for LWR programmes which no longer exist and past events. These were gradually swapped for newer ones over the next few days.

For the rest of the month, they were off the air for the 17th and most of the 18th, off again on the 25th and most of the 26th - whether these were raids or technical problems isn't known. Live transmissions were from Cammie's again on the 21st, Bentley's with the Reggae Squad on the 27th and Sinatra's on the 30th. LWR obviously hope the DTI won't have the courage to raid them at a nightclub filled with several hundred people. If they do summon up the courage then they'd probably be able to (legally!) clear the club of just about everything!

THE ERIC FILE
Raid's

This time we turn to Alice's Restaurant. Alice's has always managed to be one step ahead of the DTI and is rare among London stations in only ever losing one studio – about which you'll find more details in an Eric File special in a couple of months time. Now, the DTI don't like stations that escape and recently decided it was about time they did something about the Restaurant. Luckily they failed.

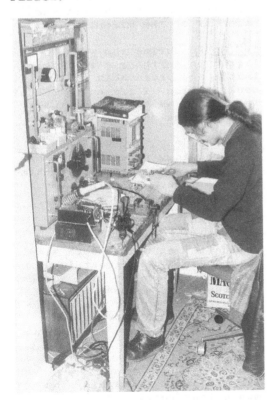

The story begins on Sunday 23rd March. Due to the extremely high winds that day they'd had problems keeping aerials up, so the Restaurant was late starting. Obviously the DTI had noticed this and decided to take advantage. At around 6 they arrived at the tower block where they were broadcasting from that week. Once at the transmitter they tried to fool Alice's into thinking there was a problem with the equipment by making the transmitter cut in and out.

Now it doesn't take too many brain cells to realise what's going on, so Alice's continued broadcasting as normal, telling Eric "If you're sitting on our block you may as well take it away as we're not going anywhere near it". Eventually the DTI got bored with it and finally removed the equipment during Dave Collins' show.

The DTI were obviously upset at this, so during the week they removed part of Alice's link equipment which was sitting on another building. With the special Easter broadcast coming up some very rapid equipment building had to take place, and because of this they didn't manage to put out any programmes on Good Friday.

The DTI then turned up again very early on Sunday morning whilst Alice's was off the air and confiscated another transmitter, which brought another halt to the programmes.

— P·R·O·F·I·L·E —

DTI WANTED LIST
Name: James Alexander
Station: Starpoint Radio

THE BEGINNING Starpoint was
basically a continuation of
Kjazz. Ben West and Chris
Philips were the two main people
who started Starpoint, others
joined after that. I was in it
from before the start and after
the start, but not at the start.

THE LIFESTYLE My life revolves
around pirate radio. I've been
in radio a year and 3 months,
which isn't very long, but I
know everyone now. I helped out
on Solar Radio at the end, and I
was one of the few people who
kept Kjazz on. I've been an
engineer for those, though I've
helped other people get on.

THE CAR I don't have one,
though I'd like a Lambourghini.
It'll take another 5 or 6 years.

THE FOOD Expensive restaurants
- preferably French.

THE MUSIC I like Sade. I don't
look at the charts much, though
there's a bit of soul at the top
at present so it's not that bad.
About half of it's rubbish in
there of course.

THE DTI I've been very lucky.
I've never had any close shaves
with Eric either on Starpoint or
Kjazz.

THE SHOW I'm on from 6-8 on a
Sunday morning, playing mainly
modern soul for anyone who
happens to be up at that time of
the morning.

THE AUDIENCE Starpoint on the

whole gets a very good response.
A lot of people phone in when we
have the phone-lines open. We
don't usually open them up for
very long, but if they're open
10 minutes we'll get 20 calls.

THE LICENCES I'd like to see a
completely soul station given a
licence, though it's probably
very unlikely. A member of the
IBA's on the community radio
panel and they want the project
to fail - so there won't be a
soul station. That's what the
majority of the minority want.

THE RADIO During the week I
listen to anything else illegal
that's on, preferably another
soul station. I listen to LWR at
the moment as there's virtually
nothing else on.

THE OTHER DJS Tony Blackburn's
entertaining, though I'd rather
listen to other people than him
because of some of his views.
He's pretty obnoxious about
pirate radio.

THE FUTURE Starpoint will
definately expand, though slowly
- it doesn't make great jumps
and fail. Starpoint will succeed
because there's good, solid
organisation in it. Anyone who's
useless will get thrown out.
Useless people have been thrown
out already, we're left with a
very tight bunch.

THE MESSAGE I wanna play the
music that people wanna hear -
so if they wanna hear anything
write to me.

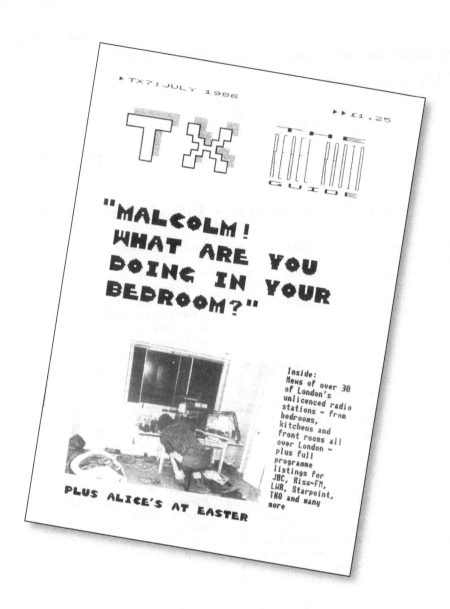

▶ TX7: JULY 1986

▶▶ £1.25

T X

THE REAL RADIO GUIDE

"MALCOLM! WHAT ARE YOU DOING IN YOUR BEDROOM?"

Inside: News of over 30 of London's unlicenced radio stations - from bedrooms, kitchens and front rooms all over London - plus full programme listings for JBC, Kiss-FM, LWR, Starpoint, TKO and many more

PLUS ALICE'S AT EASTER

TX7: JULY 1986

FEATURE

THE ERIC FILE
Raids

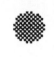

Eric Vs The Pirates - Episode Number 4976

Every now and again the complaints at the DTI pile up and they decide it's about time they did something to make it look like they're dealing with the pirates.

Usually this means trying to get some prosecutions, so they hire a few private detectives who sit in cars outside station offices or DJ's homes and then follow staff in the hope that they'll go to the studio. Once they think they know where a studio is located they call in Eric and Co who raid it - and hopefully catch a few people. Unfortunately this doesn't always work in practice.

On Sunday 4th May the DTI attempted to raid Starpoint's studio - but for some unknown reason the warrant had a different address on it so the DTI weren't able to enter the building, remove the equipment or take any names for future prosecution.

There have been quite a few other close shaves for stations. Some DJs have had to resort to tactics to try and lose their followers, like entering a building and then leaving by a back doors. Their followers haven't had an easy time too - it's been reported that one briefly left his car on a South London estate and when he returned its 2 way radio had been nicked!

After a week's rest the DTI switched to removing the aerial masts used by most of the major stations. These are often fairly expensive items of equipment, which take time to replace, particularly with some of the taller masts which can be up to 80ft high.

They started off in Muswell Hill where London Greek Radio's transmitter is sited. This wasn't the first time LGR had lost a mast - they'd previously had a 60ft one removed by a group of 20 police and DTI men back in early 1985. This time there were less people involved, as Eric was instead using an 120ft crane the DTI had hired for the day.

Having removed the mast and despatched it back to their headquarters Eric and friends headed down to Crystal Palace, home of most of London's soul stations. Starpoint was the first to go, followed shortly after by LWR. There was then a break for lunch and then finally Fame went.

This exercise didn't have the desired effect though. Within a week three out of the four stations were back on the air - at the time of writing Fame have still to return. You win some, you lose some...

COMMUNITY RADIO: WHAT HAPPENED?

We pick over the bones of the community radio experiment

This was meant to be the start of a new column in TX to keep you up to date with community radio developments in London. However, since the first version of this article the Government has axed community radio, so it may be the end of this new column as well.

So, let's so back to the beginning and trace the events that have resulted in the "delays" in making the announcement, and finally the decision to put the experiment on ice.

After various ditherings on the part of the Home Office and Government the then Home Secretary, Leon Brittan, finally gave details of the proposed community radio experiment on the 25th July, 1985. Stations had until the 30th September to make their applications – not long considering the work that needed to be carried out.

After several groups had made a mad rush to complete applications on time, it was then announced in the press on the 10th September that the deadline was to be extended to the 31st October. The Home Office also produced some additional notes for applicants including some technical amendments as the original specifications wouldn't have allowed stereo broadcasting!

Originally, it had been proposed that a decision on who had got the licences would be given in December, but due to the change in the deadline for applications this was put back to January. Then, when all 266 applications were in, the panel deciding who would get the licences had to be given more time so that they could make a "proper" decision. Eventually they reported to the Home Office in March, recommending that London should get an additional three stations. This was a problem for the Home Office as the BBC had already determined for them which frequencies would be used, and having to find two more would take even longer.

At this point a new Home Secretary, Douglas Hurd, came in, who it's been reported wasn't entirely happy with the way the experiment was to be run or the decisions the panel had made. Some of the chosen stations were judged to be politically "sensitive" (seemingly the ones with local authority grants) and it seems that the Conservatives were worried that stations with a left-wing bias, however slight, might damage their chances at the next election, and possibly some of the more extreme ones might be able to incite riots.

Therefore a Governmental committee was set up to go over the chosen stations again and make sure they were "suitable". Civil servants at the Home Office were also drawing up revised regulations for the experiment to try and remove the Government's fears and prevent the stations falling into the hands of political extremists.

However, at the meeting to approve these new safeguards, they decided instead to shelve community radio, with the excuse that they wanted to take a wider look at the future of radio in Britain and the part that community radio would take in it. After nearly a year of bungling, everyone's back to square one again.

WAFFLE
Decoding what the DJs say

"Firing on all cylinders"
(We're broadcasting)

"And don't forget the 01 if you're calling from outside London"
(Actually we're a two watt station and miles from a non-London exchange)

"London's number 1"
(The transmitter blots out everything else round here)

"Now whatever happened to them?"
(That was a one hit wonder and nobody cares)

"Live and direct"
(We've got a link transmitter and we're gonna use it)

"And now it's time to pay the rent"
(Today we're broadcasting from the engineer's kitchen)

"Tell your friends, the groove is back"
(We've just figured out the cause of our technical problems"

"Bigger and badder than ever before"
(We left out the filters on the transmitter to get more power)

"If you'd like to join the growing number of advertisers"
(We persuaded someone else to advertise a few months back)

"We lead, others follow"
(We once had an original programming idea)

"Supersoul Three-in-a-Row"
(I'm gagging myself so I don't talk for two whole links)

"We've got a few technical problems. but don't worry the engineers are working on it right now"
(Will someone at the office try and wake him up – if you can find him)

"It's DJ X doing overtime"
(The next DJ doesn't like me so he always turns up to the studio late)

"Commercial Free"
(The DTI took the tape decks again)

ALICE'S AT EASTER
Chris Miles gets out his camera for the rock station's holiday broadcast

TX presents the first ever published photographs of Alice's Restaurant's studio.
Includes Debbie Smith's first show at Easter and Chris Miles at the controls (who took the photo then?).

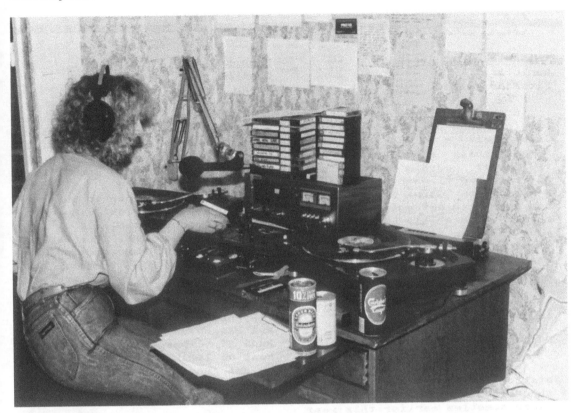

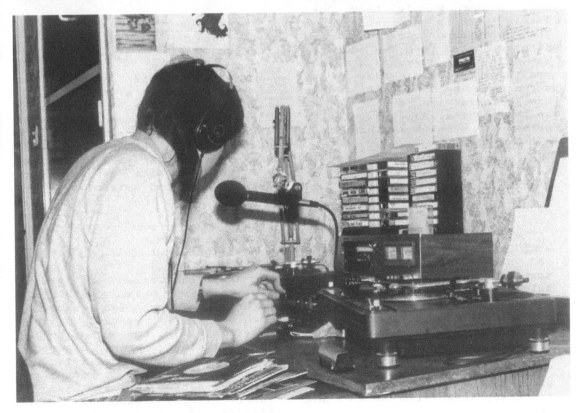

SELECTIONS

> ## The American Chart Show
> Radio 1
> Saturday 3-5PM

A great improvement over the previous show presented by Paul Gambaccini - a DJ who can talk intelligently about music and radio for hours, but sounds incredibly dull when he presents a music show. Gary Bird's show has a greater emphasis on black music - generally ignored by most American "Contemporary Hit" stations which are even more restrictive in what they play than daytime Radio 1.

> ## Tim Allen
> Radio Gemma: 90.3(ish)MHz VHF
> Sunday 1-2PM

A new time and another new station for Tim Allen following the close of Three Boroughs' Radio sometime earlier this year (the Medium Wave's been bad lately - excuse the inaccuracy). This programme overflows with jingles culled from two decades as well as Gemma's helium breathing (!) ones. To accomodate the 3BR staff, Gemma has increased its hours to start in the morning, and the station hopes to eventually broadcast all Sunday.

> ## Irish Profile
> JBC: 105MHz FM
> Sunday 4-5PM

With the extension of broadcasting hours on Sunday, JBC has introduced some more specialist programmes, including Asian music, jazz and Irish music. London's largest ethnic minority have long been without any radio aimed at them, except for Ireland's Radio 1, with variable reception (and Caroline next to it). Irish Profile, presented by Patricia, attempts to remedy this with music and news.

> ## Brunch
> Capital Radio: 95.8MHz VHF
> Sunday 10AM-12PM

Capital's attempt at the successful Zoo concept which has rapidly spread from its originators WHTZ in New York throughout the USA and other parts of the world. Capital's version has been changed quite a lot from the original idea to make it more suitable for its Yuppie service CFM. The speed and punchiness, complemented by a fast top forty format, has been lost and the presenters are rather older than the original.

Angus Deaton, Steve Brown and Jan Ravens have joined from Radio 4 - where Angus and Jan sent up I(L)R in Radio Active - and Paul Burnett, Jeremy Pascal and Roger Scott complete the team.

> ## Johnnie Flux / Bill West
> Radio Neptune: 1566KHz AM
> Sunday 12PM/1PM (varies)

A new double act on the station, playing a mixture of oldies and some chart material. There's also a strong free radio content with some news, discussions between the presenters about various radio and music topics as well as occasional taped extracts.

> ## Paul Buick
> LWR: 92.5MHz FM
> Sunday 10PM-1AM

After the close of Solar, Paul Buick was briefly with TKO, before joining LWR shortly before they resumed live programming. At present he only has this single show, although he does occasionally fill in for other DJs. This programme features softer soul and jazz / funk, without much of the electro influenced soul to be found in most other shows today.

▶ TX8: AUGUST 1986

LONDON'S ALTERNATIVE RADIO MAGAZINE

▶▶ £1.25

TX

THE
ANCOR
INTERVIEW
We reveal the
Capital jammers' plans

PLUS FULL LISTINGS FOR LONDON'S
UNLICENSED RADIO STATIONS

TX8: AUGUST 1986

CHRISTOPHER ENGLAND'S RUMBLINGS

USA radio

Every time a typical British "free radio-ite" gets off a 'plane in New York his hands immediately reach inside his anorak. His eyes glaze over, and after a few moments of violent thrusting he withdraws the radio. Not just any radio. No, this radio, which was held close to his heart throughout the journey over, and even on a few brief occasions switched on over the Atlantic Ocean, is covered with free radio stickers. It's his anorak radio!

He bares his teeth in a fixed grin as he moves his head back and his shaking fingers switch it on. His eyes almost bulge through his National Health glasses, held firmly together by elastoplast, as he rests his ear against the loudspeaker. Stopping only to wipe the sweat from the palm of his right hand over the leg of his badly fitting and highly scuffed black polyester trousers, he tunes from one end of the band to the other. His zits almost burst with what he hears – 120 different stations.

He returns to London with his seventy C-120 cassettes of recordings of the stations, which he places on his free radio altar in his bedroom, opens up one of his well-thumbed free radio magazines and nods in feverish agreement when he reaches the article slagging off British broadcasting and worshipping America's stations.

Now, this really gets my goat. Yes, America does have a lot of radio stations. But, the vast majority are just carbon copies of each other with just fractionally different playlists. The truth is that the amount of real choice is about the same as in London. Except, of course, that British broadcasters do it far better. In fact, when it comes to speech radio we excel. Speech radio in New York confines itself to news, sport and phone-in programming. All the Yanks can really do is play records. And that's done badly.

The playlisting of most stations is so tight that listening to any one station for more than half an hour reveals a tedious repetition of records. In fact, in New York nobody stays tuned to any one music station for more than 20 minutes. To get the musical variety you hear on just one British pop radio station, listeners have to constantly flick from one station to another. And, with very few exceptions, all American disc-jockeys sound the same. Experimentation in presentation styles is positively discouraged.

So, whilst there's a lot wrong with this country's broadcasting system, and we do desperately need more radio stations, let's only envy the quantity of stations in America, not their quality.

The community radio experiment

I suppose the Government had no choice but to ban community radio in this country. There was pressure from the existing music stations who said that it would've been unfair competition if a load of mini-Capitals (such as Radio Jackie) had been licensed. There was pressure from within the Government not to licence politically-oriented groups, as they may have contributed towards the downfall of the Tories at the next election. There was pressure not to be seen to favour any one particular ethnic group. PPL were under pressure not to give community radio stations much (if any) needle-time. If the community radio experiment had gone ahead it would have been a terrible disaster.

Instead, what's needed is a Government regulatory agency to which ALL radio broadcasting organisations apply for permission to operate. That includes the BBC. The IBA should revert to controlling television only (ITA). This new

agency, which I would guess would be similar to the FCC in America, would cut out the previous need for three different radio authorities (should community radio have gone ahead), and ensure that no one type of broadcaster suffers from crippling surcharges (such as ILR cops at the moment) compared to another. This way, whether a radio station wanted to be a community / public service minority type, or a fast moneymaking music service wouldn't matter. They'd both answer to the same authority. I'd guess that ideally a group or organisation would apply to this new authority to operate in a specific area, and providing that there was a band space, and they kept to a few common-sense rules, they'd be granted a licence.

Obviously, there will always need to be rules and a controlling body, but let's keep them simple and sensible, encouraging stations to set their own paces. This, to me, must be the approach that we should take towards a free radio in Britain.

For the last couple of years we've all been campaigning for "community radio". Maybe now it's time we reverted back to that almost forgotten "Fight For Free Radio".

COMMUNITY RADIO: WHAT NOW?

Steve Hamley considers if those spurned licences might now go pirate

Last month we looked at the Governmental bunglings that led up to the decision to scrap the community radio experiment. This month we're going to outline what could happen as a result of the axe.

There were two main lobbies for community radio (CR), although inevitably they do blur together slightly. First, and perhaps most easy to define, are the small business pirates, symbolised best by stations such as Jackie and Horizon. These were essentially profit making concerns, delivering advertisers a specific audience – SW London residents for Jackie, soul fans for Horizon. On the whole programming was fairly "safe" due to their desire to become respected by the authorities and advertisers.

The second group were the community radio lobby. They were campaigning for stations serving a particular locality or minority, with the people from that locality or minority making the programmes and running the station themselves. This group also contained an element of activists more interested in using radio for political purposes than for the benefit of the wider community.

When Leon Brittan put forward the idea of the CR experiment, he thought only of the first group. In fact, Radio Jackie's Peter Stremes was involved with a report on CR for the Adam Smith Institute, the right-wing "think-tank" which was largely responsible for persuading the Conservatives to back CR at the time.

The Home Office panel came up with choices from the second group, who perhaps had the more creative programming ideas. When the Government realised that there were people in these groups who wouldn't vote Conservative, and the completely free rein on programme content the groups would have, they panicked and axed the experiment. As Clement Freud, the Liberal broadcasting spokesman commented "Could it be that Mrs Thatcher is afraid of the voices of ordinary citizens; that it is alright for Mr Murdoch to take over The Times, but too dangerous to allow 21 community radio stations to experiment".

This now leaves us with a situation where the applicants all feel let down, and want to

take some kind of action. First off the mark were ANCOR, Action Now for Community Radio, who jammed Capital Radio one Friday morning in July. Media attention for this wasn't very spectacular, what with a Royal Wedding coming up, and it only served to prompt raids on LWR and TKO, who'd only just got back on the air after their last raids.

Many stations are proposing to take to the air as pirates, with a "day of action" being planned soon, when everyone will take to the air simultaneously. However, if stations plan to go pirate, they'll need to plan their operation carefully if they're to stand any chance of surviving.

For the moment it has to be assumed that the DTI won't adopt a laissez-faire attitude, so stations will continue to get raided regularly. With this happening, we're likely to see four main groups appearing, which will stand varying chances of survival.

First of these are the commercial pirates. Providing they're good at advertising sales, and have the technology to keep their staff from being found and prosecuted, then they should continue. At present it's easiest to sell to nightclubs, as they've got so much money, but other businesses can be just as profitable, though more effort may be needed at first.

The second group are the more community-angled stations, probably covering a smaller area. These will rely on some income from adverts, but most costs will be paid for by the volunteers working for the station. One possibility that has been ignored by pirates are subscriptions, where listeners are invited to contribute to help keep the station on the air. For stations with programming that may not be attractive to advertisers, this may hold the key to their success. Many stations of this kind will be new to pirate radio, and hence may not have the operating knowledge, or the right equipment. What is potentially the most interesting group, could be the shortest lived.

To stay on the air such stations will have to be very careful over their political output (the DTI "censor" certain stations with massive raids but won't admit it). Instead, political stations will probably take the model of Radio Wapping for their operation. Broadcasts will come from different locations at different times each week, making it impossible for the DTI to get to the transmitter site in time.

As to the final group, that's the traditional part-time pirates run as a hobby by their members. No matter how hard the DTI try, there's always going to be someone who'll build a transmitter and start a station from their bedroom.

This time round, the DTI don't seem likely to relax the raids, like they were back in '84. However, stations may still stand a reduced chance of being raided if there are more of them.

There's a great deal of paperwork that goes with each raid they carry out, including testing the equipment and recording details about its operation. Time also has to be spent preparing for court appearances, which are then often slow. When they do go out and raid stations, they are slowed down by the traffic in London, hindering them from getting to where they want to go. Then, once they've traced a station they have to get into the premises. A warrant will be needed from a local magistrate, and police will then need to accompany the DTI men if they're entering private premises. On a busy night in London they obviously have much greater priorities than stopping people playing records on the radio.

There is now the potential for the biggest pirate radio explosion yet, providing the stations are properly planned and organised. London may begin to get a decent choice of radio at last!

INTERVIEW: THE ANCOR JAMMERS

Christopher England interviews the people behind the jamming of Capital Radio

Within 24 hours of the announcement that there was to be no community radio experiment, I was approached for advice and a read-through of some strange scripts and statements from a group calling itself ANCOR – Action Now for Community Radio. I soon realised I was dealing with a very clandestine organisation, which seemed set on reversing the Government's decision.

With delicate negotiations I managed to secure this exclusive interview with their London Co-ordinator "Richard". I've been sworn to secrecy about the location and description of their headquarters. On arrival to conduct this interview I was asked to surrender the batteries from my tape recorder, and was only allowed to take notes in writing, which they checked before I left.

Q: Richard, what exactly is ANCOR, and how did it start?

A: We got together after the announcement that there wouldn't be community radio. We're a fairly loosely-based, country-wide organisation.

Q: So who's in ANCOR?

A: No comment.

Q: Well, what sort of people?

A: Mostly applicant groups, ex-pirates, that sort of thing.

Q: What are your aims?

A: We firmly believe in direct action to publicise our cause, and embarrass the Government over this – its latest U-turn.

Q: What sort of direct action do you mean?

A: So far, we've published a list of the groups that were about to be licensed before Tebbit stepped in, and we've jammed Capital!

Q: Tell us about the jamming.

A: Yeah, last Friday (11th July) we took out their commercial breaks throughout most of London. The w***ers even got Kid Jensen putting out apologies, and featured it during one of their news programmes. It got a lot of good publicity.

Q: What's your grievance with Capital?

A: None really. No, we just need to be heard. We're not stopping there. The Midlands is next. Then the Chart Show nationally.

Q: But doesn't this give you a lot of bad publicity?

A: No way. The public love it.

Q: What else, apart from jamming do you have planned?

A: Right. In a couple of months we're opening The Platform. That'll be an open access station, see, that many of the groups that Hurd s*** on will be using to get their programmes aired.

Q: Where will this be based?

A: Initially in London, then every major area that should've got a licence. We've proved we've got technology behind us, and we're gonna give the applicants what Hurd wouldn't – their own on-air Platform.

Q: Will this broadcast on top of Capital too?

A: No. Our brothers at Radio Wapping got reduced coverage by being on top of LBC. No, we'll have our own channel and a massive signal throughout London and the South East.

Q: What'll make you different from the other pirate stations?

A: Look, once people hear real community radio they'll just laugh at those t***ers who just play records. No-one takes the existing pirates seriously.

Q: No, surely a lot of people do. There's evidence that -

A: – Yeah, the ethnic stations are okay. Look, community radio is for the people, and with our direct action the Government's going to be forced to offer us something.

Q: Like what?

A: A gesture. Like, they could licence some of the existing cable stations. Or, there's hospital and campus radio. They're already on and providing programmes, so just give them a transmitter. Power to the people, that's all Hurd needs to offer.

Q: Do you believe ANCOR's direct action campaign will be strong enough to make the Home office reverse its decision?

A: Well, if it isn't then we'll just keep stepping it up until we get somewhere. I mean, the IRA had to take out buildings and people before they got taken seriously. One day they'll get Britain out of Ireland. One day ANCOR'll get community radio. It's the same struggle.

At this point an internal phone buzzed, and after a few words, I was told that the interview was over and escorted off the premises. Well, whatever else people say about ANCOR, they certainly know how to increase the size of their battery collection. I never got mine back.

SELECTIONS

Steve Hamley's pick of the radio – pirate and legit

CFM seems to be going down fairly well, despite it's slightly odd mix of music. In a single show you can expect to everything from the direst(raits) MOR through to some obscure New Age Music and the usual AOR. Alice's don't need to worry about losing their rock audience yet. The flow on CFM is broken up rather by the presence of the Network Chart Show in the middle. With LBC providing an FM outlet for it in London, it's a shame they don't continue CFM, but then it might seem a bit odd for the ILR flagship which originates the programme not to carry it.

On the pirate side, thanks to R Snow for pointing me in the direction of the Jonathan Moore programme on Kiss-FM between 3 and 5pm on a Saturday. He plays a wide range of music, and had an excellent programme of vintage blues recently. Straight after him, tune over to Starpoint for Jez Nelson's Different Hats show in a similar vein, though with more jazz. It's always nice to hear something different from the usual on a soul station. Maybe there's opportunity for a more sophisticated black music station?

Back at Kiss again, Max LX and Dave VJ of the Hard Rock Soul Movement and also Richie Rich have been enjoying reasonable success with records recently, Richie Rich being the first to appear on a new DJ label started by Spin-Offs, the Hammersmith record and equipment shop. Hearing Mike Allen, Capital's 42 year old Hip-Hop DJ, announcing them on his shows just goes to show how entrenched pirate radio now is.

Out in Hertfordshire, Newtown Radio has recently had the return (for how long I don't know) of Swage, one of the better 'personality' DJs around on the pirate circuit. Too many end up sounding like bad imitations of Steve Wright (i.e. aaaaaaarrgh), but Swage manages to be more original.

Briefly, watch out for brothers Mark and Mike Rider who have joined TKO. When the reception's not too good it's practically impossible to tell which one of them's on the air, which makes compiling the TX guide nearly impossible!

FEATURE

With the decision to axe the community radio experiment, many pirates are now coming back on the air. We therefore thought that now was a good time to explain how to set up a pirate station in London today (in theory of course - you wouldn't really want to do something like that would you now?).

We're going to start off looking at how a live operation would work, before going back to taped stations in a later issue. We begin this month with building a studio.

STUDIO EQUIPMENT

The main rule is Keep It Basic - these days it's pointless using expensive studio gear if the DTI are only going to confiscate it. Simpler equipment can be just as effective, although presenters will have to work harder. 95% of listeners won't even notice the difference! Any complicated production work can be carried out in a more comprehensively equipped studio which never goes on air. Programmes and adverts from this studio are then played on cassette from the on-air studio.

So, what sort of gear will you need? Well, first you'll want a mixer. Most pirates use budget models from Tandy, HH or Phonics, costing anywhere from £50 to £150. These are usually designed for disco work, so most DJs will be used to operating them. Next, you'll need turntables and a switch box - just a box with two mains switches, which supply power to each of the turntables. Go for reasonable quality, but simple, turntables - such as those from

Technics or similar. Above all, remember that decks should be easy to use.

Don't bother with jingle machines unless you are sure of the security of your studio. Although much simpler to operate, both jingle machines and cartridges are expensive and time-consuming to replace after a raid. Instead, use a pair of identical cassette decks with a countdown or tones on the tape for manual cuing by the presenter.

```
┌─────────────────────────────────┐
│         CHECKLIST               │
│                                 │
│  1x Mixer                       │
│  2x Turntables                  │
│      (incl. cartridges)         │
│  2x Cassette decks              │
│  1x Microphone                  │
│  1x Receiver                    │
│  2x Speakers                    │
│  1x Clock                       │
│                                 │
│  Plus switchbox for turntables  │
│       connecting leads          │
└─────────────────────────────────┘
```

Microphones need some time spent choosing them to determine which will sound the best. A mid-range mic - costing around £50 will probably be adequate for most stations. Don't forget a stand, most stations use an anglepoise stand fixed to the table holding the equipment.

Finally, ensure you've got a decent radio to make sure the signal's going out OK - some people continue for ages before discovering that the rig's blown up or been confiscated by the DTI!

CONTINUED >>>>

FEATURE

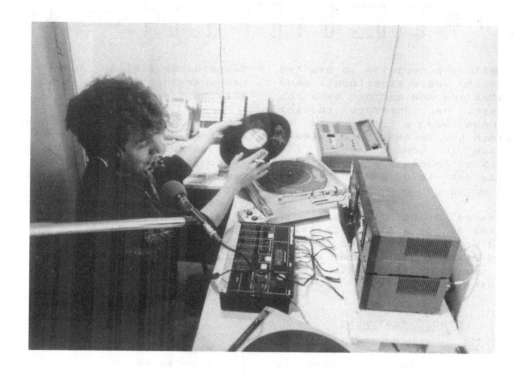

KISS-FM'S STUDIO - TYPICAL OF MANY OPERATIONS

Most of the studio equipment you'll need can be easily obtained in an afternoon's trek down the Tottenham Court Road or Edgeware Road (usually cheaper as there aren't so many gullible tourists / visitors). Don't forget to buy connecting leads - and make sure these won't fall apart easily and cause endless breaks in transmission.

STUDIO SITE

Choose this carefully. If you're sure that your link system is secure and the DTI won't know the names and addresses of any of your staff, then you're probably safe to use a house belonging to one of the presenters. Alternatively, hire a cheap bedsit or office somewhere, making sure you aren't going to disturb the neighbours with a constant trek of people going to and from the studio day and night. Explaining

to them what you're doing could prove difficult.

BUILDING THE STUDIO

Make sure that the studio contains only the bare minimum needed for broadcasting. Let's assume that you're starting with a completely empty room. First of all, paste cork tiles / thick carpet / egg boxes (if you really can't afford anything else) on the walls and put a carpet on the floor to reduce echoey effects. Next, you need a table or two to put all the equipment on, and a comfy chair for the presenters to sit on.

All the equipment needs to be easily reached by the presenters. The usual layout is to have the mixer straight in front, with the cassette recorders stacked in front of

CONTINUED >>>>

FEATURE

that. The record decks are then placed to the right and the left, with the switch box next to the mixer. Keep audio (especially microphone) cables away from any mains leads if you want to avoid nasty mains hums appearing. Remember, that it's much easier to trace faults if there isn't a rat's nest of cables...

For monitoring of the transmitted signal, use a stereo receiver (tuner + amplifier) with the speakers placed on the wall in front of the presenter. With the volume kept at a reasonable level, and a unidirectional microphone aimed away from them there shouldn't be any feedback problems.

Often a table on the left will be used to put records, tapes and papers on. Use racks to house cassettes of jingles and adverts, if you want to avoid problems with DJs hunting through a mess for the commercial they're meant to be playing.

A phone is very useful, and can be linked up with the mixer via a suitable interface – though ensure the studio number is known by as few people as possible and never given out over the air. If people are calling in to the station for competitions, etc, arrange another phone number for them to call. Then, if it is required to take a caller live on air, the person manning the other phone will take down their number and pass it on to the studio who call them back. This also has the advantage of reducing problem callers on the air...

Programme schedules, advert schedules and other important notices should be placed on the wall where they can easily be seen – this is where the cork tiles have another use. If presenters are busy, they want to easily find out the details they want, not hunt through wads of paper.

Of great importance, is to remove everything from the studio once you have finished with it. Listeners' letters should only be brought in for the duration of a programme, and on no account should any material relating to financial matters be present in the studio. Playlist records can be left in the studio, but all others should be left with caution.

Most of this is common sense. Above all, keep the studio CLEAN. A happy DJ makes for a happy programme (I feel like a McDonalds' training manager saying that...).

TO THE TRANSMITTER

The next stage after the signal leaves the mixer is the compressor. This is a device which prevents loud passages from distorting at the transmitter. This needs to be of a special design for FM Radio use to be effective. From there the signal passes to the stereo encoder, if it is required to broadcast in stereo. The signal then passes to the transmitter chain.

<<<<< CONTINUED NEXT MONTH >>>>>

ON-AIR

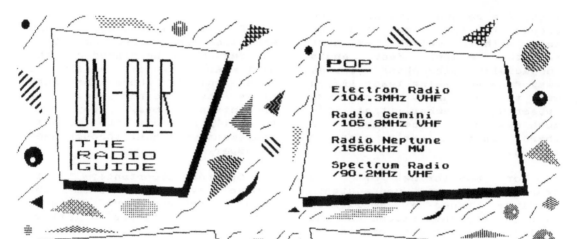

ON-AIR
THE RADIO GUIDE

POP

Electron Radio
/104.3MHz VHF

Radio Gemini
/105.8MHz VHF

Radio Neptune
/1566KHz MW

Spectrum Radio
/90.2MHz VHF

BLACK MUSIC

Radio Badger/91.8FM

Direct Line Radio
/105.5FM

JAR Radio/97.85FM

JBC/105FM LWR/92.5FM

Kiss-FM/95.3FM

People's Choice/103.5

FAS/105.5FM TKO/90.9FM

Trax-FM/103.3FM

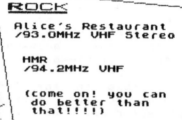

ROCK

Alice's Restaurant
/93.0MHz VHF Stereo

HMR
/94.2MHz VHF

(come on! you can
do better than
that!!!!!)

VARIOUS

London Greek Radio
/105.1MHz VHF

Radio Memphis
/1260KHz MW

Sina Radio
/90.7MHz VHF

Radio Wapping
/97.0MHz VHF

MIXED FORMAT

Radio Gemma/90.3MHz VHF

Newtown Radio/90.6MHz

Starpoint Radio/88.6MHz

Thanks as usual go out to everyone who contributed this
month, especially Chris Miles, Clive Glover, Mark and all
the anonymous voices on the Voicebank.

We try to make the On-Air section as accurate as possible,
however occasional errors do slip in. If you can correct any
of fill in any gaps then call 01 400 8282 or write to us.

▶ TX9: SEPTEMBER 1986

LONDON'S ALTERNATIVE RADIO MAGAZINE ▶▶ £1·25

TX

ALICE'S RESTAURANT
JBC KISS—FM
STARPOINT—FM LWR
SEALAND NTW TKO
21

TX9: SEPTEMBER 1986

THE ERIC FILE: ENGLAND'S ENCOUNTERS

Christopher England delves back into his murky past to recall some memories of his meetings with the dreaded twosome

Until the law changed in July 1984, during a Home Office (now Department of Trade and Industry) raid no one had ever needed to answer the question "what is your name?" with anything but "I'm sorry, I'm not obliged to tell you". Also, equipment could only be removed on the specific order of a court. It's such a shame that so many pirates were prosecuted because they told Eric's mob their names, or let them walk off with the equipment. In fact, not one pirate should have ever needed to face a court until after the Telecom Act of July '84, if only they had realised their rights.

I have met Eric's mob on a few occasions, whilst being the perpetrator of serious offences against the 1949 Wireless Telegraphy Act. The first was back in February 1979 when I went bounding up to them as they were looking at some Medium Wave equipment sitting in a field. Well, they bought my story about having DFed (Direction Found i.e. tracked) the station myself, and I got a letter some months later telling me they'd let me off this time, but if it happened again they'd prosecute me for listening. I bet they'd wished they'd known what I'd had in my pockets: spare 807 valve, crystal, programme tapes, etc, etc...

Apart from a few very near misses, my next major encounter was during May 1984. On this occasion, they came bursting into the studio just as I had finally convinced a studio guest to take her clothes off live on the radio (less fun for the listeners than for me, I think). Caught me right in the middle of saying something. Angered by the interruption, I upset them greatly by not letting them take names or equipment.

This proved highly embarrassing for them in front of the police and press who'd accompanied the midnight swoop; so Eric took a load of photos with a camera drawn from a belt holster, while John Garlic tried to caution and question me. Very difficult when you've got no legal power to force the person to even tell you his name. They then tried to "inspect and test" the rig (which is all they were empowered to do). This seemed to consist of Eric grabbing the rig and announcing he was taking it. A stand-up argument ended with me asking the police to insist that he reconnected the rig and left. Red faced, he did. According to the press who were with him (and later contacted me) he was extremely upset as they drove away.

So, with the law changed, imagine Eric's glee when at 8.58pm on Wednesday, 2nd January 1985 (you'll note that TX is the only publication to get this time and date right!) he raided Radio Shoestring. Despite what other notoriously inaccurate magazines may have said, I was not on the air at the time. Paddy Jaye was. So they found me sitting on a sofa in a room adjacent to the studio. Whilst they were dealing with the chap in the studio, I had a chat and joke with one of the two coppers that had come with them. As a regular listener, he was very apologetic and turned a blind eye as I emptied my pockets and bags of anything slightly incriminating, and stuffed the cushions full of letters, tapes, and running orders.

I was eventually called into the studio. A huge smile broke over Eric's face. "Hello, chum, er what IS your name then?"

Double drat. I had to answer the question properly this time.

"That's right. I remember. 1979 wasn't it. DFing it this time as well, were you?"

And so the questioning continued. Now, of course, it's important to remember that once they've got your name and address you don't have to say another word. Once the notebook had been put away, the atmosphere became more relaxed. Despite Eric's protests I forced a conversation about the current pirate scene.

He seemed confused as to why pirates used "links" (a signal from the studio to the main transmitter), but accepted my explanation that it was a bit cold operating studio equipment sitting on the roof of a tower block. He admitted that they hadn't always been able to track the links until mid-1981. We chatted on quite amicably, as they carried the studio equipment through to the van.

He explained away the reason Radio Jackie hadn't been raided, suggesting that it was being allowed to continue as phase one of the Home Office Community Radio experiment. (Whoops, me and my big mouth – I said I'd keep that a secret!) He told me, though, that Jackie would be finished within a few weeks (he was right). We stood there laughing and joking about this and that, and mutually complaining about the fact that there were so many Greek stations (17 at one count). A good time was had by all – well it was just after Christmas! They even wished me a happy new year as they left.

I had to wait until Monday, 24th June, 1985 for the court case. I plead not guilty. The chap caught in the studio got a conditional discharge, on account of his very young age. They deferred my hearing to Monday, 2nd August. 1985. Even though I was in a totally different room, the circumstantial evidence they'd amassed (remembering they don't have to prove things conclusively as it's a "summary" conviction), going right back to 1978, seemed to indicate that I was a long-term naughty boy, so the rightly confused magistrates had to go away and think about it.

During this interval, some of London's top engineers and disc-jockeys (who'd come to gloat) encased Eric and John in interesting conversations about the introduction of community radio being the end of pirate activity. The DTI's view was that the pirates would be around forever. I was in the middle of a conversation with Mr Davies, the prosecution counsel, about the legalities of his habit of persistently listening to Laser when the magistrates returned.

They decided to relieve me of £666.75 (including all costs), but nicely ordered the return of my priceless collection of oldies, which just happened to be in the studio at the time of the raid. There are a number of highly innovative stations I've been involved in, but I had to get caught at the worst station I've ever known. How embarrassing!

Anyway, Eric brought the records back to my home personally. We had another nice long chat. I fact, he popped round twice. He immediately recognised a friend of mine he'd caught over ten years before, and left messages for me to pass on to different pirates. We chatted about many things whilst he recalled with affection how pirate technology has changed over the years.

Did you know that he's been involved in Wireless Telegraphy tracking since 1966? His favourite station was Radio AMY (one of mine!). (John Garlic preferred Radio Telstar South, an oldies station sadly not one of mine.) I didn't quite get to ask Eric his favourite food, car, animal or colour, but I think he's a nice old fella, and it'll be sad to see him go when they revamp the DTI mob. From this summer, it seems, they plan to bring in Bodie and Doyle... makes a sad change from Steptoe and Son I guess.

≡ FEATURE ≡

Last month we took a look at building a studio, this month we turn our attention to the transmission equipment.

First of all, you'll need a transmitter site. This should ideally be in a high location to enable the signal to get out well over the coverage area - which is why most of London's major stations can be found congregating around Westow Hill and Church Road in Crystal Palace.

Usually a station will hire a small office, which will be used solely to house the

prove even more difficult.

Next, you need to consider how you'll get the signal from the studio to the transmitter. The main priority is to ensure the studio is as difficult as possible to trace, so DJs won't get caught and fined large sums of money. To do this you need a series of complex, hidden links.

The first one from the studio will be the most secure, maybe infra-red (like TV remote control units) or possibly an even safer method. This may then be followed by a microwave link to take the signal across town,

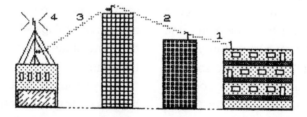

1 INFRA RED LINK FROM STUDIO
2 MICROWAVE LINK
3 UHF LINK
4 UHF BROADCAST SIGNAL

transmitter. A high mast will be erected on the roof and cables will link the antennas and transmitter equipment together.

Finding a suitable site will prove the most difficult task. You'll need to have a friendly landlord who won't mind the 80 foot mast on the roof, the regular visits by the DTI to remove your transmitters, and your visits in the early hours of the morning to replace them! In the light of the recent court case involving London Greek Radio (see page 25) this may

where it's converted to UHF for the final trip to the transmitter site.

The DTI will need to work backwards from the transmitter site to detect the links. The UHF repeater is usually fairly easy to locate - which some small stations haven't yet realised. Microwave links are more difficult, but given time they can be found. Basically, the higher the frequency, the more difficult it is to find the

CONTINUED >>>>

FEATURE

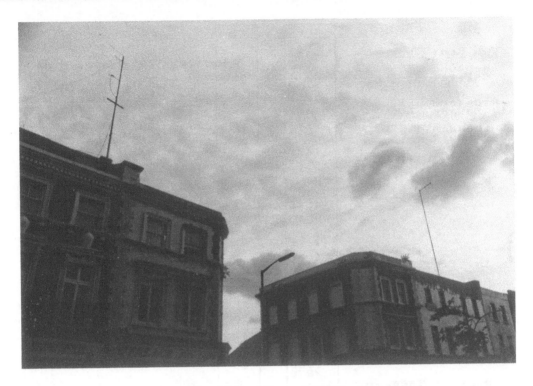

LEFT: KISS-FM RIGHT: TKO

transmitter, but the DTI are now capable of finding just about any radio signal after importing new tracking gear from the USA last autumn.

Infra-red links have the advantage that they are undetectable unless you find the transmitter or receiver - the army uses them for secret communications in battle! Even once they've found a receiver it won't always be easy to find where the signal is coming from.

As you can see, it takes time to locate these pieces of equipment. And if the station is only operating one day a week, they may disappear before the DTI have finished got very far down the chain. With equipment hidden on buildings, finding the precise location may be even harder.

Pirates still have the leading edge over the DTI, but

they're catching up slowly on present methods. However, pirates are moving on all the time. In the future we may see lasers being used as links (not as far fetched as you think!). Lasers outside the visible range are completely undetectable and can travel large distances which makes it extremely difficult to find the transmitter.

So, how much does this all cost? Starting at the studio (see last month) you could expect to pay around £400 or so for a reasonably decent set of equipment. Link equipment would come to around £400 also, depending upon its complexity. A mast and antenna system could be typically around £500, depending upon the exact type, height and antenna gain. Then finally, you could expect to pay around £250 per transmitter. Total cost: around £1,500. Sure beats the 1/2 million for ILR!

ON-AIR

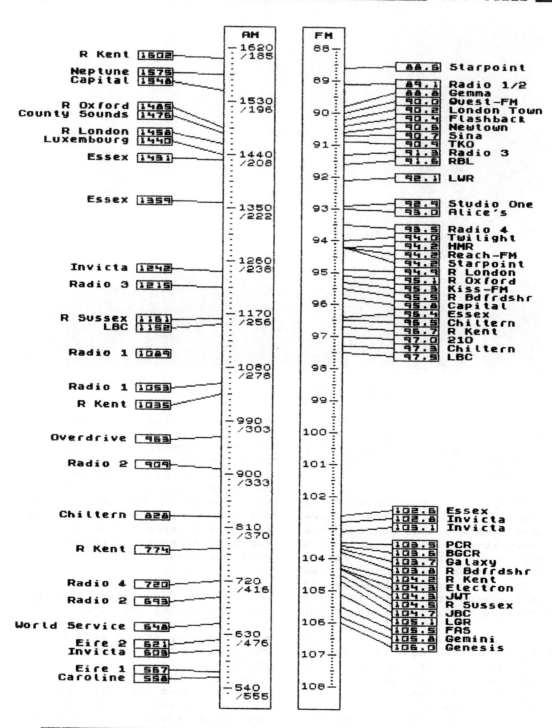

Thanks to everyone who contributed to this month's On-Air reports, especially Chris Miles, Clive Glover, David Priest, Mark from Streatham and the anonymous Infobank message leavers. All corrections and infomation greatly appreciated.

≡ ON–AIR ≡

LONDON GREEK RADIO

London Greek Radio continued to try and keep up their 7 day a week broadcasts to the Greek community of London during July - although it wasn't exactly easy.

They began the month alright, but lost an FM rig in the afternoon of Thursday 3rd. They returned on Friday evening, but then lost another mast and rig on Sunday morning. They returned briefly on Wednesday 9th, but had disappeared again by the afternoon.

There then followed a slightly unstable period, with a return on the 14th, gone again on the 15th, back lunchtime on the 16th, only to go again in the afternoon, a test on the 17th in the evening, and finally a proper return on Friday 18th. Precise details for this time aren't available.

GREEK RADIO

London Greek Radio
PO Box ▇▇▇
London
N19 QSN

POWER: 100W
SITE: Muswell Hill
TIMES: 7 days a week

TX FAX

Programmes went out normally over the weekend, but they were then raided again on Tuesday 22nd. Back they came the next morning, and nearly made it through to the rest of the month - only a raid on Thursday 31st put them off the air.

LGR has not been back since then because of a court case involving the owner of their transmitter site. From not long after it started, LGR has always broadcast from the same site,

above a shop in Muswell Hill. Although the studios have regularly moved around North London to avoid detection, the actual signal you tune into has always come from there.

105 FM RADIO FOR THE GREEK LONDONERS

Unfortunately, the DTI recently took it into their heads to prosecute the owner of the site for possesion of illegal transmission equipment. In his court appearance he explained that he was not involved with the station, that he had several tenants in the same building and that he did not know who installed the equipment. With most court cases about pirate stations being simply the word of the DTI officials against those being prosecuted, he didn't stand much chance of winning.

In the end, he was fined £1000 plus £250 costs. This has meant that LGR have had to look for a new transmitter site, as it would be unrealistic to expect to continue at their old one. A provisional return to the airwaves has been set for the 6th September.

This court case sets an nasty precedent for other stations, who could now find themselves having difficulty finding and keeping sites. Landlords will be under pressure to reveal their tenants, or risk prosecution themselves. Perhaps the only solution would be if stations created untraceable offshore companies to claim ownership of sites and equipment.

PIRATE TV WITH NETWORK 21

Since the brief mention of Network 21 in TX6, we've rather neglected the station. However, they've been kind enough to send us some more details, and we hope to arrange a fuller feature in the months to come. For now, a brief introduction to the station.

Network 21 began on the 4th April, 1986 and have been on the air ever since, being the first pirate TV station to operate in a continuous manner. Previously in London there have been only brief transmissions from "Channel 36" to try and get a test and development licence out of the Home Office for their TV transmitter, and a few broadcasts from Thameside TV, who were raided shortly after starting because they relayed the TV sound over an easily traceable FM Radio channel.

Network 21 is on the air every Friday night / Saturday morning from 12 midnight for around half an hour on Channel 21. The easiest way of picking them up is to wait till around 5 minutes to midnight, then tune to ITV. Then slowly turn the tuner control and you should find Network 21 just below ITV with their logo and some music. Obviously the difficulties of setting up the equipment means that sometimes they're late on the air or aren't able to make it. So, if you haven't received anything by 12.30, it probably means that they aren't broadcasting that night.

The transmitter site is in the Crystal Palace area (just for a change) which means that most TV aerials should be pointing in the right direction. However, if you don't get a very good signal on the legit channels, then you won't stand much of a chance of receiving Network 21. Reception isn't limited to just South London, and those living on high ground in North London (Hampstead, Highgate, etc.) should be able to pick it up well.

So, what are you likely to see when you tune in? Well, Network 21 provides an outlet tor a range of independently-produced videos, so "anything could happen". Much of the material is produced by groups allied to the station, along with material from a variety of other sources. Without the creative restrictions of copyright law, they're free to do what they want.

The TV pirates haven't finished expanding yet. Planned to come on the air soon is Network 21, The Radio, to do for radio what they're already doing for radio and also provide a stereo simultaneous broadcast for the TV. They're also offering to lease airtime to other organisations who want to put their programmes out. To provide extra finance they're now taking advertising, although at £10 a second it's only just cheaper than Sky Channel, which reaches a rather larger, if less specific, audience.

So far, the DTI seem to have left Network 21 alone, though this may be due in part to the over-cautious methods employed by the station. Tune in this weekend, and let us know what you think...

► TX10: OCTOBER 1986

LONDON'S ALTERNATIVE RADIO MAGAZINE ►► £1.25

TX

THE ANCOR INTERVIEW
TWO-PLATFORM 88
RADIO POLITICS
TOWER BLOCKS
THAMESIDE REVISITED
PLUS LONDON'S ONLY
PIRATE RADIO GUIDE

TX10: OCTOBER 1986

NEWSDESK

Everyone tapes it

Several major unlicensed stations in London have moved over to taped shows. It is believed that the DTI have recently acquired new technology that makes it easier for them to trace the UHF links that stations have been using between their studios and VHF transmitters. This has led to several studio raids in recent months and prosecutions of a number of leading radio DJs.

Programmes on LWR, TKO and Starpoint are recorded earlier the day onto high-quality cassettes, before being rushed to another site where they're typically played out from a tape carousel. This system has the advantage that studio equipment can't be confiscated or DJs so easily prosecuted for illegal broadcasting. Newer link technologies are in use by a small number of stations that cannot be so easily detected, often combined with a cheaper UHF link for the final hop to the VHF transmitter site.

IBA to cut IR rental

After years of complaints that the rental fees for transmitters that Independent Radio stations pay the IBA are too high, the IBA is finally going to cut the cost. This change is probably due to a combination of massive lobbying by the AIRC and the need by the IBA to show that there's no need for a new "slimline" radio authority, which is a widely rumoured proposal of this autumn's Government Green Paper.

Pirates in drugs bust

LWR and TKO were taken off the air on Friday 29th August shortly before a major police operation on Bentley's Nightclub in Canning Town, where both stations held regular gigs. LWR had its "Reggae Squad" present on Thursday nights, and TKO had their Roadshow there on Friday nights.

It's been reported that several radio DJs were present at the time of the Police Drugs Squad raid, but confirmation of this and more exact details aren't available.

Both gigs were major money spinners for the stations. LWR has since been negotiating for new residencies at other clubs around town.

Cuts

- More proof that Capital Radio's got more money than sense. They recently commissioned a survey into CFM's listeners' habits and aspirations, which came up with such wonderful revelations as CFM listeners are much keener to own a Ferrari than average Londoners, and that 72% of them would like to stay in bed all day with a partner as opposed to 45% of Londoners in general. Wot? And listen to the radio?

- Strange lot who call the TX Infobank. Recent messages have included (rather bad) singing, the occasional burp, assorted four letter words and someone trying to impersonate a foreign accent who left the message "Hello. I am watching you, very, very carefully".

- Radio Thamesmead were recently given a "special event" licence for the duration of the Greenwich Festival, which allowed them to use a low power medium wave transmitter in addition to their usual cable outlets. They subtitled the broadcast "The First Legal Transmission by a Community Radio Station in this Country", and despite the low power were able to be picked up quite a distance away from the site – helped no doubt by engineers used to extracting those vital last micro-watts.

- Apologies for getting the issue number on the cover wrong last month – the one with the Alice's studio on the front...

CHRISTOPHER ENGLAND'S PIRATE EYE

Aha! Despite being the man you love to hate, I'm obviously the chap with his ear to the ground. Last month I predicted the birth of a new federation to truly represent the views of the radio lobby. It's happened! The Community Radio Applicants Meeting has spawned the "Association for Broadcasting Development" (ABD). Let's wish them luck, and hope they get the Governmental recognition they deserve for radio's sake.

I'm sick of this word "community". I'm sure it doesn't really apply in this country. Presuming that "community" radio as originally defined in the Home Office guidelines ever gets on the air, I think it should be referred to as "Third Tier Radio" (TTR). The definition of TTR would be stations licensed by someone other than the BBC or IBA – a third authority. The word "community" tends to mean an actual geographic area or neighbourhood. Under the original Home Office guidelines whereby a soul or rock station could well have been licensed to cover half of London, it could hardly have been called a "community" station, could it? So, let's ditch the word "community" in favour of TTR.

Actually, going one stage beyond the fight for community / TTR, I must declare something.

In reality, I'm against any "tiers" at all. I believe there should be only one. I'm one of those who supports deregulation (a swear word in some circles). Let me explain the meaning of "deregulation" as I see it.

At the moment we have two authorities "regulating" broadcasting in Britain. Firstly, there's the BBC which controls and regulates its own stations. Then there's the IBA who appoint companies to run the commercial stations. If the Community Radio Association (CRA) have their way, they'll become a third authority, having charge of appointing "community" radio stations.

Three different organisations in charge of broadcasting? How ridiculous! I'd suggest the Government establish just one "Broadcasting Authority" (BA), like in America or Canada for example. The BA's brief would be to constantly seek to widen consumer choice. They would allocate the frequencies and coverage of both the TV and areas radio stations that organisations applied to run. They'd grant (say) three year "rolling" licences to successful applicants. As well as listening to the complaints and suggestions of lobbyists, they'd constantly monitor the performance of licensees, warning and terminating those in breach of contract.

Groups, organisations or individuals could petition the BA to become new stations. or replace those didn't seem to be doing their job properly.

Obviously, the IBA would no longer exist. However, the BBC would still exist, funded by the licence tee, and would compete alongside other organisations for the allocation of frequencies. These "others" might wish to establish highly commercial stations (such as Capital, etc.) or they might be tiny operations funded by grants, subscriptions, etc. (currently called "community" radio).

Any organisation applying to the BA for a licence to operate a station would have to detail the programme style, funding, structure, etc. of that station. They would be strictly licensed as per their application. This means, for example, that an all-speech "community" station run by a workers' co-operative, funded by grants and subscription, could not suddenly become a money-making pop music station. It would have to stay exactly as it specified in its initial application. Should it fail and co bust, then it would close down, releasing its frequency back into the BA's "pool". The BA would not necessarily try to find a direct replacement,

unless one had already come forward of its own accord.

We, as listeners (and viewers), would be free to challenge any station on the air if we thought it wasn't doing its job properly, or, ultimately anyone could set up a rival group to apply for its licence when it came up tor renewal.

The problem at the moment is that the current BBC / IBA structure doesn't allow for direct failure, or the fact that the needs of the consumer are constantly changing. If a commercial station goes bust, the IBA just finds another company to step in, disregarding the fact that there may not have been any demand for that type of a station in that specific location in the first place. Also, for example, let's imagine BBC Radio London has completely outlived its usefulness. Instead of there being machinery in existence to close it down, the BBC would constantly try to revamp or rescue it. Currently the idea of just switching some-thing off is unacceptable, so the two Radio London frequencies would remain occupied by rubbish, instead of being released to a "pool".

Having a single Broadcasting Authority would mean that we'd no longer have a situation whereby somebody says "I know, let's have commercial radio", and ten years later the Government works out how to establish it, and then someone else says "I know, let's have community radio" and it's a further ten years before the Government can establish some structure for it to go ahead.

Instead, with just one authority to whom any potential broadcaster applies when a brand new idea came up, it wouldn't have to be debated for ages before the new type of station could come on the air.

Surely this has got to be the most flexible and forward looking way to get the kind of broadcasting we all really want. Let TX have your views!

A BEGINNER'S GUIDE TO RADIO POLITICS

Ever been confused by the organisations that seem to have a say in what you hear on your radio, when you don't? We explain who they are, what they do – and how it affects you.

Organisations

The Home Office

The Home Office carries out the Government's duties for broadcasting, such as allocating frequencies to stations, deciding the basic terms under which they should operate, etc. With the community radio experiment, it was to have been the licensing authority, deciding how the experiment was to have operated. This would have been the first time the Government would have had direct control over broadcasting.

The Department of Trade and Industry (DTI)

The DTI are in charge of making sure that the radio spectrum is used properly, through its Radio Interference Service: the airwave police. It carries out the tracking of unauthorised stations (i.e. pirates) and subsequent prosecutions.

The Independent Broadcasting Authority (IBA)

The IBA is the licensing authority for Independent Radio and Television. Together with the Home Office, it decides what areas should

have a station and then chooses a suitable operator from applicants. In consultation with the stations it decides what sort of programmes they should put out to ensure there'll be something for everyone at least sometimes. Pleasing all of the people some of the time.

It also keeps an eve on the quality of programmes and deals with any complaints from the general public that arise. It also owns and maintains the transmitters which the stations use. The stations pay the IBA a proportion of their advertising which finances its operation.

The Association of Independent Radio Contractors (AIRC)

The AIRC looks after the interests of the Independent Radio stations. As well as carrying out such things as bargaining over pay rises with the unions involved in independent radio, it is also recognised by the Home Office as the representative for the stations.

The AIRC believes that Independent Radio is at present too tightly controlled, and believes the system should be deregulated. It would like to see a "slimline" authority which simply issued licences and dictated general terms. The stations would then be free to decide what programmes to put out and would own and maintain their own transmitters.

The British Broadcasting Corporation (BBC)

Like the IBA, Government owned, independently managed (or should be...). The BBC provides Britain with public sector broadcasting, funded by the television licence fee.

The Community Radio Association (CRA)

The CRA began as an organisation to campaign for a system of radio by the people, for the people, seeing community radio as a way of redressing the bias of the existing media. Their ideal was a station serving a small area, such as a London borough, collectively owned by local residents. Programmes would be provided by different "user groups", such as special interest groups, ethnic minorities, pressure groups, residents associations or anyone who wanted to make a programme about a particular subject. Stations would be non-profit making, with funding coming from a mixture of grants, listener donations and limited advertising and sponsorship. There would be a small number of paid staff to supervise the operation, but all the programming would come from volunteers. They later took on-board the idea of Community of Interest broadcasting as well, in particular ethnic stations.

The CRA took on a major role when it became the only community radio lobby group to be recognised by the Home Office, who perhaps didn't see the more radical aims of the Association. This was to prove a problem, as many applicant groups then joined the CRA, believing likewise, thinking that the CRA would represent all their interests to the Home Office. Not willing to compromise on their original ideals, this left the CRA in a difficult position, leading to growing criticism from those people who didn't agree with their proposals and who would be left without a voice if they resigned from the association.

Radio stations

Independent Radio

Capital Radio, Essex, Invicta, Mercury et al. Stations are financed by advertising and licensed by the IBA who determine what sort of programmes the station should put out. IR was formerly called Independent Local Radio (ILR) with the aim of having each station covering a major population settlement.

With the inability of stations to be profitable, through a combination of bad marketing to advertisers and the high costs imposed by the IBA, stations merged and as new contracts for areas were given out, they went predominantly

to existing stations. For example, there were originally to be two contractors for Kent one for the Medway towns, the other for Canterbury, but following a series of financial problems the two contractors merged, ending up covering the whole of Kent with the same programming. This has led to stations covering larger and larger areas and getting less and less local, hence the name chance.

Stations are owned by private shareholders, who were originally to be locally based. However, most now have substantial investment by foreign multinationals, like Canadian radio giant Standard Broadcasting, who own a large chunk of Capital, and the Australian owned Chalford Communications, who have a big chunk of LBC.

Independent National Radio (INR)

A system put forward by the IBA, which at present feels independent radio lacks the prestige of BBC Network radio. The Home Office has allocated frequencies for the service, which become free once the emergency services have moved from the band at the end of the decade. The IBA isn't totally sure about what it wants to do with INR, with suggestions put forward ranging from a national CFM-type station to a radio version of Channel 4, perhaps owned by all the existing IR stations.

BBC Network Radio

BBC Radios 1, 2, 3 & 4. Broadcast by a chain of transmitters throughout the UK.

BBC Regional Radio

BBC Radio London, BBC Essex, Radio Kent, etc. Stations are now county-wide, taking the name of the county they are situated in. However, in counties where there isn't yet a station, such as Hertfordshire, neighbouring stations extend their coverage – Radio Bedfordshire in Hertfordshire's case.

Funding is limited, so most go for a cheap

diet of "All Over the Road" music mixed in with local interviews, news, information and phone-ins. Although some county stations are very successful, those in the major cities, such as Radio London, attract only a limited audience.

Neighbourhood Radio (NR)

These are stations broadcasting to a particular community, such as one of two boroughs in a city. Stations would be locally owned and funded, with a strong mixture of local material in the programmes. These could be either Community-Access stations or music based local programming.

Community of Interest Stations (COI)

These are stations broadcasting to a particular section of the community they cover. These include specialist music stations playing one kind of music only (such as soul, rock, country & western, jazz) as well ethnic stations (such as those aimed at as Afro-Caribbean, Asian or Greek people). There are also possibilities for other kinds of radio aimed at special interest groups.

We've now looked at the main organisations involved in radio and the different types of stations on the air already and those proposed by the Home Office for the community radio experiment. Next month our attention to the we turn different types of radio systems around the world and examine the pros and cons of each of them.

We also outline how they would link in with different types of stations community access neighbourhood radio, specialist music radio, ethnic stations and music based neighbourhood stations and whether they offer listeners a real choice in radio listening. Later in the series we look at music copyright and much more besides.

FEATURE

This month we tie up a few loose ends from the last two months, with a look at live tower block broadcasting, as opposed to fixed site operation.

Tower blocks have two big advantages: they're tall so stations don't need high masts and there's no way of finding out the owners of the equipment. On the minus side, the DTI don't need warrants to enter tower blocks, but as a warrant for a permanant site lasts a month anyway they have nearly as easy access - once they've broken the door down!

Basically the operation is much the same with regard to links, etc. - see last month - but instead of an office,

place to attach the aerial. This may be a specialist design, or more simply a two element FM receiving aerial stripped of one of its element sets. This is attached with gaffer tape to a suitable pole, which in turn is attached to an access ladder, communal aerial or other suitable point. The antenna to receive the UHF link, usually a cheap TV aerial, will be mounted just out of the way of the other.

The transmitting aerial is connected with as short a lead as possible to the transmitter, so as little as the signal as possible gets lost on the way. The transmitter will be housed in a suitable, cheap, metal container - such as the infamous

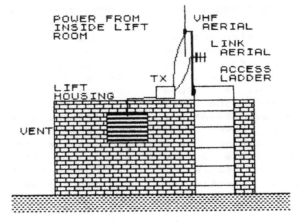

there's a rooftop! Getting onto the roof is a comparatively easy matter. To enable easy access for the fire brigade, all council blocks use a master key. These originally came from caretakers or, more commonly, obliging lift engineers, but most people copy them from other pirates these days.

Once on the roof it's simply a matter of locating a suitable

biscuit tins - with more gaffer tape round it to keep out the rain.

Power for the transmitter will usually come from the mains. A lead will be run through ventilation grills, suitable holes, etc. to a suitable power point, often a cleaner's socket, light fitting, etc.

CONTINUED >>>>

FEATURE

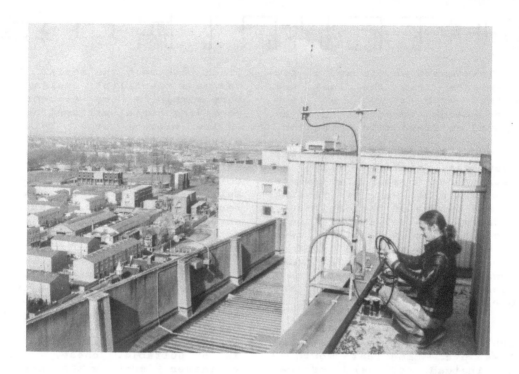

ALICE'S RESTAURANT SET UP ANOTHER TRANSMITTER SITE

Some stations prefer not to operate live, but instead use taped programmes from the transmitter site. The method is largely outdated, but for some small stations it's the only choice, and does have advantages if the operators have good eyesight and are quick on their feet as they may be able to save the equipment from vanishing into the DTI's overflowing vaults. However, most pirates aren't willing to sit out in the rain, wind and snow anymore and prefer the immediacy of live broadcasting.

Instead of the UHF link receiver and aerial, a cassette recorder is used, with programmes put on C120s. A good look-out will need to be kept to avoid the DTI. Staff have the choice between staying by the transmitter to whisk it away as soon as they see the DTI coming, or going up to the roof for tape changes only, though that increases the risk of being spotted by caretakers who are liable to jump to the wrong conclusions...

If a station can't afford to lose a transmitter, then it may be possible to quickly remove it, store it in a flat or cupboard and hide / vanish. The DTI used to be more interested in getting the equipment, rather than catching someone, but this has now changed, so pirates have to be much more careful. If they see the same faces around each time they raid a station, they're much more likely to take action these days.

Having now covered VHF broadcasting, we continue next month with a look at Medium Wave stations, which haven't really changed much in nearlt two decades!

<<<<< CONTINUED NEXT MONTH >>>>>

KISS-FM

Kiss-FM were off the air the first week in August, due mainly to a lack of their engineering department who was away in a different part of the Galaxy. They were back the next week, however, but then lost another transmitter to the DTI early on Sunday morning.

```
BLACK     Kiss-FM
          ■ Dysons Road
MUSIC     London
          N18 2DG
```

```
POWER: 100W
 SITE: Crystal Palace
TIMES: Weekends
```

The next Saturday it was again business as usual, though only Dennis O'Brian and Gordon Mac managed to complete their shows as the DTI came round again at around 1.30PM in the afternoon. By the next weekend, the DTI had something better to do instead, so they at last managed a full weekend of programmes. It's a shame they don't occasionally swap the DJs from Saturday onto Sunday and the Sunday DJs onto Saturday so the ones late on Sunday get more of a chance.

94 FM STEREO | THEY ARE THE BOOM

With the Bank Holiday weekend there was a slight re-shuffle and they had their first live OB from Bentley's nightspot with a carnival special. Obviously tired out by this, there were only a few hours of programmes on Monday afternoon, still they are only a weekend station.

The final weekend of August was again devoid of DTI problems, though Dennis O'Brian wasn't sure of what was happening at first as someone had removed the programme schedule from the studio – should've looked inside TX. By the way, Kiss have now moved back to 94 megs since the arrival of BBC Essex on 95.3.

TX INFOBANK 01 400 8282

The TX Infobank is a 24 hour a day phoneline with the latest news about what's going on on the radio in London.

From M.O.N.D.A.Y afternoon till Wednesday morning you can catch up on news from the major stations.

From W E D N E S D A Y afternoon till Friday morning it's community radio news and information.

From F R I D A Y afternoon till Monday morning there's details about the smaller stations you can receive.

You can also leave messages, news and comments for us.

ON-AIR

LWR

Another mixed month for LWR, which finished rather more successfully than it started.

After another raid on July 31st, they came back on the air on Saturday 2nd with Yomi presenting the first programme at 10PM. The DTI were around that weekend again, and by the next morning they were off the air again.

They returned on Friday 8th at 10AM with Jasper starting his Vinyl Freaks show early. A fairly normal line-up of DJs took LWR through till Sunday lunchtime when the DTI arrived in the middle of Cliff Ringwood's show. He was apparently caught at the controls and subsequently ended up in court. As the transmitter was still in place, the DTI only getting the studio, they were able to continue with a live outside broadcast from their First Summer All-Dayer from the Town and Country Club, Kentish Town, as planned.

LWR
New Cavendish St
London
W1

POWER: 100W
SITE: Crystal Palace
TIMES: 24 hours a day

This started at 6PM, with a pair of jocks taking half an hour each – including Cliff Ringwood. The DTI finished off the job they'd started earlier in the day at 8.45, when they removed the main FM rig from its site, which brought the OB to an end. Even so, they managed to attract a large number of people to the event.

With a large amount of equipment to be replaced, they were off the air for just over a week, putting in their next appearance on Wednesday 20th with continuous music during the day, and programmes beginning at 6.

92.5 FM STEREO

Having lost several studios in recent months, they decided to move over to taped programmes instead – where the most the courts could get you for would be "aiding and abetting" and then only at a pinch. This had the added advantage of improving the sound quality, as they could use more expensive equipment and the engineers could keep a closer control on it. The first few days of this arrangement had with several gaps or continuous music, and only the stalwart jocks were presenting programmes, which were running around an hour late.

Over the bank holiday weekend the station were over at the Notting Hill Carnival, although live broadcasts weren't possible. There were a few problems with the transmitter at the start of the week, and it kept suddenly changing frequency down to 91.9, then back to the more usual 92.1!

Meanwhile, G.T. was back with his first shows on the station for some time, and Tim Westwood presented a superb show with extracts from the New Music Seminar Hip-Hop content in New York. The problems gradually got less over the week, until they were raided on Friday 29th.

TX

TX11: NOVEMBER '86 £1:25

LONDON'S
ALTERNATIVE
RADIO
MAGAZINE

**RADIO IN
VENICE**
+RADIO POLITICS
+FORTY PIRATES

TX11: NOVEMBER 1986

NEWSDESK

Platform 88 axed

After several months of preparations for their broadcasts, Platform 88, the group planning a weekly showcase for community radio programmes, has decided not to co ahead with their plans after all. Group member Giles told TX "It was Douglas who decided the whole thing should break up. He was under peer pressure from members of the CRA. I would have liked to have gone ahead with it, but unfortunately that's the way it is".

Meanwhile another group calling themselves the Hackney Broadcasting Authority have begun regular transmissions of community radio material to London. So far the coverage area has been restricted and they've suffered from a few technical problems, but these are now being sorted out and they hope to eventually have capital-wide coverage.

CRA submit their plans

The Community Radio Association has submitted their ideas for the development of community broadcasting to the Home Office, as part of their input for this autumn's Green Paper, which will look at the future of radio.

The main proposal is the establishment of a new authority to oversee community stations, which they would like to be non-profit-making operations. They reject deregulation and also the control of third-tier stations by an existing authority, such as the Cable TV authority.

Border Radio in heavy raid

Twickenham based Border Radio, which was gearing itself up for the resumption of its late night programmes to the elderly in the area, suffered a massive raid on 14th September as it was carrying out test transmissions.

The DTI officials are reported to have caused serious damage to founder Harry Marshall's home, including smashing the door down, as well as taking away several items not connected with the broadcasts and missing out items on their receipt.

The DTI have been increasingly accused of unnecessary heavy-handedness, relying on offenders' ignorance of the law to get away with it. At unmanned sites and with no police present, equipment (especially aerials) is frequently smashed up instead of being confiscated.

Harry Marshall has since been in hospital, suffering from a complaint thought to have been brought on by the raid. However, he hopes to recommence broadcasting in the New Year.

Raid count

The DTI report that so far this year they have carried out 167 raids on 61 different unlicensed radio stations throughout the whole of the UK. 57 people have been convicted, with the largest fine being £1,000 with costs. LWR and LGR in London, together with PCRL in Birmingham have been hit the hardest. However, reports now suggest the Radio Interference Service overspent in the first half of the year, which will mean cutbacks now.

Applicants return?

Turkish Community Radio returned to the air on the 4th October with taped programmes from 8.30am - 8.30pm, which will be repeated on 29th October, to coincide with the CRA's lobby of Parliament. The success of the broadcast and the clamour from the 120,000 strong Turkish community in London have persuaded them to return to the air as soon as possible. Plans are now well under way to commence 7 day broadcasting from late November on around 103.7.

Cuts

- Ever wondered what happened to all that equipment the DTI keep on confiscating? Well, it seems they've at last decided what to do with it all, after leaving it languishing in Government warehouses for years. All the transmitters are to be incinerated, as they "don't come up to specification" – now what specifications could those be? However, all the studio equipment is to be auctioned off, so if you're after a job lot of 1,000 Phonic mixers then you know who to ask! There's also record decks, cassette recorders, a few jingle machines, processing equipment, loads of microphones and a selection of studio furniture. Then maybe if you're looking for some rare DJ releases, or a complete set of Horizon Radio jingles on cartridge? Ideal really for starting a new station – or shouldn't I have mentioned that...

- Sigue Sigue Sputnik (remember them?) seem to have got themselves in a spot of bother recently with our friends from the DTI. One of the adverts between the tracks on their album was for Network 21, (seen them?) and now the DTI are threatening to take them to court for "aiding and abetting". The DTI have been trying to get someone for this offence for years, including all the advertisers on pirate stations at one point, but have always slunk off for some reason. Not worth it spending a fortune on a prosecution you might not win?

A beginner's guide to radio politics, part two

This time we look at the different types of radio systems in the world. From November 1986.

Mixed Public Service Radio

This is basically the system in the UK at present, which was drawn up along similar lines to the Independent Television system. There are two competing groups. First, the public sector: regulated and run by the BBC and funded by the licence fee. Second: the private sector: regulated by the IBA, run by private contractors and funded by advertising.

Although they compete for listeners, the two sectors don't compete for finance. This means that stations are able to carry out programming which would otherwise be financially unviable. In return for the monopoly on radio advertising in their area, the independent stations are expected to carry out various "public service" duties: ensuring their output has something for all sections of the community and includes a proportion of news, religion, specialist music, documentaries, plays, etc.

With the introduction of community radio the Public Service concept would again have been slightly altered. The CRA proposed (incredibly naively) turning themselves into a Community Radio Trust which would regulate the CR stations. This would have led to three tiers, none of which would have competed with each other on a financial level, community radio funding coming solely from small advertisers who couldn't afford Independent Radio rates, subscriptions and Local Government grants.

Unfortunately, when the original Independent

Radio plans were drawn up, a few vital differences between TV and radio were neglected. Firstly, although TV advertising has no direct competitors, radio stations have to compete with local papers, free news-sheets, posters, etc. for local advertising. Second, the system was imbalanced. There were far more competitors for IR than for ITV – BBC Network Radio, BBC Regional Radio and also the pirates. With five BBC stations to every one Independent, the audience share will be in the BBC's favour.

In the early days of the IR stations. they were obviously achieving only a small share of the audience. This meant that advertisers weren't willing to use the medium, and subsequently the owners weren't seeing much in the way of profits. Therefore, the IR stations began to slowly change the rules to attract mass audiences – and the IBA mostly went along with this as their income was dependant upon the stations. This has led to a situation today where IR stations are largely ignoring their Public Service commitments, predominantly going for hit music formulas with token "local" elements to keep the critics at bay. All in a situation where they still have a monopoly on radio advertising – not what Parliament originally envisaged.

Privatised BBC

One of the suggestions of the Peacock Committee, set up to look into how the BBC should be funded, was the privatisation of Radios 1 and 2 to form a new national independent channel and the merger of BBC Regional Radio with its Independent counterparts. This would lead to a situation where for each area there would be two BBC national channels, one independent national channel, and one independent local channel.

With the prospect of lower regulation for the independent channels, maybe under the control of the Cable Authority, they would get massive audiences – which would greatly please the big advertisers as the commercial channels would have more of a market share than is possible at present. Community Radio wouldn't figure in the plans at all – it doesn't make any money for people with influence and, most of all, the Government now seems to think it would give them too much of a headache.

Not a very nice prospect, but unfortunately with the lack of interest in radio by the people in power (much more interested in the big bucks: TV, satellites and cable) and the might of the big advertisers, it might just become real. Obviously they haven't thought about the pirates – or would they be crushed even more than they are at present?

Free market radio

This is a system whereby radio is completely at the mercy of market forces, as favoured by many offshore fans. Systems favoured include the Italian model, where anyone can start a station and don't require a licence – all they have to do is find a spare frequency. However, if a station suffers interference from another then it is entitled to take the station to court and claim damages for loss of business, which can amount to a substantial sum. They are also affected by the laws of libel, etc. and still have to pay copyright according to station size.

America has slightly more regulation – but only just. There the Federal Communications Commission (FCC) issues frequencies and power levels to stations and dictates general technical standards, which ensures much better sound quality and cleaner signals than generally abound in Italy. Originally, the FCC had more regulations, but in keeping with current US thinking, they've been relegated to not much more than a frequency allocation agency.

Although this "Free Market" concept initially sounds a good idea, it leads to problems in practice. Firstly, there is often too little advertising around for all the stations to make a profit, or even break even – taken as a whole, the

radio stations in the good ole USA make a loss!

To try and compete in this impossible market, whatever the biggest station is currently doing will be echoed by all the rest in the hope of getting a share of the bucks. With the success of "clutter-free" top forty stations in the early eighties, everyone has followed suit, resulting in a plethora of second rate top forty stations. Only a few provide alternatives – and then it's usually only popular specialist music or programming from groups with a cause.

Advertisers' budgets for radio are geared to how large a station's market share is. Just a few drops in the number of people listening and many thousands of pounds could be lost in revenue. This creates an atmosphere where experimentation, even just slight alterations to the music format, will be discouraged by the owners in case the audience drops. Just a few mistakes and they could be sliding down the charts into oblivion...

Meanwhile, the successful stations get bigger, and as they get bigger they have to do something with all the money they're earning. Many of them buy up other radio stations around the country which aren't doing so well in the hope of improving them and making them profitable. They will then usually programme their new "networks" as a whole, which will lead to a further reduction in the variety. Then, once the system gets going, it's impossible for anyone to get in without spending a fortune – so it certainly isn't "free" radio.

Light-Touch Regulation Radio

A system favoured by many people, and probably subscribed to by most of the TX contributors. Under such a system a new radio authority would be created which would oversee all radio – BBC, IR and community stations. All applicants would apply to the authority giving an outline of their proposed station. They would then determine whether there was a suitable frequency available and whether the proposed station would enhance the range of broadcasting available in that region, so you wouldn't end up with stations in an area all doing the same.

Although the programming of the stations within their chosen format would be left entirely up to the operators, there do need to be other basic regulations. Technical standards need to be drawn up and maintained if there isn't to be any interference to other users of the radio spectrum. Ownership of stations needs to have certain restrictions, so that large chains of stations aren't owned by the same company or are in predominantly foreign ownership – which in both cases leads to disinterest by the owners and lowers the standard of programming or leads to it all becoming the same.

There is the never ending problem of editorial freedom. Should stations be made to have a complete separation of advertising and programming, so the advertisers don't influence the rest of the stations output? Should political parties, religious organisations or anyone else who wants to get their point of view across be allowed to own a station and influence its output with a particular view?

Then there's public accountability. If someone has a complaint about a station, then it needs to be handled so they feel their grievance has been properly dealt with. If an individual or group feels that a station isn't doing its job properly, or that they could do better, then the authority should assess whether it's time for a chance.

And finally, above all else, the rules that are drawn up need to be adhered to, so there is no gradual bending and changing of the regulations, as there has been with Independent Radio, either by the stations themselves or by the politicians.

In the next TX we look at the scope for different forms of programming under each of the systems described – community programming, specialist music and ethnic radio.

FEATURE

This month we bring to a close the Teknix series on starting a radio station. However, we'll be providing updates in the future, as well as taking a closer look at individual items of broadcasting equipment. In the meantime, Teknix will be continuing to look at other technical topics, starting with how to find your way round your radio next month.

Medium Wave stations haven't really changed much since they first started to appear back in the sixties. Although a few have

DTI men. Often CBs will be used between staff to warn of any approach, though this has to be done discretely.

Site staff will need to make sure that they're not carrying any incriminating evidence - tapes, etc. will be left by the transmitter. As sites often tend to be out in the country, a car will be needed to carry the equipment. It isn't a good idea to plaster it with stickers advertising your (or other) pirate stations, as even if they can't pin a broadcasting offence on you, they may then try and do

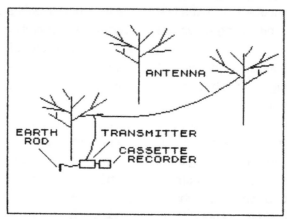

carried out live broadcasts, most operate using taped programmes. Normally, C-120 tapes will be used, so there is only a break in the programmes at the top of the hour.

Most stations operate from woods or the edges of fields. The site is chosen carefully. It needs to be reasonably high to enable the signal to get out well, provide enough cover for staff to hide in, and (most importantly) give a good view of the access routes. This ensures that staff can make a quick getaway without being spotted by

you for listening! Vehicles are probably best left away from the site, as DTI staff have been known to sit around waiting for the owners to re-appear - and can always get your name from DVLC.

Medium Wave operations need a long aerial, typically half or a quarter of the wavelength - so if you're broadcasting on 192m, you'll need either a 96m or 48m aerial. This is generally strung between two (or more) trees, often using a catapult to get

CONTINUED >>>>

FEATURE

<<<< CONTINUED

the aerial in the tree. Some stations with sites in quiet places may rig up a permanant aerial system between the trees. In raids, the DTI don't always bother to take such aerials because of the effort involved, however they may try and stop you using it again by breaking it up. MW rigs also need to be earthed, so earthing poles are used (we'll cover the technicalities in another article in the future).

Once the broadcast begins, the site staff will need to keep well out of sight. When it comes to changing the tapes at the top of the hour, one person will keep a look out for the DTI, whilst another will change the tapes. The fewer staff present, the better.

This is the most dangerous part of the operation, so various tricks get used to try and reduce the risk. Some stations today use double cassette recorders, where when one tape finishes, the next starts automatically. This means that tape changes don't have to be at regular intervals, so the DTI won't know when the change will take place.

And finally, a few broadcasting loose ends, starting off with mailing addresses. You'll need somewhere to collect the mail — the easiest way for people to get in contact with you. The DTI don't generally bother to check up on mailing addresses, so you're fairly safe on that front. Many small stations use friends' houses who aren't connected with the station. However, it may be difficult to find someone willing, in which case it's probably easier to use an accomodation address.

In return for a yearly rental and a small charge per letter, they will forward your mail, with the advantage that no-one knows in reality where you're based. You'll find a list of such companies in the business section of newspapers, however two you might like to try are:-

British Monomarks
BCM-Mono
London
WC1N 3XX

and Mercury
37B New Cavendish St
London
W1

Recognize the addresses?

The telephone is also useful, particularly for checking up how well a signal is going out. Despite rumours from some stations, it's highly unlikely that they get tapped - if only for the massive cost. Giving out the telephone number of the building your studio is located in is stupid though, if only because you'll get sick being interrupted in the middle of doing a programme.

To conclude, with a combination of good planning and good finance it's extremely easy to get on the air. Then, once you're on the air, you'll be more determined to stay. Get going, but be careful out there!

Back copies 8-10 containing the rest of this series are still available, price £1.25 each. Use the order form on the back cover of this issue.

JBC

Well, they're still there. JBC are continuing to broadcast 7 days a week, hassle free with excellent black community programming for Brent.

One programme I managed to catch this month was the Wicked Uncle's programme of Asian Music on the 3rd September, who had special guest Tariq Unis (excuse the spelling), which was fascinating listening. Also of note has been their Childrens' Programme on a Saturday morning, which you'll also find several of the TX staff regularly tuned into - beats Blue Peter any day!

BLACK RADIO

JBC Radio
Roundwood Road
Harlesden
London
NW10

POWER: 40W
SITE: Brent
TIMES: 7 days a week

TX FAX

There've been a few more changes to the Sunday line-up recently, which mainly involved swapping the afternoon round and a new show for Steve Bernard in the evening. The Gospel show continues as normal, with Smokey T assisted by Rev Michael and Rev Winston.

SATURDAY

```
12AM H.G..................Reggae
 6AM Wicked Uncle..........Soul
 9AM Children's Programme
11AM Ray Sawnee.............Soul
 1PM Wicked Uncle..........Soul
 3PM Steve Bernard.......Reggae
 5PM Kenny J...............Soul
 7PM Smokey T..............Soul
 9PM Melody.............African
11PM Soca B................Soca
```

SUNDAY

```
 1AM Challenger...........Reggae
 6AM H.G..................Reggae
 8AM T.C..................Gospel
10AM Wicked Uncle..........Asian
11AM Soca B.......60s Soul + R&B
 1PM Patricia......Irish Profile
 2PM Kenny J.................Jazz
 3PM Melita Ray.......Carribean
     News............Connection
 5PM Smokey T.............Gospel
 7PM Steve Bernard........Reggae
 9PM H.G..................Reggae
```

105 FM STEREO BLACK RADIO FOR BRENT

WEEKDAYS

```
12AM Challenger..........Reggae
  Tu H.G..................Reggae
  We H.G..................Reggae
  Th Challenger..........Reggae
  Fr H.G..................Reggae
 9AM Steve Bernard.......Reggae
  Fr Challenger..........Reggae
12PM Princess Asha.......Reggae
 3PM Dimples........Reggae/Soul
 6PM Amien Z...............Soul
 8PM Challenger..........Reggae
  Tu Soca B...............Soca
  We Wicked Uncle.........Asian
  Th Soca B...............Soca
  Fr Steve Bernard.......Reggae
10PM Smokey T.............Soul
  Tu Challenger..........Reggae
  We Ray Sawnee.....Soul/Electro
  Th Challenger..........Reggae
  Fr Soca B...............Soca
```

Daytime programmes often have special guests and some features, especially in Steve Bernard's morning show.

ON-AIR

TKO

After several weeks off the air, TKO returned on Sunday 21st September, and began a new diet of taped programmes and continuous music. Like LWR in their early days of using the system, there've been quite a few gaps between programmes at times and spells of continuous music when they haven't got a programme available to put out.

the popular jazz (really?) DJ has done a couple of programmes, not being heard on the radio since the close of KJazz, although he still regularly features in articles about the "jazz revival".

```
BLACK          TKO
MUSIC          ■Victoria Way
               ■Charlton
               London
               SE7

POWER: 100W
  SITE: Crystal Palace    TX FAX
 TIMES: 7 days a week
```

90·9 FM STEREO

THE ULTIMATE RADIO STATION

A full programme schedule is still being compiled, but watch out for... Paul Cook, Graham T, CJ Carlos, Freddy M, Dave Stewart, Angie D, Steve Jackson, Mike James, Angie D, Robin Anthony, Baz Fe Jazz, Louie St Clare, Barry J, James Alexander, Jude James and several others. New specialist shows of Gospel music, Salsa and Reggae have been heard, along with the more commercial material in the day.

They've also added several new DJs to their line-up as well as losing a couple. Baz Fe Jazz,

THE TX CHART
01 400 8282

Yep, it's that time of year again. Following on from our highly successful readers poll last year, it's your chance to vote for your favorites of '86. This year there's just two catagories with two votes per person in each:-

- Best DJ of 1986 -
- Best Radio Station of 1986 -

You can either vote by calling our phoneline on 01 400 8282 or writing to TX Survey, BCM Box 225, London, WC1N 3XX. Either way, make sure you include... * Your Favourite DJ of '86; * Runner Up DJ of '86; * Your Favourite Station of '86; * Runner Up Station of '86; * Your Name; * Your phone number or address.

There will be a prize draw of all the entries, with five £5 record tokens up for grabs. Get voting, and you may be winning!!

TALKBACK

BCM BOX 225 LONDON WC1N 3XX

Included with this month's TX you'll find a questionaire. To get you started, here's a few of the comments other people have made about TX...

It was Alice's Restaurant that first brought TX to my notice. I'm surprised so few other stations mention it - after all, we wouldn't be aware of some of the smaller stations if it wasn't for TX!

I'm not too keen on the Options guide - I prefer the separate programme listings for each station. Maybe it's just me, but I find the mass of names and times springing off the page somewhat confusing.

Generally useful, but the diatribes on CR are unfortunate and juvenile.

Don't take out Rumblings [now Pirate Eye] - Chris England is enough to brighten up the most depressing days! I remember when I first heard him on Radio Shoestring. Chris, you are missed very much.

(On Chris)... Somewhere to the right of Genghis Khan and about as funny.

I especially like Uncle Christopher's comments. I'm ashamed to say that I agree with most of the things he says, but I'm sure I'll grow out of it. The magazine would be poorer without him (no, I don't know him personally!).

I do enjoy TX, and find it very informative, but I think it is too highly priced - I also have to pay out for other magazines.

TX seems to be very self-opinionated too much of the time. I'm sure people want the latest news and make their own opinions.

Let's seee some interviews with innovative DJs (Bonnie Prince Charlie, Lepke, Jonathan More) and some features on past innovative stations (DBC, Our Radio, Zodiac, SES).

Please have an article or two in the near future on some of the stations of the late 70s - Thameside, West London Radio, Uptown Radio and Radio Suburbia were in a class unmatched in recent years.

More photos please, especially of station studios, etc. - and with titles!

How about some pub events where pirate celebrities were invited along, and maybe some reviews of events where radio DJs are present?

Don't get involved with the offshore scene because everybody else covers it and you tend to get more than enough of it.

The appearance of TX has proved that we have entered a new age of radio publications. And now, along with Free Radio Waves and the Now Radio Newsletter, you're showing the way.

Many thanks for filling a big gap in my life. If you think that's putting it a bit strong then let me assure you it's absolutely true!

Entertaining read, well laid-out, very few spelling mistakes.

TX12: DECEMBER 1986

A BEGINNER'S GUIDE TO RADIO POLITICS, PART THREE

Last month we were looking at the different types of radio systems around the world, this month we look at how well fans of particular types of programming do under them.

Specialist Music Radio

This can be any kind of radio with one main music format, such as soul music, jazz, country and western, rock, folk... the list is nearly endless. At present in our system of 'mixed public service radio' most of this music ends up in specialist slots in the evening or at weekends.

During the daytime, listeners are usually tuned in for a maximum of around 20 minutes. So that the station is consistent whichever 20 minutes they choose, it's necessary to have a rotation of the most popular music, mixed in with short pieces of news and information. Listeners are generally reckoned to be able to stand around 8 minutes of material they don't like. Play them two Latvian goat herders' songs back to back and you've had it! On a commercial station where you want people to stay tuned in for as many commercial breaks as possible, you want to take as few risks as possible of losing listeners. Because of this, specialist music in the daytime is usually limited to tracks that are well known.

However, in the evenings the audiences are much smaller, and also tune in for longer lengths of time – oh, and the advertising breaks are much cheaper. This is therefore why specialist music always ends up in the evenings.

Most of the neighbourhood community radio stations who were tipped as likely winners were proposing some specialist music. However, rather than playing commercially available material, this was generally what goes under the appalling title of 'community music'. In other words, locally produced music, reflecting its origins in the local community.

Black music fans would have been satisfied with some of the output of the black ethnic community stations. Reggae. in particular, might be well represented, but some of the more commercial black music would probably be given limited airtime. The indications are that no station with a solely specialist music format would have been given a licence.

Under a free market radio system, specialist music stations play a major part. The current ratings for stations in New York include black music stations WRKS / Kiss-FM at number 2 and WBLS trailing a few places behind. Also in the top 20 are WNEW-FM with AOR, WCBS with an oldie format, WHN with country music and WNEW-AM with big bands. On the minus side, though, the stations tend to play only the most popular current music, with less commercial music generally only getting played on college stations, where there aren't the same financial considerations.

With a deregulated radio system, there should be the best of both worlds. Major, and perhaps commercial, specialist music, such as rock and soul, would be able to support stations of their own. Some of the more minor music forms would be likely to be given time on the more 'community' oriented stations, along with locally-produced music.

Ethnic Radio

Ethnic stations have an identity problem: they tend to merge with specialist music stations around the edges. For example, is a station that plays nothing but Asian music a specialist music station or an ethnic station? The term should probably be applied really only

to those stations which are actually doing more than just playing music. They need to provide news, information, documentaries, drama and other programming which represents the interests of their audience.

Under the present system, ethnic programming gets rather a bad deal. Programmes often end up in the most unpopular times, and then often for only a short time each week. Radio 4 recently cancelled it's Asian programme as they felt it wasn't getting a good response on the channel and would be better off on local stations. Hardly surprising given that it was going out at 7.45am on a Sunday morning! Some groups are also completely unrepresented on the radio – there are no programmes for the Greek community in London, yet the success of Greek pirates is undoubted.

Were community stations introduced alongside existing radio, then ethnic stations would probably get the best deal from them. Were the experiment to have gone ahead then a licence would probably have been given to one of the multi-ethnic stations, rather than a station for a single ethnic group.

Under a free market system, some of the ethnic communities manage to raise sufficient finance to operate stations, usually in areas where they are well established. For example, one of the top 20 stations in New York broadcasts in Spanish to Latin American communities. Those less able to raise the finance unfortunately end up unrepresented on the airwaves.

Open Access Radio

This is the type of radio many of the neighbourhood community stations were proposing, where individuals and groups have access to the airwaves to put out programmes they have produced themselves about subjects that interest them.

At present, there is very little access of this kind on legal stations for ordinary people, and it doesn't seem very likely that this situation is likely to change, as most stations want to keep 'editorial control' over broadcast. Under a free market system, there probably would be difficulties in keeping such a station going. In the States, several 'community' stations have been bought out by groups with much greater finances. A deregulated system should enable such stations to broadcast without pressures to directly compete for advertising. However, many stations would envisage extra local authority grants, etc. to help them to survive.

Small Business Radio

This is what seems to have become commonly known as 'Jackie Radio' or mini-ILR music geared to the majority of the audience in a particular broadcast location (usually pop), along with snippets of local news and information.

Under the present system, independent stations seem to be getting bigger and bigger, which means that the programmes tend to get less and less local, which rules out small business stations from the system. Even if 'community radio' were to come in, then there would be a resistance against such stations being licensed from independent stations.

Small commercial stations would obviously go down well in a free market system. However, in extremely competitive markets, such as cities, then many stations would probably reduce the amount of local news and information they carried in place of music. However, with general deregulation then they would be able to exist alongside open access type stations.

That concludes our brief look at some of the radio politics issues.

LETTERS

Yes, it is true, we HAVE been reading 'TX' for some time. It is a useful source of information about authorised and unauthorised radio activity, though like your disclaimer on your editorial page we do not condone illegal broadcasting of any kind. However, we are not averse to seeing the law changed in certain areas.

I write to congratulate you on a balanced article 'A Beginner's Guide to Radio Politics' in TX11 (November 1986). It is a sensible resume of the current scene and contains a useful reminder of Parliament's wish that in return for a monopoly position Independent stations are required to assume certain 'Public Service' responsibilities. This is still the present position. Lest this should appear as a 'burden', let me emphasise that ILR's listening in ILR areas was not achieved by merely playing records back-to-back, but by a useful combination of entertaining, relevant and instructive programming of music and information.

The IBA at present interprets the Broadcasting Act 1981 as Parliament wished. It is possible that MPs may change their minds. If so, it should not be assumed that the IBA is incapable of changing its style. After more than 30 years broadcasting, and 13 of them in radio, there is a wealth of experience, contacts and skill available to those seeking to participate in what could be a growing industry and a developing service to the public.

Peter Baldwin, Deputy Director of Radio
Independent Broadcasting Authority
70 Brompton Road
London SW3

SELECTIONS

Clive Glover starts counting the pirate DJs who've made good and are now filling up more legitimate airwaves

One of the significant results of the great offshore pirate days of the 1960s was the way many of the leading DJs and 'personalities' came ashore and were immediately embraced by the establishment (i.e. the BBC!). Many of them – Kenny Everett. Tony Blackburn, Tommy Vance, John Peel – are still filling many hours of the Corporation's airwaves – and those of various Independent stations.

It is interesting, therefore, to notice the way a number of presenters from the London pirates of '83/84 have been popping up on legal stations. This is particularly true over on Radio London, where Blackburn-inspired Soul Nites seemed to be remarkably similar to events being advertised on soul pirates and many of the presenters – erhmm – seemed to be amazingly similar to the pirate DJs...

It looked at at one time as if Radio London was going to follow the soul pirates and exist solely to get the punters into the clubs (where the REAL money is made). They even financed a complete new Outside Broadcast set-up from Tony Blackburn's Thursday efforts! However, people further up in the BBC finally tumbled to this a few months ago and have cut down on the blatant advertising.

But 206 has also taken on Steve Walsh (ex-Invicta, JFM) for a regular Sunday spot (7 to 9pm) and Gilles Peterson (ex Fusion-FM,

Invicta, Horizon, Solar, K-Jazz) for a Jazz and Latin show on Tuesday evenings (10 to midnight). They'd already got Jeff Young (ex-JFM, LWR) who up till recently did the Saturday Show (11 to 2pm) AND even Telephone Programme (midday to 2.30pm) host Robbie Vincent was on Invicta at one time!

Meanwhile, Saturday nights on 102.6MHz (Essex Radio) sound ever so like 102.4 used to not lone ago, with Tony Monson presenting a soul show. And – at the same time – over on County sound there's a four hour show (10pm to 2am) presented by Lynn Parsons. Now, there used to be a request show on Sunday nights on JFM presented by someone with exactly the same name...

Then there's Pete Tong, ex-LWR, doing soul shows on Kent's Invicta Radio. Tim Westwood, also ex-LWR, has recently been doing freelance work for Saturday Live (5 to 6.30pm) on Radio One. Chris Forbes, ex-Solar, landed himself the job of presenting Solid Soul on Channel Four and has since got a show on Capital on the Sunday graveyard shift (midnight to 4am). And that spot was also home for a time for Froggy, ex-Horizon, Invicta, JFM, Skyline...

Enough?

CHRISTOPHER ENGLAND'S PIRATE EYE

TX Readers will be sad to hear of the sudden disappearance of Christopher England. In the absence of his usual contribution, we have decided to reprint an unfinished letter we found on his desk in his Fisher Price "Tutor-Typer" musical toy typewriter. It is addressed to Eric Gotts at the Department of Trade and Industry

Dear Eric.

You've got to understand what it's like being a, a... oh my God. I can't even say it! But I AM one. Oh, Eric, you've just got to help me.

Every day I see warnings about the horrors of drug abuse. There are adverts saying don't do it, yet people do. There are warnings on packets of cigarettes yet people smoke on. Alcoholics don't even realise they've got a problem until it's too late.

But, in all these cases there are people who understand, feel sorry for the addicts, and try to help. There are drug dependency clinics. There's a million and one different aids to help smokers give it up. Alcoholics can attend support groups made up of other people to help get them off the bottle.

But, Eric, and it's a big But, for me, and those like me, there is nothing. I've tried to talk it out with friends, but they don't want to know. I'm at my wits' end. People aren't taking this problem seriously, yet it's a killer. I'm sure I'm dying of it. Each day I can feel myself just wasting away.

I've tried talking to other addicts, who haven't done it for a lot longer than I haven't done it. But, Eric, they just deal with their addiction by drinking real ale in pubs, slagging off the ones who are doing it now and talking about "the good old days" when "we knew how to do it properly." I can't do that, Eric. I'm too young to die.

Oh, how I've tried to remember how you curled your lips to the right and said those magnificent words "See you in court!". I even employ a lookalike actor to do it, but he can't perfect the rolling back and forth from balls to heels with hands in the pockets. As my memory fades, so does the deterrent effect.

But, Eric, if only the Government had made it legal, then people like me wouldn't feel so

damn guilty and helpless all the time. We wouldn't be treated like common criminals. People would understand our problem. We're not hurting anyone, are we?

Gosh, I feel I can talk to you, Eric. Being as how you come across people like me every day I'm sure you understand. You see. Eric, I'm a... a PIRATE. There! I've said it now. I admit it! I'm a PIRATE! Ha! They say that admitting it in public is half way to being cured.

I've tried all sorts of different therapies I can think of to be a good boy, but I suddenly find myself sitting in my studio doing a programme. Luckily. I've not switched anything on air yet. but I don't know how long I can last just doing these pathetic "dummy run" programmes. I just have to get back to the real thing. I can't even get into my bedroom for the clutter of dummy run cassettes.

I tried distracting myself by thoroughly enjoying Essex Radio's "Rocktober", even though a lot of the tracks they played were rather obvious. I'm fed up with just being an anorak again. I'm a PIRATE! It should have been me playing those records as a PIRATE!

And Eric, somebody keeps sending me tree copies of "Jocks", a magazine tor morons who think they're disc jockeys, and that just rubs it in.

Then there's Jay Jackson's "Now Radio Newsletter" I subscribe to. Every fortnight I wait tor its arrival with butterflies in my stomach. I eagerly read it from cover to cover to find out what's going on. There's so many words in it. How does he write all those words in just 14 days, Eric? Does he stay up 24 hours a day'? I couldn't write that many words in a year, let alone in a fortnight. Does he have six fingers and type with his toes in his sleep?

But Eric, the worst thing is Anoraks UK's "Weekly Report". That does me no good whatsoever. Coincidentally, Eric, it's an excellent report. But it's got so much about PIRATES in it. All different PIRATES. Look, and none of them are me! See? I'm just an anorak, you may say, Eric, but I know I'm a PIRATE!

Hang on a mo', most of these stations it's talking about are in Ireland! Ireland? You don't work in Ireland do you, Eric? No, it's sort of legal over there, I think. I must, urm. I mean, I won't be a minute, I'm just going to...

CUTS

- Ever wondered what happened to the listings of pirate stations in Time-Out? They seem to have been abandoned after the DTI approached both them and City Limits, pointing out their listings could be inciting people to listen, and thereby aiding and abetting a criminal offence. City Limits took no notice, but Time Out was an applicant for a community radio licence and wouldn't want to upset anyone...

- With the RIS so hard pressed these days, could the Police start carrying out raids themselves when they're suffering from pirate interference? TKO has apparently been raided solely by Police recently, who may be finding that the only way to get rid of interference is to raid 'em yourself...

- Sad to hear PCRL were forced out of sanctuary in a church in Birmingham. Although the sanctuary laws have been repealed, getting a warrant to enter a church still requires a special procedure. If they hadn't then we could have seen the likes of The Church of Starpoint sprouting up...

KISS-FM

October and November went fairly quietly at Kiss. They celebrated their first birthday on the weekend of 4/5 October, with an excellent part programme on the Sunday evening with several of the station's DJs present in the studio. For some unknown reason the DTI always take against aniversary celebrations (maybe it's cos they weren't invited), and they busted Kiss at 11PM.

```
///////////////////////////////////////
  Weekends            Londonwide
///////////////////////////////////////
  Kiss-FM                      BLACK
  ■ Dysons Road
  London                       MUSIC
  N18 2DG
///////////////////////////////////////
```

The returned the next weekend, but the DTI then busted them again early on the Sunday afternoon, along with most of the other black music stations. They were then DTI free right up till the end of November,

although they missed the broadcast on 1 November for other reasons.

7AM: Dean Savon
9AM: Dennis O'Brian
11AM: Gordon Mac
1PM: Norman J
3PM: Jonathan More
5PM: Paul Anderson
7PM: Colin Favers
9PM: DJT
11PM: Desmond D

94FM

1AM: Greeny
7AM: Davey J
9AM: DJ Selwyn
11AM: Gordon Mac
1PM: Richie Rich
3PM: George Power
5PM: Danny Rampo
7PM: Toska
9PM: Colin Dale
11PM: Dean Savon
1AM: 'Mad Hatter' Trevor

EXTRA+

First of all, apologies for the delay in publishing this edition of TX. This was caused by a string of bad colds which kept me out of action for a time, and spending time on preparations for TX: Radio Today, including a re-write of the computer software which took longer than expected... Onto the latest news... First of all, the return of Solar Radio has been heavily reported, apparently on 93MHz VHF. A blank carrier has been situated on this channel for a couple of weeks now to reserve it, and on December 7th it began testing as 'Hits 93' with a mixture of pop and soul. Is this Solar's new name? Is this their new format? More details in the next TX... Also on 93MHz from a high site on the Kent Border is WKLR, staffed by some Starpoint jocks... Major raids on stations on 7 December - LWR, TKO, Starpoint, Hits 93, Kiss-FM, WBLS, Studio 1 and others. Most just lost main transmitters, although a couple of studios were lost by stations as well...

More details in the next TX... Are DBC back again? Reggae station thought to be id-ing as such heard recently on 94.1MHz early on Sunday mornings... Three Boroughs' Radio have been missed out of this month's On-Air report - they broadcast on 1125KHz AM every Sunday between 9AM and 3PM with DJs Tim Allen, Bob Williams and Dave Scott... As part of TX's expansion we're still urgently looking for someone to join the team and help out mainly with interviews with DJs - both offshore and landbased. Give me a call on 01 400 8282 and I'll fill you in with the details... Things are looking up offshore with the arrival of LASER HOT HITS on 576KHz MW - though they sound at times like on big advert for other Laser companies with continuous plugs for records, T-shirts, socks, pom-poms, American football gear, etc. etc. And some people have complained that the black music pirates are one big plug for the nightclub residencies...

LWR

October was one of the best months for ages on LWR, with just one raid at their transmitter site on Sunday 12th which kept them off the air until the Tuesday. Not bad going! With less DTI problems, the station's been going really well, introducing some new community features.

Job vacancies have been read out on several shows, and they've also been publicising a drug helpline. Community announcements have been given out in many shows — though somehow I don't think there would have been too much response to one for a nostalgia evening, but you never know!

A few changes to the schedule have been made, including Ron Tom taking up permanant residence on the weekday afternoon show, which has had several presenters recently. Tim Westwood has now left to join WBLS, and his old Tuesday show is now hosted by excellent newcomer Steve Harris, who also does one half of Drivetime with Richard Taylor.

Programmes are still taped at present, which means that the shows may not be quite to schedule, and there may be occasional breaks.

```
24 Hours            Londonwide

LWR
■   New Cavendish        BLACK
      Street
London                    MUSIC
W1M 8JR
```

SATURDAY

 1AM Continuous Music
 7AM Chris Collins
 Soul
10AM Mike Steele
 Soul, jokes 'n' jingles
12PM Cliff Ringwood
 Soul
 3PM Zak
 Reggae & Soul Selections
 6PM Steve Edwards
 Saturday Soul Selection
 8PM Joe Douglas
 Soca, Reggae & Soul
10PM Yomi
 Soul/Electro

SUNDAY

 1AM Continuous Music
 7AM Chris Collins
 Soul
10AM Clive B
 Or at least it was one
 week...
12PM Neil Charles
 Soul & Electro
 3PM Ron Tom
 Soul
 6PM Steve Edwards
 Jazz '86
 8PM Fuzzy D
 Reggae
10PM Camilla
 Soft Soul

92·5FM

WEEKDAYS

 1AM Continuous Music
 7AM DJ Elaine
 Soul & Reggae from the
 original breakfast lady
10AM Zak
 Reggae
12PM Jasper
 Good selection of soul,
 house music, hip-hop and
 much more
 2PM J.J.
 Soul
 4PM Ron Tom
 General soul selection,
 including rare groove
 classics from his famed
 record collection
 6PM Steve Harris (Mo,Th)
 Soul & electro
 Richard Taylor (We,Fr)
 Soul
 8PM Daddy Ernie (Mo, We)
 Reggae
 Steve Harris (Tu)
 Hip Hop
 Camilla (Th)
 Soft Soul
 Fuzzy D
 Reggae
10PM Barry B (Mo)
 Live Mixing
 Jazzy M (Tu, Th)
 Soul
 General Lee
 Soul
 Yomi
 'Between the Sheets' with
 one of LWR's best jocks.
 Including the Monster Mix
 — recently an hour long
 Cameo mix!

ON-AIR

WBLS

Not another black music station you say? Well, actually WBLS sound rather more interesting than some of the stations of late, with a wide range of music from Soul to Hip-Hop, Salsa, Go-Go, R&B, Jazz...

They'd also managed to pick up some of the best club DJs in the Capital, with such people as Tim Westwood, formerly with LWR for many years, Jay Strongman, Gaz Mayall of Gaz's Rockin' Blues, London's longest running one nighter, and Nick Jones from the Titanic. Sadly though, in the process of getting together this line-up they may have put the backs up of some of the other stations.

Plans were made to launch WBLS on Thursday 6 November. All the studio and transmission equipment had been assembled and one successful test transmission had gone out. Preparations were also made for a live link-up with the launch party at the Limelight Nightclub in the Shaftsbury Road. However, shortly before they were due to begin the broadcast, their studio was broken into and smashed up. Their transmitter suppliers then pulled out after pressure from other stations.

Fri 9AM-Mon 4AM Londonwide

Address Unknown BLACK MUSIC

Despite these problems they still managed to get on the air on Friday 7th November and managed to put out their planned schedule. However, the next setback came on the Sunday when the DTI raided their transmitter site morning which took them off the air again.

WBLS plan to be back, although they are still short of engineering staff.

FRIDAY

9AM Rob Milton
11AM Bugsy
1PM Rob Foster
3PM Jules (Family Funksion)
5PM Josh Ritchie
7PM Rob Day
9PM Jazzy B
11PM Noel Watson

88·5FM

SATURDAY

1AM Maurice Watson
3AM Aitch Be
5AM Steve Devonne
7AM Bobby B
9AM Frankie
11AM To'Mek
1PM Chris King
3PM Mr Magic (Lyndon C)
5PM Jay Strongman
7PM Rob Nagel
9PM Nick Jones & Olly Daniaud

SUNDAY

12AM Hector
2AM Des Parkes
4AM Mark Vaughan
6AM Doctor Cleanhead
8AM Ben Anthony
10AM Jason Mayall
12PM Nassa
2PM Gaz
4PM Derek Boland
6PM Tim Westwood
8PM Dave Dorrell
10PM Barry Sharpe
12AM The Brothers Slide
2AM Damon Birchinall
4AM Close

COMMENT

REWIND

Well, it's certainly been an interesting year. We began back in November last year, expecting the start of the community radio experiment to be just around the corner. Many ex-pirates became tied up with applications, leaving the airwaves to those who thought they had no chance of getting a licence, or who judged there were no identifiable links between their application and their pirate operation. I mean, who'd have guessed that Alice's Restaurant had applied for a licence to be London's first 24 hour a day Serbo-Croat folk dance music station!

1986 was certainly the year when soul music radio reigned supreme, for the simple reason of the money involved - quite a few thousand a week at the top stations. The growth of such stations was also helped by the heavy DTI raids, making it necessary for stations to have good financial backing to survive, which nightclubs all too easily provide. The way things are currently working out, we'll soon have one soul station for each chain of nightclubs.

With the CR experiment being abandoned, there've already been a few disillusioned applicants back on the airwaves. Many more are waiting until after this autumn's Green Paper on the future of radio, before deciding whether to return as well - an option which increasingly seems to be the only one worth pursuing. If a large number of pirates do take to the airwaves, then life will be considerably easier for all of them, and a strong financial backing won't be so necessary.

In the case of pirate radio, there's certainly safety in numbers. Despite the 1984 Telecommunications Act, the raiding crews are still held back just as much now as before it by the sheer weight of red tape which surrounds raiding a station. The RIS now appears to be nearly working at its limits - after all, they sent a representative along to a CRA meeting to plead with them not to encourage more stations as they couldn't cope! The RIS's chances of keeping down a large number of pirates are slim.

Looking back at '86, I think the thing I miss most of all is the lack of soul. No, not the lack of the music but the lack of interest by many DJs and stations in their audience. When I first started listening to pirate radio, the biggest difference from the legal stations was that you knew the presenters were REAL and that they cared about what they were doing and the music they were playing. These days, rather sadly, it seems some couldn't care less.

Quite what '87 will hold in store for pirate radio listeners, nobody knows. Whatever happens, we'll make sure TX keeps you informed.

TX
RADIO TODAY

TX13: Mid-February to March 1987
£1.25

AERIAL
WARFARE

NEW PIRATE
ATTACKS

TX13: FEBRUARY 1987

AERIAL WARFARE

Steve Hamley investigates the DTI's new tactics

It all began at the start of the year. A casual meeting in the street between John Garlic, one of the DTI's main London raiding crew, and an ex-pirate which produced the information that the pirates were going to have a hard time of it this year.

This was backed up by the adverts that had been appearing in Wireless World and a few local papers. The DTI's Radiocommunication Division was after new people to join the Radio Investigation Service (RIS), helping to track unlicensed stations in the London area. Next came the stories of a further increase in budget for the service, and a glossy brochure about the division's work. All the signs pointed to the DTI being about to step up action against the pirates – though quite what action no-one was exactly sure.

The first practical signs came on Sunday 25th January, in a day that saw probably the heaviest raids on pirate stations that the UK has ever known. The DTI had a crane on hire once more and took down many pirate stations' aerial masts, as well as confiscating other transmission equipment. Altogether, equipment was taken from Kiss-FM, LWR, TKO, Direct Line Radio, Studio One, London Greek Radio, Twilight Radio, RFM, Community Development Radio, Quest-FM, RJR and the new Greek station on 91.7, a split from LGR. They even removed the aerial mast at London Greek Radio's previous broadcasting location, which hadn't been used for some time. By the end of the day, only a few stations were left on the air, mostly the smallest operations and the community stations Time and JBC.

LWR returned the following day, albeit on lower power, having taken precautions against raids of this kind. Thinking the DTI would have finished for now, Starpoint then returned to the airwaves late on Monday night. However, they'd made the wrong decision in hindsight. The DTI were back in action that night and took away LWR's new transmitter first, followed shortly after by Starpoint's. It lasted just 55 minutes on the air – and they'd been off for three weeks after losing their previous transmitter 65 minutes after switching on! The DTI then moved on to West London where they then raided Time Radio.

On Wednesday at 10.50pm Radio Duck lost all their equipment, on Thursday at 3.15pm JBC was raided at their studios. However, the DTI were in for a shock there as filming was taking place for a report on pirate radio for Channel Four's Bandung File programme, screened on 7 February. The entire raid was filmed taking place – a rarity as the raiding crews are usually rather publicity shy. Time Radio were then raided again later in the evening at 11.20pm.

At the end of the week 18 raids are known to have taken place. This is probably the largest number that have ever been carried out in a single week, and took off the air all the major stations. These raids are seen by many people as the start of new, heavier tactics by the Radio Investigation Service. With the return of Laser to the North Sea, there are also serious reports of a second 'Eurosiege' about to take place, with the aim of finally getting offshore stations off the airwaves for good.

Despite all the talk of the Government's Green Paper on the future of radio, we aren't likely to see any practical effects from it until at least the 1990s – in other words, no new legit stations for at least three years! This could be even longer if there is a change in Government: a new party coming into office wouldn't regard reform of the radio system as a priority.

If, in the meantime, the existing pirates

are going to be crushed, then a crest deal of people are going to be even more unsatisfied with what is available on their dials. Ethnic minorities which currently have stations serving them will be denied a voice on the radio. Young people in London, having grown up listening to black music stations playing what they want to hear will have to get used to the music chosen by middle-aged men. Fans of music other than Top Forty will find the occasional ghetto slot at an inconvenient time to tune in if they're lucky. Top Forty fans will have to return to stations where the DJs' egos take priority over the hits.

It is no longer possible to serve radio listeners with four national channels, a regional station and Independent station (which may not be very local, and is probably owned by an Australian multinational). They have come to expect more from their radios.

Looking at other European countries, such as France, the only way the existing radio system was changed there was by mass piracy. Quite simply, there were so many pirates on the air that the Governments had to concede to pressure in the end and make changes to their radio systems. This could be the only way to set things moving over here.

When there's just a few pirates on the air then they are easily controllable. The greater the number, the harder it becomes to contain them. The technology for cheap radio is here and the RIS's budget can't keep on expanding for ever, so there must come a time when the pirates begin to win.

Many radio groups are still hanging around waiting for the Government to move. They may soon reach the decision that they'd be better off taking to the airwaves.

RAIDFILE

At the end of last year a question was asked in the House of Commons about the deployment of RIS staff, which provided the information that at the time there were 55 members of staff based at the London branch, Waterloo Bridge House. These are apparently deployed in different activities depending upon requirements. The London office is also involved in the management of the RIS throughout the UK, liaison with the press and media, and also monitoring the offshore stations Caroline and Laser.

A number of MPs have recently asked questions in Parliament about the activities of the RIS against unlicensed broadcasting stations. According to Mr John Butcher, the DTI minister responsible for the RIS, they made 218 raids on 84 different station in the 12 months to mid-November 1986. Checking the names of the stations against TX's own records shows that 45 of the stations were in London, 14 in the Liverpool area and the remainder scattered across the country from Sussex to Glasgow and Telford to Basildon. Equally interesting is that Mr Butcher' s list was missing a number of stations, who therefore haven't seen the RIS at all in 1986! Mr Butcher's latest statement said that 'Raids will continue in all cases until illegal broadcasting activity stops".

Eric to retire?

1987 could be the year when Eric Gotts finally retires, after happily busting pirates for the past two decades. Several people have suggested that everyone ought to get together and organise a party for him if he does. Voice of the Immigrant have agreed to supply the coffee and biscuits.

Records and tapes

Remember there was a court case last year in which the High Court ruled that "Records and tapes do not constitute part of a radio station's broadcasting equipment and can therefore not be confiscated" (i.e. they shouldn't be able to take 'em away in raid). We reported this is TX6, but failed to follow it up, The DTI (of course) appealed against the High Court's decision to the House of Lords, and it seems likely that the appeal will finally be heard in the Spring.

At present, the RIS seem to be carrying out the High Court's decision rather strangely. They are still continuing to confiscate records and tapes from stations when they raid them, but then being forced to return them by magistrates when the cases come to court. Everyone is hoping that the Lords' decision is a favourable one, which should bring to an end the DTI's current practice.

DTI costs

The DTI also keep trying to get magistrates to award them costs for the operation of tracing and raiding stations, estimated to be around £2,000 altogether, excluding legal costs should the raid actually result in a court case. However, they've yet to succeed in winning this from any court. Even so, they keep on trying. It seems that the courts are too busy trying to keep up with the backlog of more serious offences, rather than worrying about people playing music on the radio.

DTI v Philips

At the end of November, Starpoint Radio's Chris Philips was fined £450 plus £100 coats in Camberwell Crown Court. The DTI also pressed for their costs, at £48 for every hour of the operation, but this request was refused. The court also ordered records and tapes seized at the time of the raid to be returned to him.

DTI v Rodgers

Dave Rodgers was recently fined £100 plus £150 costs at Hertford Crown Court for broadcasts from Radio Neptune up until the summer Of 1985.

DTI v Marshall

Harry Marshall was fined £125 at Richmond Magistrates Court in November, for unauthorised broadcasting on Border Radio. The raid was reported in a past edition of TX. The DTI's solicitor had asked for a fine of £1,000 for broadcasting before midnight, and a second fine for broadcasting after midnight, as well as £1,600 towards the cost of the raid, but this was refused by the magistrates. They also ordered records and tapes confiscated in the raid to be returned. Supporters of Border Radio had raised more than £3,000 to pay for any fines that the court might impose.

DTI v Jasper

LWR's Jasper The Vinyl Junkie was recently fined £200 after he was caught at the controls of LWR on 31 July last year.

DTI v Cliff Ringwood

Cliff Ringwood was fined £600 after a raid on LWR on 10 August.

DTI v Mike Steele

LWR's Mike Steele was fined £600.

DTI v Challenger

JBC's Challenger was recently fined £185.

PROFILE

THE NAME: I do regret calling myself the Mix Master Mac now. Someone made it up at College one day, so I thought 'yeah, let's us it'. I only thought about it in the short term, and there it is - stuck!

FOOD: The post popular food I eat is probably a kebab. My favourite though would have to be a pizza. I do enjoy the odd pizza.

WHEELS: I had a battered up old Capri which is currently rotting in the front garden. So, at the moment it's LRT.

NIGHTLIFE: I go to places like The Raw, a good place to go on a Saturday night, or maybe The Wag on a Monday or Saturday night. A place I haven't checked out yet is the Africa Centre, with Norman J.

TELEVISION: The only programme I really go out of my way to watch is Moonlighting. Otherwise, I just put on the TV and it'll be there.

RADIO LISTENING: On Starpoint, the newest recruits like DJ Jazz, who is one of my favourites. I really enjoy listening to his show. Also there's Maxi Jazz - he's got a good show lined up as well. Also Kevin Beadle's shows. Kiss are probably the other station that I really listen to. DJs like Tim Westwood, unfortunately - although he talks a lot he has good music - and Norman J.

WEEKENDS VS 7 DAYS: We started off weekends only, and for all intensive purposes that was when we were best. But I think when we hit 7 days it was such a big step, and maybe we weren't really ready for it. I don't think we realised what it entailed. Well, now we do. It's hard work, but then again, now we've started it can only get better. I'd love to get back to live radio again though.

MOST EMBARRASSING MOMENT: I think the most embarrassing was when DJ Dorsky started out and he was doing a dual show with me because he wasn't totally aquainted with the equipment. So, I'd say 'What do you think of that DJ Dorsky' and there'd be stunned silence... Then at one point he swore accidentally over the airwaves, and everyone

said 'Hey, who was that kid you had who swore'. I've never lived that down!

MUSIC: Chuck Brown and the Soul Searchers have to be my favourite. That would have to be because I love Go-Go music. Apart from them, Grandmaster Flash, Slave... None of this House rubbish. It's so tedious.

THE SHOW: I don't count the weekday shows. I don't like them basically - put that in please!! I'm not too keen on them because I can't play what I like, I have to please everybody. I'm selfish in that respect. I like to play what I like, and what I think is worth listening to. My musical preferences are Go-Go, Hip-Hop, Heavy Funk and the old stuff. That's what I aim to have on my weekend shows. It seemed to get a lot of attention when I did that, so it obviously worked to a degree. I just like to make it entertaining; to pretend I'm sitting down with a group of friends and talking.

THE FUTURE: There's a lot of good things, some of which are still in the nursery stages, so I'm not going to say much yet. My work will be appearing shortly in the record stands, not necessarily me on vinyl, but maybe me compiling or writing. So, hopefully, in the very near future something like that will appear on the streets.

DJC

MIX MASTER MAC

MOST EMBARRASSING MOMENT: I was doing a show on a Sunday night and I heard a lot of noise outside, so I went out and was scouting around the area. When I came back I found the studio door was locked and I couldn't get back inside the studio, so we had an abrupt halt there.

FOOD: It's got to be rice, peas and chicken: the traditional West Indian meal.

WHEELS: I've got a Cortina but I'd like to get an XR2. In the next few weeks I intend to get something like that: sporty and flash.

TIME OFF: Sometimes I go down to the Bell Club in Brighton on a Monday. I don't really like entertainment in London cos it's a bit rough. So, when I do gou out it's generally outside London. I also play football for a team on Sundays. Other than that, just drinking at the local wine bar.

TV: Blockbusters. I think it's excellent, old Bob Holness.

TUNING AROUND: Tony Blackburn for his presentation. I think his presentation's really good, though not his music choice. Also Jasper. Jasper's got good presentation, and Robbie Vincent for his music. I think the pirates today haven't got anything over Horizon and JFM from the past. That's how I feel and I'm involved in them! But that's the truth. I think the presentation then was much better than it is now.

MUSIC: It's got to be soul and funk. I hate jazz cos it's b******s music!! Make that quite clear!

THE SHOW: When we were on weekends I had more time to prepare them. I used to play soul, hip-hop, a bit of garage. stuff like that. Doing the breakfast show I'd be turning up at 3 in the morning and recording the tape, so it was really thrown together at the last minute.

THE FUTURE: We're going to see if we can keep Starpoint on. It's a bit depressing when you lose a transmitter after an hour, that dampens everyone's enthusiasm. Even so, if the pirates do die I should still be in the radio industry somewhere.

"I THINK WE'RE ONE OF THE BEST SOUNDING STATIONS BUT WE ALWAYS GET TRODDEN ON"

"SINCE THEY SAID THERE'D BE NO LICENCES, THAT'S WHEN ALL THESE STATIONS CAME ABOUT"

"I THINK THE PIRATES TODAY HAVEN'T GOT ANTHING OVER HORIZON AND JFM"

THE CHART

1 Kiss-FM

2 Alice's Restaurant

3 LWR

4 Starpoint Radio

5 JBC

6 Radio Duck

7 Solar Radio

8 WBLS

9 Radio Expansion

10 TKO

This year Kiss-FM swept the board: voted top radio station and also with four DJs in the top 20 - including the top two black music DJ positions. Last year they came in at only number 9, but in the year since they've managed to beat last year's winners Alice's Restaurant - just. They also went on to have the largest number of DJs in the top 20.

▶ ▶ ▶ ▶

The recently returned Solar and newcomers WBLS put in a good showing considering that they haven't on the air long. No doubt they'll make a bigger impact in next year's chart.

▶ ▶ ▶ ▶

▲STATIONS
▼DEEJAYS

Surprises included Radio Duck with a high chart placing, and one of their most popular DJs Tim Allen in the Top 15 - mostly on the 'traditional anorak' vote. Radio Expansion did well, often as second choice for Alice's Restaurant listeners.

▶ ▶ ▶ ▶ ▶ ▶ ▶ ▶ ▶ ▶ ▶ ▶ ▶ ▶ ▶

1	Steve Price	(Alice's Restaurant)
2	Jonathan More	(Kiss-FM)
3	Norman J	(Kiss-FM)
4	Yomi	(LWR)
5	Tim Westwood	(Kiss-FM)
6	CJ Carlos	(Solar Radio)
7	Gordon Mac	(Kiss-FM)
8	Chris Stewart	(TKO)
9	Mix Master Mac	(Starpoint)
10	Brian Marshall	(Alice's Restaurant)
11	Jasper	(LWR)
12	Princess Asha	(JBC)
13	Derek Boland	(WBLS)
14	Nicky Lawrence	(Starpoint Radio)
15	Tim Allen	(Radio Duck)
16	Louie St Clare	(TKO)
17	Chris Philips	(Starpoint Radio)
18	Jez Nelson	(Solar Radio)
19	Steve Davis	(Radio Expansion)
20	Camilla	(LWR)

London doesn't have a complete monopoly on unlicenced broadcasting in the UK, and from this issue we're listing the stations you can tune in to outside the London area. As this is a new area for TX, we'd be grateful of any information that readers can provide about stations where they live, either by phoning it through on 01 400 8282 or writing to RX (UK), TX Magazine, BCM Box 225, London, WC1N 3XX. Finally, we acknowledge the help of Anoraks UK's Weekly Report in compiling this listing.

KENT

RADIO ATLANTIS......103.8 FM
RADIO PAMELA........1608 AM

Pamela have been noted in the Kent area since the middle of November with pop music programmes. They also put out a SW relay, which further enlarges their listening area. Back on the air after quite a while off is Radio Atlantis. They have a rock format and amongst their DJs is Steve Davis, last heard by many people in London on Radio Expansion / QMR, and who features in the TX Chart. Atlantis also have the dubious honour of being the last station which Mr England has graced the airwaves of. Sunday nights between 7 and 9PM is the time.

HERTFORDSHIRE

FAS.................105.5 FM
RADIO FIONA.........1584 AM
RADIO NEPTUNE.......1575 AM
NEWTOWN RADIO.......90.6 FM

In this issue, Hertfordshire stations FAS and Newtown Radio have been listed under London. However, a few miles north of Newtown can be found Radio Fiona, who have now ended up under this section. Don't ask me to explain the logic behind this decision - it just sort of happened that way... Fiona must now be the longest running pirate in the country, having now been on the air for 18 years and you can catch them on Sunday afternoons. There'll be a Rewind feature on them in the next TX.
Fiona's neighbours, Radio Neptune are still off the air, but should return in the new year on 1575KHz - see Raid Report about their recent court case.

LIVERPOOL

CAROLINE NORTH.......1611 AM
CENTRAL RADIO........1404 AM
RADIO COMMODORE......105.3 FM
CONCEPT RADIO.......104.3 FM
RADIO JULIE.........104.8 FM
MERSEY-FM............??? FM
MERSEY SOUND........103.5 FM
RADIO MERSEYWAVES...1242 AM
STORETON CR.........103.5 FM
RADIO SUBURBIA......1449 AM
RADIO SUPREME.......105.5 AM
RADIO VERONICA......104.8 FM

Outside London, Liverpool easily has the largest number of pirate stations, and as a result a large number of DTI staff running around trying to get them off the air. Pirate technology in Liverpool still lags a way behind London, with only simple link systems in use. This means that many use taped programmes and have frequent changes of transmitter site to try and avoid being detected.
There are also a number of stations on the medium wave, including the biggest operation in the area, Radio Merseywaves. Despite many raids over the past few years, they still keep on broadcasting, with times varying between 7 days a week operation and weekends only, depending upon DTI activity. The format is mainly pop, though as several DJs work in Liverpool clubs there's also a fair chunk of soul. Over Xmas they were putting out a massive signal, with reports of them being received over 100 miles away!
Another of the more popular stations, Storeton Community Radio (or SCR for short) has been off the air recently, but hopes to be back soon. Radio Veronica features a general pop / rock format, and also includes weekly recordings of other free radio stations, such as Radio Caroline which of course isn't easily received in the North. Also on the air recently has been Radio Caroline North (1611KHz), rather an overused name but then it's easy to nick the jingles...
Like London, there are also a plethora of tiny stations, some of which you'll find listed above. Merseyside certainly shows no signs of keeping quiet.

LEEDS

ABC-FM.............94.6 FM
MUSIC CITY RADIO.....90.4 FM
RADIO RADAR........104.5 FM

Leeds now has three pirates, two of whom are soul stations: ABC-FM Music City Radio. There is also the more established Radio Radar who are more pop oriented, and aim to carry some community items. Leeds hasn't done too badly for pirates in the past, and seems like getting even more in the future.

MIDLANDS

NORTH MIDLANDS RAD..104.9 FM
PEOPLE'S CR LINE....103.3 FM
WREKIN RADIO........103.8 FM
UK RADIO............105.2 FM

Despite being thrown out of the sanctuary of their church tower, People's Community Radio Line are still running daily (DTI permitting) with their black music programmes. Anyone got a mailing address for them? PCRL have now been joined by a few other stations of late including Wrekin Radio who operate on the last Sunday of

each month, Chesterfield's North Midlands Radio and UK Radio who took to the air over the Xmas holidays.

NORTH EAST

WLNG...............104.9 FM

Scunthorpe's finest, on the air twice a week for the past two years to provide Scunthorpe with a proper radio service - at present it's only really on the edges of the Independant station in the area. WLNG also provide the only outlet for demo tapes from local bands.

SOUTH COAST

ABC RADIO..........105.3 FM
RADIO ATLANTIS........105 FM
CHANNEL RADIO........??? AM
CVR................105.6 FM
RADIO ORION........105.3 FM
RADIO SOVEREIGN......105 FM
RADIO VERONICA.....105.3 FM

For some strange reason, the South Coast of Britain, particularly around Eastbourne, is a rather busy pocket of activity. They also have a rather too efficient Radio Investigation Service branch, based in Brighton. But then I have a theory that the number of pirates increases until they reach a level when the DTI are no longer able to do their job efficiently. Rumours also suggest that some of the DTI's raiding parties in the area also spent time on the Dioptric Surveyor watching Caroline and Laser - must be missing the Laserettes though...
Onto the stations. Longest going is Radio Atlantis who have a rock format as far as I remember, unless I'm confusing them again with the Kent Atlantis. This lot are presently operating alternate Sundays between 7 and 9PM and you can write to them at at PO Box 5, Hunstanton, Norfolk. Also going alternate Sundays between 7 and 9PM is Radio Orion but from the East Sussex area.
Radio Veronica finally made it to the air properly in November after they were raided a few months back while carrying out test transmissions. Veronica have been noted here in Hertfordshire on one occasion - with a transmitter site 650 feet above sea level they get out over quite a wide area. Cuckmere Valley Radio are a relatively new addition to the clan, though they've had some technical problems with their first broadcasts which are now being sorted out.
Finally for this area are Radio Sovereign now at the new mailing address of PO Box 3, Rye, East Sussex, ABC Radio and recent Southampton arrival Channel Radio, who were on the air over the New Year's Holiday.

CARVING UP THE DIAL

The main argument employed for many years by the authorities (Home Office, DTI and Government) against anyone suggesting any new radio services has been that 'there are no frequencies available' or 'all the frequencies have been allocated'. Anyone who has visited Paris or New York – or for that matter any major city around the world, will know that they have scores of different radio stations in relatively small geographical areas, whereas London has only three (legal!) local stations. As the laws of physics which govern radio emissions apply equally in London as in New York or Paris, it is clear that the differences are not technical, but administrative and political. Most groups interested in setting up new services are interested in the VHF / FM band, so for this two part series I will concentrate on how frequencies are allocated in this band.

THE STATE OF THE BAND

Since the World Administrative Radio Conference (WARC) in 1979, the whole band from 88 to 108MHz has been allocated entirely to broadcasting in most countries. However, in the UK, no less than 40% of it is still allocated to 'Land Mobile' services, such as police, fire, gas and electricity vehicles. Use of these frequencies by non-broadcasting services will be phased out by the end of 1994 by the latest, and the whole band will then be available for broadcasting.

THE BAND PLAN

Use of the band by broadcasters is governed by the 'Band Plan' which is administered by the Department of Trade and Industry. Two types of broadcaster are recognized: the National services (i.e. BBCs Radio 1, 2, 3 & 4) and 'Local' services (BBC Local Radio and Independant Radio). No provision

has been made for any 'Third Tier' services, such as Community Radio, Specialist Music stations or any other 'neighbourhood' services.

The band plan allocates three, 2.2MHz wide, sub-bands for each of the three BBC national services across the country (so that anyone can find their favourite station easily wherever they are in the UK). Each service is provided by a few high power transmitters and several hundred low powered relays for areas of difficult reception. The main transmitters and relays for the same service are all allocated frequencies within the appropriate sub-band, which is why you may hear, for example, Radio 2 on several different frequencies between 88.0MHz and 90.2MHz.

The band plan also allocates two sub-bands for Local Radio, and these will be split into 'BBC' and 'IR' two sub bands, purely for administrative neatness as far as I can tell. This is why a number of stations have been changing frequencies over the last year or so. Interestingly, Capital Radio is not going to move from 95.8MHz, despite being in the BBC's part of the band – this appears to be because they have refused to do so after spending a lot of money on making sure everyone knows their existing frequency - and producing loads of merchandise like car-stickers with it on!

The current band plan therefore looks like this:-

CLEARING THE BAND

The first of the Land Mobile services to go will be the police and fire services (97.6 to 102.1) and this part of the band will be available for broadcasters by January 1990 at the latest. However, the Government has already agreed that Radio 1 should have its own VHF service, instead of currently sharing the VHF transmitters with Radio 2. So, 97.6 through to 99.8MHz will be used for this service. Similarly, the IBA has been

after its own national service for some time, and 99.8 to 102.0 has been provisionally reserved for this. But there is already much opposition to this idea (if you wish to join in, write and protest to the Home Secretary now!).

The final Land Mobile services will be the gas, electricity and water board vehicles, clearing 104.5 to 108.0MHz by January 1995 at the latest. The local radio sub-band will then be extended to cover 102.0 to 105.0MHz. The remaining 3MHz up to 108 could be allocated to 'Third Tier' radio. However, (surprise, surprise!) the BBC and IBA have their eyes on this sub-band for what they call 'National Extensions' - in other words, yet more relays of Radio 2...

So, on current plans, the band plan in 1995 should look as follows:-

At present it seems unlikely that the IBA will ever offer any more franchises to run stations, but they are tending to enlarge the coverage areas of existing stations, often involving new transmitters and therefore taking up more frequencies. The BBC plans to establish several new local stations, including ones in Surrey and the Thames Valley around Reading. However, it seems unlikely that there will ever be more than 90 local radio stations across the whole country.

In contrast, the number of pirates and the huge response to the community radio experiment have demonstrated that there is considerable demand for new, smaller and specialist stations. Throughout the country there could be over 1000 such stations (Government permitting) and the demand in London suggests there could be 80 to 100. Next month I shall be looking at the specific problems in London and the South-East, and suggesting how this many new stations could be accommodated.

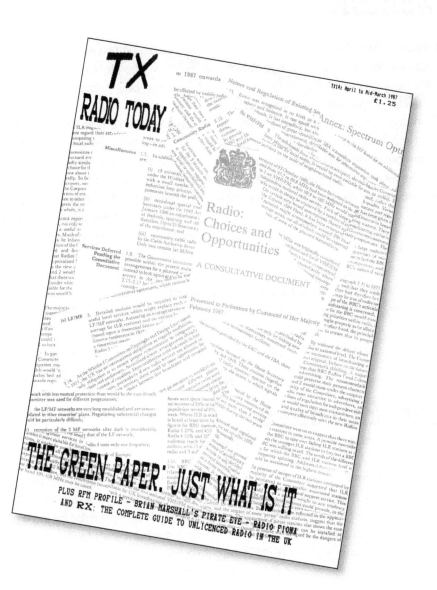

TX14: APRIL 1987

NEWSDESK

Farewell Alice – Take Two

After originally going to say goodbye to London's rockers at Christmas. Alice's Restaurant will now make its final broadcast at Easter. The Christmas broadcast didn't go ahead for a number of reasons, including the possibility of resuming regular transmissions again in the summer. However this is not now to be, and the group has decided to call it a day as they are occupied with other projects.

Farewell Kiss?

Kiss FM were off the air or 5 weeks from 8 February following the departure of their original engineer. The station returned on 21 March with several changes, including more reggae being programmed. Kiss FM were voted number one station in London in the 1986 TX Readers' poll, published in the last issue.

Jackie: 'We're Not Relaunching'

Radio Jackie's official management have denied that they are restarting the station, or that they are behind the test transmissions on 1332KHz on the medium wave. However, TX has received information that different group, which includes previous members of Jackie's broadcasting team, plans to launch a station under the Jackie name. The new station is reported to be starting at the end of March on 1332KHz, from a transmitter site in the New Malden area.

RADIO FUTURES

Steve Hamley finds out what's in the Green Paper

What is a Green Paper?

A Green Paper is a report that looks at whether there is a need for future changes in the law, and what those changes should be. It is a consultative document: once published the Government invites individuals and groups to comment upon its findings and give their own views. In the case of the Green Paper on radio, people have up till 30 June to respond.

Taking into account the responses that have been received, a White Paper is then drawn up, which sets out the Government's intentions. If they decide to proceed further (and they don't always do so) then the White Paper is turned into a Bill, which is put before Parliament.

This gets extensively discussed and debated. Additions are made, parts are removed or amended, and eventually it becomes an Act.

After the Queen sticks her paw-print on it, the Act finally becomes law. The whole process is extremely slow, maybe taking a couple of years or more from start to finish. That is, unless the Government decides it's a priority and rushes it through.

What is in the Green Paper?

The Green Paper looked at two main areas: national and local (including community) radio. Many people expected it to deal primarily with local radio and the inclusion of a big national element was a surprise. This is also likely to slow down its progress to becoming law.

The basic proposals are as follows:

• Up to three new national commercial stations, which would provide increased competition for BBC National Radio.

- A new tier of community radio services: both neighbourhood stations and community of interest.
- A new radio authority, which would regulate both independent and community stations. Both would be subject to a minimum of regulations, and would be free to decide their own programming policies. (Currently, Independent Radio stations have to submit their programming plans to the IBA and have certain quotas for news, religion, etc.)

Let's look in more detail at the individual proposals:

National Radio

Currently we have four national radio services provided by the BBC. The Green Paper proposes that three national independent stations are set up as competition. However, as it stands, there aren't enough frequencies available for all these services, so the Paper proposes giving space currently used by the BBC to these new stations. This would mean that, say, Radio Two which can currently be received on both Medium Wave and VHF might only be on VHF, with a new station on its old MW frequencies.

These new stations would be allowed to choose for themselves what sort of programming they wished to carry, and wouldn't have to conform to current ideas about 'Public Service Broadcasting'. Whereas even Radio One has to carry out certain duties such as news, documentaries, information campaigns (Action Special, AIDS, etc.), the new stations would be free to just play the Top Forty continuously – much like Laser. Quite what effect this would have on Aunty Beeb we'll have to wait and see...

Local Radio

Like their new national counterparts, local stations would be free to do as they want programme-wise, as well as now owning their own transmission equipment and being released from various financial restrictions.

Community Radio

The Green Paper proposes the licensing of hundreds of new community stations (yippee!) around the country, depending upon available frequencies. The Government wants to see a wide variety of different radio services, from neighbourhood stations serving a small locality to specialist music stations, ethnic stations or other new forms of radio.

Community stations would be free to pick their own programming, but they would have to deliver the service they promised when they were granted their licence. No good applying to be a folk music station thinking you'll get a licence if really you're planning on going Top Forty cos they won't have it! This is also necessary to ensure there is a real choice, and a station with a genuinely different format isn't being kept of the air while several with the same format have been licensed. The only major restriction on programme content is that stations must be 'impartial' in their news coverage, and mustn't allow particular views to dominate.

Stations are expected to be self-supporting, most obviously through advertising. A possible restriction for community-access stations hoping to be funded by local authority grants is that stations would not be allowed to be dependent upon one major source of income.

Overall the Green Paper is good news for the future of radio. It should give listeners a much greater choice in radio listening from a wide variety of different kinds of stations. The only major problem is the long wait there will be before the first stations are given their licence. Everyone seems to have generally agreed that it will be 1990 by that time, always supposing that we don't get a change in Government at the election. The other parties would obviously have different ideas about the future of radio.

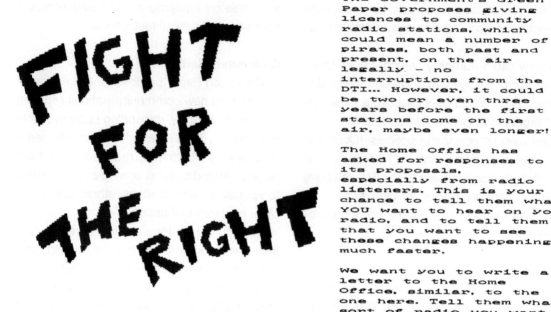

FIGHT FOR THE RIGHT

The Government's Green Paper proposes giving licences to community radio stations, which could mean a number of pirates, both past and present, on the air legally. - no interruptions from the DTI... However, it could be two or even three years before the first stations come on the air, maybe even longer!

The Home Office has asked for responses to its proposals, especially from radio listeners. This is your chance to tell them what YOU want to hear on your radio, and to tell them that you want to see these changes happening much faster.

We want you to write a letter to the Home Office, similar, to the one here. Tell them what sort of radio you want to listen to, and that you want it NOW.

Instead of sending the letter direct to the Home Office, send it to us here at TX. Using your letters we will then write a more detailed document outlining your views together with our own research. This will then be presented to the Home Office together with your letters.

In the pages of TX we'll then keep you up to date with developments, and in TX16 we shall be printing details of our submission along with some of your best letters.

It's important that you get writing now. We need all your letters by June 12th, but preferably as soon as possible. Write:-

TX CAMPAIGN
BCM BOX 225
LONDON
WC1N 3XX

BCM Box 225
London
WC1N 3XX

Room 66A
Home Office
Queen Anne's Gate
London
SW1H 9AT

14 March, 1987.

Dear Sir,

I welcomed the Government's Green Paper on the future of radio as like many listeners I would like to be able to tune-in to a wider range of stations than is currently available. In particular, I am a black music fan and would like to see a black music station licenced to serve London.

However, I do not want to see the introduction of Independent National Radio. New national stations would not greatly widen the choice for listeners, whilst occupying a large amount of frequency space that would be much better used for community stations.

As a priority, the Government should press ahead for the licencing of community radio stations at the earliest possible opportunity. 2 to 3 years before the first stations come on the air, as has been reported, is far too long. Its introduction is also be hampered by the slow movement of emergency services from the VHF band. Giving the frequencies proposed for the new national service to community stations could greatly speed up its introduction.

As the paper suggests, Community services should be left to decide their own programming policies. However, they should have to keep to the format that they specified in their licence application. If they do not, then the licence should be taken away and re-advertised.

This method should mean that there is nearly as wide a choice of different types of radio as there are available frequencies. There should be space for specialist music stations playing soul, rock or oldies; neighbourhood stations with open-access programming presented by volunteers, ethnic stations serving their communities and other types of new, exciting radio.

I look forward to the licencing of community stations with interest.

Yours faithfully,

Steve Hawley

Steve Hawley.

ROCK RADIO

NO PUNK · NO FUNK · NO REGGAE · NO SOUL · JUST ROCK 'N' ROLL

CLAIRE MANSFIELD

FOOD: I'm mostly vegan. I've been vegetarian for just over 2 years and now I've cut out milk and eggs too though I do eat a bit of cheese every now and then. I like Pasta, Italian food, stuff like that. Cream I love but obviously can't eat.

WHEELS: I'm planning to learn to drive. I'd love an MGB VTV8, I'm very fond of those. It'll probably be down to a clapped out mini by the time I'm on the road.

CLOTHES: Very faded jeans, short skirts, lots of T-shirts - RFM ones of course - denim jackets, leather gloves and high ankle boots. Probably sums it up.

NIGHTLIFE: Checking out a lot of new bands at the Marquee. After there we usually go to the San Moritz which is just opposite. Then there's a new rock club opened at Gossips on a Tuesday which we go down to now and again.

TV: Don't watch much, but when I do I like things like Horizon, documentary type programmes. Most of the comedy shows I find very inane and patronising.

RADIO: I don't really have any favourite DJs as there aren't very many female DJs. I don't listen to very much of Radio One or Capital at all and there aren't many rock pirates on the air so I don't listen to much radio it has to be admitted. Except on Sunday!

MUSIC: Band of the moment has to be FM. There's also a new American band called Tesla which is getting a lot of press, they're very, very good. I'm hoping to play some tracks by them on forthcoming shows.

THE SHOW: Really I'm trying to develop my personality. Because we've been pre-recorded I was afraid of the tape I suppose you might say. Getting used to having to pretend you're talking to a live audience is difficult. Really it's just a question of improving, getting the links tighter and trying to get across me as a person; that's what I'm aiming for.

MATERIAL: I started off being very self-indulgent in the music I play, which didn't work. Now I'm trying to playlist my show with more of the audience in mind, and I find that hard. Most of the bands I play on the show are all from my collection. I do find a shortage of material a problem, because not being a big station we don't have the resources to buy all the records we'd like to. So, repetition is a problem. But I do try and play new singles, tracks that are relevant to bits of news. We don't have a fixed format, being only a Sunday station it doesn't work.

EMBARASSING MOMENT: Definitely when we were sitting listening to the shows going out and I started to sound suspiciously like Al Jolson. It was the tape running down in speed - we'd forgotten to change the batteries in the machine! We then couldn't find any batteries on the way either, so we were delayed while we tried to find a garage that was open. By the time we'd got back to the site, everything was going out at just under half speed.

THE FUTURE: 6 days a week, live broadcasting. We aim to be the first station to broadcast through the week. The initial experiment may not work, but until we've tried we won't know.

DAVE FULLER

FOOD: Beans, corned beef and chips apparently. I'm a very boring person in that respect.

WHEELS: Ever heard of a Geneta 215? Well, I've got one. It's a sixties kit car, and I'm busy restoring it at the moment.

NIGHTLIFE: Zero! Nil! I go to the pub a lot and fall over...

TV: Magic Roundabout, things like that - all the kiddies programmes! I love 'em!! Especially cartoons. I Love Tom and Jerry!!

RADIO: Tom Anderson on Caroline Overdrive. All the Overdrive mob. Maybe that's because of the music they play, but I like the atmosphere they give over.

MUSIC: I like Suzanne Vega. I'm really into that, but for credibility purposes I also like the heavy stuff: Def Leppard I reckon are one of the best. There's no current bands at the moment that could be considered worthwhile listening to - especially FM! I don't think much of thrash metal at all, I'm a seventies rock person myself and that's where I'll stay. I'll grow old and get cobwebs cos of it I suppose.

THE SHOW: I try to create a very informal atmosphere, not structured at all. I try and make it like I'm just one person talking to another person. It's a concept that's been tried on T1 and Radio Amanda in the past. I don't want to sit on a pedestal and be just another voice on the radio. I haven't perfected it yet, I'm still learning and still trying.

PIRATE PROBLEMS: I had to take a replacement aerial on the tube one Sunday. It was about 7 feet long and wouldn't go through the doors of the tube properly! Then it wouldn't stand up inside, and I had to juggle with a suitcase as well.

CLOSING THOUGHTS: I'd like to thank everyone who's helped the project. We've had some tremendous help and support - it's overwhelmed me. It's really left me speechless. I think we're being seen as the replacement for Alice's Restaurant. Alice's was a station I had a lot of respect for and it's a mantle we'll have to hold.

REWIND

JON FROM RADIO FIONA LOOKS BACK AT THEIR 18 YEARS ON AIR

This year Radio Fiona will have been on and off the air for eighteen years. This probably makes us the longest running unlicenced station in the UK - even though we aren't on the air EVERY Sunday!

Broadcasts started in spring 1969 using relatively low power and covering our then home town of Letchworth, Herts on Thursday evenings and Sundays on 1179KHz. After a few months of this we operated two 10 watt transmitters either side of Letchworth, alternating every hour on Sundays. During this time we changed the name briefly from Radio Fiona to Radio 206 North and South.

We began to penetrate more of North Herts and East Beds from 1970 when a Collins ex-USA Navy transmitter was used again on 206 metres, and as Radio Fiona once more. This transmitter ran up to 50 watts. From summer 1974 until 1978 we were silent. Since then several frequencies have been used. In the early eighties we got out further than ever before, on 189m, and more people heard the name Radio Fiona for the first time. We then received reception reports from far afield - up to 100 miles away.

DJs TELL: WHY WE BECAME PIRATES

Musically on Fiona we like to vary the things considerably: rock music, album tracks, reggae, soul, rock 'n' roll, sixties beat and many new independent labels' stuff gets an airing. Although the hours are limited we try and play an interesting assortment.

One fact that we're particularly proud of is that in 1981 for several months, all four members of The Stingrays broadcast on the station, with their brand of rock 'n' roll, doo-wop, rockabilly, R&B and the like. Since then they've become famous and alas we've lost contact. We've also always been interested in plugging things we believe in, such as Greenpeace and FoE.

'We'll be back' vow by illegal station
RAID PUTS RADIO PIRATES OFF AIR

Altogether some 32 people have been on the station throughout the years, though unfortunately only 4 were female. The station has had a bit of a lapse lately, though hopefully this is only temporary. Still, at least we don't get busted so often that way! 189 metres, 1584KHz is where you'll find us. Although the other stations on this frequency restrict long distance reception, it's still good for Letchworth, Hitchin, Baldock, Stevenage and East Beds.

★ UNUSUAL SOUNDS! ★
RADIO FIONA BROADCASTS ON SUNDAYS FROM 11:00AM ON 1584KHZ ~ "THAT'S 189 METRES".

BACK TRACK

A look at pirate radio anniversaries in the forthcoming weeks.

19 MARCH 1969
Radio Jackie, Britain's best know landbased pirate, is launched.

20 MARCH 1980
After being holed on a sandbank in rough seas, Caroline's boat the Mi-Amigo sinks.

22 MARCH 1972
The House of Commons is told that 116 people were successfully prosecuted for illegal broadcasting the previous year (nothing changes).

22 MARCH 1986
After being off the air for several months after a series of heavy raids, Kiss-FM returns as a weekend stations

29 MARCH 1964
The official start of Radio Caroline, with Simon Dee uttering those immortal words "Hello everybody. This is Radio Caroline on 199, your all day music station".

29 MARCH 1984
Radio Shoestring makes its first broadcast. DJs on the station include Mitchell Johnson (now with Virgin-FM at the London Megastore), Paul McKenna (now with Chiltern) and TX's Chris England and Chris Miles.

1 APRIL 1967
Radio East Anglia is heard testing on the same frequency as Radio London, increasingly interrupting Radio London until finally it takes over completely. However, at midday the station vanishes. It turns out the station was an April Fool's Day joke concocted by Radio London DJs.

1 APRIL 1976
A pirate station takes over the Isle of Wight Radio One relay, playing several records banned by the BBC.

15 APRIL 1970
The British Government begins jamming Radio Northsea International from a Naval radio station in Rochester, Kent.

7 MAY 1978
Radio Amy, Britain's first ever community access station, is launched.

12 MAY 1964
Radio Atlanta, the first rival for Caroline, begins transmissions.

RADIO TODAY

TX Publications
BCM Box 225
London
WC1N 3XX

01-400 8282

Welcome to a special Radio Today Update. Unfortunately, our computer system finally collapsed at the beginning of May and as a result, production of issue 15 has been severely delayed. A new computer has now been installed, but we are still awaiting the arrival of software so that work can carried out on the magazine again. The next edition of the magazine will now be published in late July, so to bridge the gap and explain to our readers the problems, we've produced this news-sheet.

We're all very excited about the next issue, as it marks phase two in our planned expansion. We'll be adding many more pages and bringing in several new features. For example, in the centre will be our new 'At A Glance' pull-out guide to what's on, which you can keep by your radio. Plus, as this issue coincides with the 20th anniversary of the outlawing of the offshore radio stations, we'll also be taking a look back through 20 years of pirate radio. There's also one, big change which you'll notice straight away: we're becoming simply "Radio Today".

From the large number of comments from readers it seems that our decision at the start of 1987 to publish eight times a year is not working. Publishing dates are too confusing, and haven't been helped by the problems we've been suffering. Regretfully, we have decided to move over to publishing six times a year instead. However, we promise you that *from now on we will do our best to get Radio Today to you* on time every two months.

To provide you with an improved service between issues, plans are underway for a new telephone information service. This will give you all the latest news as well as a complete rundown of changes since the last issue of the magazine. In the meantime, keep dialling 01-400 8282 for a one minute news summary.

Obviously, we have let you down in recent weeks. We're now doing our best to ensure that the problems we have had do not happen again and hope that you have confidence in us. Should you still feel unhappy, then we are willing to return your subscription money.

Again, please accept my apologies... Steve Hamley.

NEWSDESK

We kick things off with news of a victory by the pirates. The House of Lords has ruled that only transmission equipment can be confiscated by the courts. The case began last year when a liverpool pirate DJ had all his record and tape collection confiscated. His solicitor appealed, and eventually the high court ruled that the DTI should return his collection. However, the DTI appealed to the House of Lords against this decision, and on Wednesday 3 June, the case was finally decided.

As far as we are aware, the situation is now as follows. Courts have the right to order the forfeiture of any apparatus restricted under the Wireless Telegraphy Act. Under the newer 1984 Telecommunications Act, the law was changed to allow the DTI to 'Seize and Detain' for the purpose of any relevent proceedings, any apparatus which is relevent to the offences found during the search. However, the Lords have ruled that after the case has been to court, they have to give back all the items which aren't 'Wireless Telegraphy Apparatus'.

Put more simply, the DTI can still raid a station and take away whatever they think the station needs to work: studio equipment, records, tapes, chairs, telephones, etc. However, they must give it all back after the court case, except for the tranmsission equipment. This should mean studio equipment is returned too, but it seems likely that the DTI will manage to persuade most courts to confiscate it too.

Next, a couple of recent court cases. At the beginning of May, DJC from Starpoint Radio was fined £850 for illegal broadcasting and remanded in custody for 'assaulting a DTI member'. No further information on that case is to hand. Secondly, Barry James, also from Starpoint, was fined £50 plus £250 costs after being caught changing the tapes some time back.

INFORMATION

The Community Radio Association is organising a London Forum to discuss issues facing community radio projects in the Capital. They would like any broadcasters from unlicenced stations who are interested in non-profit making, community-access radio to come along. The Forum takes place at Imperial College Students' union, Prince Consort Road, London, SW7 from 6.30PM to 9.30PM On Tuesday 16 June. Further information from 01-274 4000 ext. 335.

OFFSHORE DIARY

Rather a busy time for Laser - and very little action at Caroline. We begin with the news of Laser's hijack. Laser Hot Hits have been suffering from major financial problems for quite some time now. As a result, they accepted help from Radio Monique in the form of supplies, etc. in the understanding that they would move to Laser's boat, the MV Communicator. They were unable to do this, though, because of the poor state of the boat. Radio Monique's Dutch service is currently broadcast from Radio Caroline's 963KHz transmitter, however Monique have long been unhappy at the deal they have with Caroline, which means they provide all the major supplies for the boat.

Reports began to come in of Laser selling out to a new group, who were prepared to invest two million dollars in the project. The Communicator was moved from its position near Caroline to a new mooring off Kent, supposedly in preparation for work to be carried out by its new owners. Then, in the early hours of Wednesday 27 May, a Dutch tug acting on instructions from the boss of Monique took the Communicator in tow to a position off the French / Belgian coast. It seems that Monique were taking no chances and snatched the boat as security against losing their money.

At the time of writing, a great deal of speculation has been going on about the future of the boat. A sanitised version of events has been put out by Laser's owners through certain channels they are close to, whilst

other reports in the press have been wildly inaccurate. By the time the
next issue is out, the mist might have cleared a bit...

LONDON DIARY

A busy month with the DTI rather more active than the past couple of
months. LGR, BGCR and LWR have all been hit heavily, and some of the
smaller stations have seen the DTI for the first time... <u>Friday 1 May:</u>
The arrival of a new anarchist station on the airwaves, Radio
Interference, broadcasting on 106MHz every Friday to SW London. Three
more anarchist stations are promised in the summer, all using around 5W
of power and altering location regularly to avoid detection. <u>Sunday 3
May:</u> Heaviest raids yet in the history of pirate radio in London.
Stations raided were Kiss-FM, Greek Radio for London, British Greek
Community Radio, London Greek Radio, Flashback Radio, Rock To Rock, TKO,
RFM, Radio Shoestring, Studio One, RJR, Quest-FM and several very low
power stations. All the major stations returned quickly, but it seems
that the DTI have managed to wipe out some of the smaller stations for
the time being. <u>Monday 4 May:</u> A special broadcast from "Not Alice's
Restaurant", to complain about the lack of the station recently, or even
its promised farewell broadcasts. Rock To Rock, LGR and BGCR return.
<u>Tuesday 5 May:</u> LGR and BGCR are raided again. <u>Wednesday 6 May:</u> TKO and
LWR return. LWR had been off following an incident at the end of April.
<u>Thursday 7 May:</u> Raid on Radio Gemini's studio. <u>Saturday 9 May:</u> LGR and
BGCR return again in the morning. BGCR is taken off again by the
evening. It is understood that an electricity board relay in North
London on 105.5MHz has been suffering interference from both stations.
RJR returns in the evening. <u>Monday 11 May:</u> Raids on RJR and LGR in the
afternoon. LWR is raided at 6PM, TKO manages to remove their transmitter
in time. However, whilst the DTI had left their car unattended its tyres
were slashed. <u>Wednesday 13 May:</u> LWR and TKO return in the early hours of
the morning. Phase One puts in a new appearance on 90.9MHz, and LGR and
BGCR return yet again. A new Asian station begins broadcasting on
93.3MHz. A former Trax-FM DJ is fined £140 in court. <u>Thursday 14 May:</u>
Phase One goes off the air with technical problems. To avoid a raid at
their studio site, LWR switches off and moves location. Taking advantage
of them being off air, Radio Badger broadcasts most evenings from the
West of London. The Asian station moves to 94.3, where it has continued
most evenings since. <u>Friday 15 May:</u> LGR and BGCR are raided yet again.
<u>Saturday 16 May:</u> LWR returns. <u>Sunday 17 May:</u> LWR is off the air for much
of the day when their transmitter fails. London Town-FM, a new station
composed of several ex-Skyline jocks, begins broadcasting to the South
side from a high site just outside the Capital with a pop and oldies
format. Clockwork Wireless makes the latest in its highly successful
series of broadcasts - just two minutes... <u>Monday 18 May:</u> LWR is raided
at 6AM. LGR and BGCR are taken off later in the day and Studio One in
the evening. <u>Tuesday 19 May:</u> JBC is raided at 6.50AM. The front door to
its building and the door to the studio are smashed in in the process,
and the DTI completely strip the studios. Radio Activity in South London
is raided. A new LWR transmitter is installed, but it only manages to
relay taxi conversations. <u>Wednesday 20 May:</u> RJR finally returns, along
with Phase One. LGR begins broadcasts with a new transmitter at 8AM as
usual, only to be taken off air again at 10AM. BGCR is also raided again
and Studio One loses their new transmitter just 5 minutes after
switching on. <u>Friday 22 May:</u> LWR returns 3AM, but with numerous
technical problems, making the sound very distorted and suffering from
interference. JBC returns to the air. RJR is busted at lunchtime.
<u>Saturday 23 May:</u> LWR manages to put out programmes, but still with poor
sound quaility. MRS-FM broadcasts all weekend on 94.2. <u>Sunday 24 May:</u>
Although just about coping with MRS-FM as neighbours, the appearance on
94.3 of the Asian station in the evening and also a high power test,
reportedly from Starpoint, almost drown RFM. RJR returns, on lower
power. <u>Monday 25 May:</u> LGR return yet again. Little extra bank holiday

activity, although Solar and Kiss broadcast throughout the Monday.
Tuesday 26 May: Phase One is raided in the afternoon. Wednesday 27 May:
After several breaks in transmission over the past few days, LWR is off
until the end of the month with technical problems. Phase One returns.
Friday 29 May: RJR is back. Sunday 31 June: RFM are off most of the day
with technical problems. Greek Radio for London finally returns, after
being off the air since the 3rd May.

LISTINGS

And finally, news of changes to the listings section in the last TX...

Radio Activity keep going on 89.5 in South London. Arabic Community
Radio seems to have died before it even began proper broadcasts. Radio
Badger pop up in West London on 91.9. British Greek Community Radio on
105.3. Clockwork Wireless seem to be slowly getting in their stride,
after a string of transmissions lasting only a few minutes before
transmitter problems set in. Community Development Radio are now
broadcasting 24 hours a day, and sounding much better than they did in
their early days. Confidence Radio have just returned on a new frequency
of 92.2 - they always seem to be batted around between other stations.
DBC keep on playing the old tapes on 93.9, Fridays. Direct Line Radio
are currently only carrying out test transmissions, and hope to begin a
new 24 hour local service for South East London in August. Radio Duck
have had a number of problems recently, and I wouldn't be certain of
them returning. Elite-FM turned up for a while from North Surrey, but
have now sunk. Radio Gemini should be back soon. Greek Radio For London
on 88.4 aren't doing too well, suffering heavy raids most weeks - the
DTI seem to have it in for the Greeks. Horizon Radio on 94.5 broadcast
fairly regularly to SE London. Radio Interference anarchy on the
airwaves, 106FM, 6PM Fridays. JBC keep on going, 104.7. Kiss-FM have
suffered a few staffing problems since their enforced break, but these
have now been largely settled. London Rock can now be heard on 104.2 on
Saturdays from 6PM in North London. London Town FM is the brand new pop
station beaming into London from the South. Staffed by several ex-
Skyline jocks it seems to be getting an excellent response judging by
readers reports. 92.4 all weekend. LWR have had big problems, mostly on
the technical front. Radio Memphis are still on the air - I think...
MRS-FM is an East London soul outfit who are on most weekends on 94.2.
Network 21 are now back after a slow return after their raid. Phase One
bring soul to South of the Thames on 90.9, 7 days a week, but have had a
few problems with neighbours on the dial nicking their rigs. Quest-FM
keep at it on 89.9 to SW London. RJR seem to attract the DTI rather a
lot, but are still pushing out the reggae over North London on 89.9.
Rock To Rock are on several days a week and all weekend on 90.2. RFM
have moved to 94.3. Radio Shoestring are back on 94.4 with an across the
board mix of programmes for the East London area. Sina Radio are still
going over in West London on 90.9ish. Sky-FM is what Twilight turned
into, 7 days of black music and community info for SE London. SOL
haven't been noted for a while - they were planning a change of night
for broadcasting. Solar 93 seem to be doing OK, although some listeners
complain that reception isn't what it used to be. Studio One seem to
have rather a lot of DTI problems, but even so are considering 24 hour a
day broadcasting soon. Time Radio seem to be doing OK, despite a few
dubious stories in the press. TKO seem to be on the air almost non-stop
these days. Traffic Jam join the NW London reggae circuit on 97.9.
Turkish Community Radio keep going on 103.7, while Green Isle Radio
continues on 90.9MHz and Voice of London Turkish Radio operate on
1611KHz MW. Radio Vicky may have missed a few broadcasts recently. WLFM
haven't been heard for a while, with their pop broadcasts to NW London.

That's about it. See you in a month.

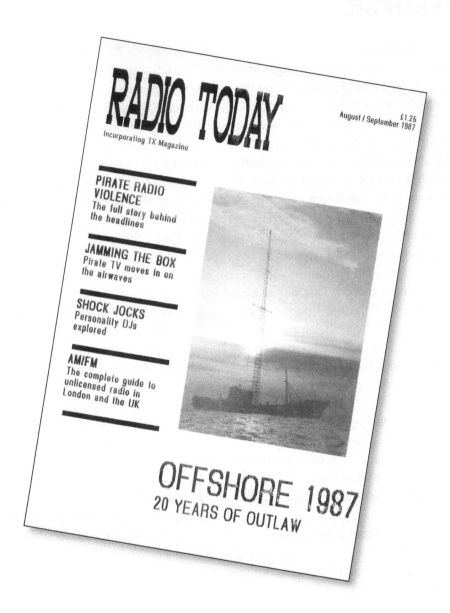

RADIO TODAY

August / September 1987 £1.25

Incorporating TX Magazine

PIRATE RADIO VIOLENCE
The full story behind the headlines

JAMMING THE BOX
Pirate TV moves in on the airwaves

SHOCK JOCKS
Personality DJs explored

AMIFM
The complete guide to unlicensed radio in London and the UK

OFFSHORE 1987
20 YEARS OF OUTLAW

TX15: AUGUST 1987

NEWSDESK

Confiscation Confusion

The House of Lords ruling in June that records and tapes cannot be confiscated has caused confusion among many station staff.

As the law now stands, courts have the right to order the forfeiture of any apparatus restricted under the 1949 Wireless Telegraphy Act. Following a change to recent editions of the Act, this no longer includes "electrically connected" items. In addition, the DTI can 'seize and detain' for the purpose of any relevant proceedings any items relevant to the offences found during the search.

This means that records, tapes, studio equipment, listeners' letters, management instructions, etc. can still be taken by the DTI in a raid. However, once the case has come to court and a person found guilty, only 'Wireless Telegraphy Apparatus' can be permanently confiscated. The recent alteration to the Act has been successfully used in court by one station to get their studio equipment returned as well. However, the DTI may yet appeal against this decision and it will probably take a High Court ruling to decide whether it should be upheld.

Radio Today Green Paper Submission

The Radio Today submission to the Green Paper on the future of radio was delivered to the Home Office in June.

Based on Comments from many Radio Today readers it urged the Government to proceed with plans for the licensing of new stations at the earliest possible opportunity. It also rejected Independent National Radio and instead pressed for the licensing of a wide variety of services, from specialist music services and ethnic stations to neighbourhood and community-access stations.

Radio Ban on New Music

The BBC and Independent stations are considering a joint ban on playing new music in an attempt to negotiate a better deal over copyright payments and needletime.

At present the companies who look after the copyright interests or musicians and record companies still claim that the playing of a record on the radio reduces its potential sales, and insist on high copyright payments to compensate for this. However, as one broadcaster commented 'What other industry charges its shop window to display its products!'

Slapped Wrists For Blackburn Over Plugs

Tony Blackburn has landed in trouble with BBC bosses again over allegedly giving plugs on his show to shops in return for records and prizes.

Tony, who recently confessed that he would like to be on the air 24 hours a day, was sent a memo by Radio London management telling him to drop all mention of Bluebird Records. This followed a complaint from a member or the public about the number or plugs they were getting. Bluebird responded by saying that they thought it was part or the deal for supplying the station with import soul releases.

It was then revealed that shops were being approached by the producer of the show for prizes in competitions and were offered mentions of their shop on the radio in return.

DJs on the station were cautioned last year about giving plugs on the air to their own gigs. BBC Bosses are reported to be unhappy with the way Radio London is developing. A working party is currently reviewing the station's operation with its closure one possibility being considered. Radio London has never managed to pick up as large a share of the audience as other BBC Local stations.

PIRATE RADIO VIOLENCE
The real story behind the headlines

John Butcher, DTI minister responsible for cracking down on pirate radio, has accused the pirates or terrorising investigators working for the DTI's Radio Investigation Service (RIS).

He produced a dossier of alleged attacks on investigators stretching back to 1984. These included:
- Investigators' vehicles being chased by gangs.
- An attack on investigators by masked men with baseball bats off the Edgware road, on their way back from monitoring duties in West London.
- One investigator having a ladder pulled from under him whilst trying to reach a transmitter on a tower block.
- The death of an investigator in Birmingham from a heart attack after being dragged from his car by a gang.
- Threatening calls and letters to investigators and their families.

He also accused an anarchist group of coordinating and organising attacks on investigators. He gave figures which showed an increase in the number of attacks: 1 in 1984, 2 in 1985, 3 the year after and 7 already this year.

Incidents Exaggerated

However, these incidents have been exaggerated. We have established that in one case of an investigator's vehicle being followed there was no intention of violence. In another case of an investigator being assaulted, the person concerned was subsequently charged. Police have also said that they do not link the attack in Birmingham with the man's pirate radio investigations.

The allegations of anarchists coordinating or organising attacks are completely unfounded. The anarchists referred to by John Butcher

are from a loose collective of anarchist groups centred around The Hooligan Press / Crowbar Squatters Magazine. They were also involved with Our Radio in 1982/3 and more recently Radio Interference. They have little, if any, contact with the rest of the unlicensed stations in London. The tactics they propose in their pirate radio manual, Radio Is My Bomb, would certainly not be considered by most stations.

Along with the vast majority of people working in unlicensed radio, we condemn any violence or intimidation of RIS officials. It is only a very small minority who would consider such action. It should also be remembered that in the past stations that have been violent to the RIS have often been hit harder in the future. They have also often faced condemnation from other stations for damaging the image or pirate radio.

Increased Heavy-Handedness

But, why has there been an increase in violent incidents? We consider that there are two main reasons.

First, there is an increasing heavy-handedness on the part of the RIS. For example, the raid last September on Border Radio, which used to serve the elderly in the Twickenham area. Serious damage was caused to the home of station's founder, including smashing the door down. He was later admitted to hospital with a complaint thought to have been brought on by the raid. The chief RIS investigator in London was also convicted of assaulting a member of one station.

Second, is an increasing frustration with the Government's interest in licensing stations. It is over 20 years since pressure first began for the licensing or a large number or stations – and we're still told that these changes are not to

happen for at least another 2 years. The new Home Office Minister for broadcasting has also made clear that he does not regard the licensing of new stations as a priority.

Singling Out of Stations

We have also established that the flash point for two incidents is the singling out or stations by the RIS for no apparent reason. In the past, stations have not been raided on the basis of the interference caused to other services. The RIS are now beginning to move towards this, but they would be doing themselves a service if they made clearer their motives behind the apparent singling out or stations.

There seem to be several reasons for the timing of these allegations.

John Butcher has spoken about how he hoped that members of the public would help in the fight against the pirates. This is right at the time when the Government is proposing cutting another 30 to 50 staff from the present 200 employed by the Radio Investigation Service. There have also been stories of reluctance among RIS officials to risk injury in closing down stations.

The RIS have themselves admitted that they could not cope with a large number of pirates on the air. At a meeting of the Community Radio Association (CRA), a member of the RIS urged the CRA not to condone unlicensed broadcasting, as they would not be able to cope.

Police sources have admitted several times that they are unhappy with having to devote manpower to helping the RIS in their work in closing down the pirates. It has also been admitted that the pirates have often helped the police. Appeals for help in solving crimes have been aired on pirate stations in the past.

Major Campaign Against Pirates

These allegations could mark the start of a major campaign, with the RIS channelling their efforts into a huge round up with the aim of silencing them for good. Already there has been a massive raid at London Greek Radio when not only did they lose their third studio in a row, but their office was also raided and almost completely stripped in a search for evidence relating to unlicensed broadcasting. Many pirates saw this as the first signal of the start of a new campaign.

The RIS could not embark on such a campaign without greater support from the public. They certainly wouldn't have done so before the General Election. Turning the public against the pirates does look like the main reason behind the allegations. Older readers may wish to draw a parallel with the Oliver Smedley affair in the sixties, when the Marine Offences Act was only able to be brought in after one station owner was shot by a shareholder in another.

This is where the RIS has probably failed. There is still a massive support for the pirates, from the young kids today who've grown up listening to the stations to people who remember how the pirates were treated in the sixties when they were young. The pirates will never go away until listeners have a legal alternative.

Final word must to Soca B from JBC in an interview in The Times "We have never heard of this anarchist group and we detest violence, we just want a licence".

TALKBACK

Pirate Or Not Pirate

Dear Radio Today,

Hi. I like the new format. I've read the magazine on and off for a while now, but now it's a must.

I must say that I agree with Neal West in #14. The free radio operators are not pirates; they are attempting to expand the narrow world of British Radio, and breaking through the 'closed club' attitude of the established radio world. The fact that few of the people involved see it that way doesn't matter because most people who get caught up in a cause have different reasons or getting involved. But I think they all deserve a better title than pirate.

Onto Brian Marshall – who is quite right. The amount of soul / disco on the airwaves is completely over the top. It rather knocks a whole in the choice argument that we all use when discussing the community radio proposals.

I can never get RFM – despite being just over the London border. I have hopes for London Town FM, although they'll probably be blotted out by a soul station. There are times when it wasn't for Caroline I'd go mad.

Simon Martin, Surrey.

Soul Complaint

Dear Radio Today,

Full marks to Brian Marshall or his brilliant 'Pirate Eye'; what he says about the black music stations is so right and I am glad at long last someone has said it.

As Brian says, most of the stations are the same: having 375 stations (or is 380 – I lost count years ago) playing the same type of music is pure daft. It's rather like starting up a station and doing a top forty rundown between 5 and 7pm on a Sunday or a pirate TV station putting out sports programmes on a Saturday afternoon.

There seems to be a trend at present for a good 80% of the DJs to talk all over records which is just crazy. In my deejaying days you never 'crashed a record'. Today it seems to be the norm. Not only does this happen right at the beginning of records, but right in the middle of them as well. I think the whole thing boils down to the fact we want quality not quantity. One good old JFM / Horizon / Solar was better than 20 odd crappy distorting rigs which seems to be the norm in 1987. If a station, whoever they are, cannot put out a decent quality signal then they should not bother.

Once again, congratulations Brian on a first rate article.

Richard Norris, South Harrow.

Satisfied With Soul

Dear Radio Today,

Thank you for producing such a good magazine about the good work the pirates do in London. When in the City I would never contemplate listening to the main legal stations as their format is far too boring. For a start, I think their normal way of presentation and the continuous adverts ruin their popularity.

Take CJ Carlos from Solar or example. Here we have a real joker and an excellent presenter. He is able to bring a relaxed presentation that produces such a good atmosphere. I am mainly into the funk and black music stations and have been listening since the days of Horizon and JFM.

Charlie Davey, Wiltshire.

LONDON AM/FM

RADIO ACTIVITY 89·5 FM

Radio Activity broadcasts to South London with a wide range of music mixed in with local information.

////NEWS/////////////////////////

Radio Activity now seems to be doing pretty well, after some initial technical problems and a raid on the station earlier in the year. The station is offering free advertising for record companies who provide promo releases as well as charitable organisations.

```
Soul/Pop

Radio Activity
■ Thrale Road
London
SW16

SW London

Mon-Fri 6PM-12AM
Sat-Sun 24 Hours
```

////PROGRAMMES//////////////////

Weekdays

```
 6PM Mark Atkins (Mon,Wed)
       Soul/Dance
     Steve Ash (Tue,Thu)
       Hi-NRG/Pop
     Trevor Dawson (Fri)
       Soul/Dance/House
 8PM Nick Harris (Mon,Thu)
       Hip Hop
     DJ Foo (Tue,Fri)
       Soul/Dance
     Gary Fuller (Wed)
       Top Forty
10PM Paul Taylor (Mon,Wed)
       Pop/Indie
     Chris Scott (Tue,Fri)
       Reggae
     Tony Henry (Thu)
       Reggae
```

Saturday

```
 7AM Pete James
       Breakfast show
10AM Steve Jenkins
       Soul/Dance
12PM Steve Ash
 3PM Trevor Dawson
 5PM Tony Henry
 7PM DJ Foo
10PM Paul Taylor
       with new releases
```

Sunday

```
12AM Mark Atkins
 2AM Toshca
       Soul/Dance
 4AM Back to back music
 7AM Pete James
10AM Steve Jenkins
```

```
12PM Nick Harris
 3PM Trevor Dawson
 5PM Paul Taylor
 7PM Gary Fuller
       Various
10PM DJ Foo
12AM Mark Atkins
 2AM Toshca
```

ARABIC COMMUNITY RADIO

Originally testing on 93MHz before the arrival of Solar, we have recently had reports of what's thought to be an Arabic station operating round about the 106ish part of the band. Despite various enquiries we've yet to establish any more...

ASIAN COMMUNITY RADIO

Asian Community Radio began broadcasting on 94.3MHz at the end of May. The station is shortly to move to somewhere in the hundreds part of the band to avoid the extreme crush at their present part of the band.

RADIO BADGER 93·2 FM

After possibly the longest ever period of testing (Badger was first on the air in December 1985!), Radio Badger finally started regular programmes in Mid-May, on 91.9MHz whilst LWR were off the air. When LWR returned they moved to a new frequency of 93.2MHz.

////PROGRAMMES//////////////////

Programmes go out nominally seven days a week to West London / Middlesex, with the following DJ line-up:-

```
 8PM Terry Peters
10PM Mike C
```

BASE 105 106·4 FM

Base 105 told Radio Today back in May of their plans to start a new service of soul / disco / pop at the start of July. This was originally to have been on 105.4MHz, but has now been changed to 106.4MHz instead. Base 105 hoped to use a high quality, 15W transmitter and CDs in their programming to give them a sound quality that would put other pirates to shame.

BRITISH GREEK COMMUNITY RADIO 105·4 FM

BGCR broadcasts programmes to the Greek Community in North London, 7 days a week.

////NEWS/////////////////////////

Raids, raids, raids, raids and even more raids. Why? Well in North London there is a certain Electricity Board relay on 105.5MHz and the Electricity Board have not been happy at having their communications interfered with by illegal Greek stations and have been making their feelings extremely clear to the DTI. As a result, BGCR have been hit pretty hard, with an average rate of one raid a week for the past couple of months. As the interference from some pirate stations is causing increasing problems for some services on the FM band, it has been reported that several are pressing for a faster move to new, less vulnerable frequencies.

```
Greek Community Radio

Address Unknown

North London

7 Days a week
7AM-1AM
```

AM/FM LONDON

CALIBER FM
106 FM

Or should that be Calibre? Either way, they came on the air on 94.5MHz on Friday 1st of May, announcing that programming would start on the Sunday on 106MHz. Since then they've been heard briefly on 94.6MHz and were reported to be trying to keep up a 7 day a week schedule, without much success. As for the frequency... take your pick!

RADIO CAROLINE

Zzzz... What?! Ah, um. Radio Caroline. Live from the North Sea with a mixture of the latest hits, classic oldies and new music.

////NEWS/////////////////////////

Not a great deal of news of late. They kicked off in May by reading out all the late arriving Christmas cards. If you want to be sure of a request this Christmas you'd better get down to the Post Office now! The past couple of months have seen quite a lot of new arrivals: Mick Williams, David Foster, Andy Robin, Jackie Lee, Paul Graham (who went under the name Johnnie Flux on Hertfordshire's Radio Neptune), Jeff Morris and Dave Wilson. However, quite a few haven't stayed and the old regulars are still very much around.

```
Pop format

Radio Caroline
New York
11518
USA

SE England

Seven days a week
5AM-1AM
```

Major story at the station has to be the move from their old anchorage in the Knock Deep Channel to a new position off the Kent coast. This change was due to the new Sea Bill increasing the range of British Territorial Waters. Because of the move, reception is down over London, and with the possibility that they may have to move even further out, the future for nightime reception doesn't look too good.

CHIC FM
94.4 FM

Chic-FM have been promising a return to the airwaves, although as yet there hasn't been much actual sign of them happening. On Sunday 7 June they reported just 10 minutes on the air before their transmitter blew up.

CLOCKWORK WIRELESS COMPANY
90 FM

Clockwork Wireless broadcasts a highly innovative mix of topical chat, comedy clips, listener participation and pop / rock music.

////NEWS/////////////////////////

After several false starts and what were assumed to be numerous technical problems, Clockwork Wireless at last seem to be getting their act together and managing to complete their two hour broadcasts. However, on June 14 they only managed 15 minutes of their Election Special and into July just 5 minutes on the 5th.

Although the signal is usually strong over much of West, North West and Central London, there is strong interference in North London from RJR and SW London from Quest.

```
Pop/Rock, comedy.

Clockwork Wireless
Suite ■
Creasy House
Tower Bridge Road
London SE1 4SL

West / Central London

Sunday 7-9PM
```

////PROGRAMMES/////////////////

7PM Terry Anderson
8PM Dave Birdman
9PM Close

For a review of Clockwork Wireless see 'Rate It' on page 26 of this issue.

COMMUNITY DEVELOPMENT RADIO
88.6 FM

CDR aims to be 'An important experiment in Community Radio', with access programmes, Black music and other specialist programming.

////NEWS/////////////////////////

CDR were going really well through much of May, with a higher powered signal reaching most of London, much improved in quality from their early days. However, in recent weeks there have been problems at the station, with them frequently off the air, and only low power at times. We haven't been able to find out the reason for this, but it would seem that they possibly suffered a raid and have had difficulty getting the station together since.

////PROGRAMMES/////////////////

WEEKDAYS

1AM Nighthawk
7AM Good Morning London
11AM Community Education
12PM Norman G.
2PM Chuck E.
4PM Alternative Cruise - L.B.
6PM Future Funk Show - K.K.
8PM Community Education
9PM Reggae Show - Sugar Ken

```
Black Community Radio

CDR
■ Byam St
London
SW6 2RB

Londonwide

24 Hours a day
```

SATURDAY

1AM Nighthawk
7AM Good Morning London
11AM Indie Show - Twizzle
1PM
3PM African Show - Prince A.O.
5PM Community Education
6PM Future Funk Show with K.K.
8PM Community Education
9PM Norman G.

SUNDAY

1AM Nighthawk
7AM Good Morning London
9AM Jazz
10AM Late Breakfast Show

LONDON

AM/FM

1PM Pork
3PM Uncle - Heavy Reggae
5PM Community Education
6PM Future Funk Show with K.K.
8PM Community Education
9PM Norman G.

RADIO CONFIDENCE 92.7 FM

Still on the air on assorted evenings to mainly West London. Although they are still announcing 92.7, the frequency has been nearer 92.2 recently, no doubt to avoid the higher powered Studio One. Confidence has an almost entirely reggae format, with a little soul.

DBC 93·9 FM

DBC continues to put out tapes from its heyday in 1981-3 every Friday night from around about 9 through to the early hours of the morning. In addition, live broadcasts usually take place on Bank Holidays and for special events, such as the Notting Hill Carnival. If you want to hear what reggae presentation should sound like, DBC are well worth tuning in to. Dunno what the Beeb think about one of their DJs still being aired on a pirate though. Reception is good mainly in the West London area, although they come in quite well over much of London.

DIRECT LINE RADIO 92·4 FM

Planning a big return to the airwaves in Mid-August with seven day a week community programming for South London (or should that be Westow Hill - only joking Dan!).

////PROGRAMMES////////////////////

DLR plan to provide two services. DLR through the day

with a pop format, local news and information, etc. and Wildside-FM through the night with more of a soul format. DJs on the station will include Danny T, Timbo, James Lawson, Tim Crushell, Nick Day, Def Jeff, Ben & Bill, Marconi, DJ Cyclone, The Godfather, Original T, Steve James, Paul Cook and The Soul Doctor.

Pop / Local Info

DLR
■ Bishops Thorpe Rd
London
SE26 4BA

South London

24 Hours

RADIO DUCK 89·8 FM

Radio Duck is London's only oldies station, with tracks from the sixties, seventies and a few from the eighties.

////NEWS////////////////////////

There's been rather a lack of Duck recently - are the Duck crew chicken? (Sorry, couldn't resist that one.) However, Stuart Price does promise us that they will be back in a big way soon. At the time of writing, Duck has been carried out a few broadcasts on Short Wave, which are likely to continue in line with the VHF broadcasts in London.

Oldies

Radio Duck
■ Church St
Stoke Newington
London N16

North West London

Sunday 5-9PM

////PROGRAMMES////////////////////

DJs on the station include Tim Allen, Stuart Price, John Silver and Mike Peters.

FLASHBACK RADIO 90 FM

Flashback Radio came back on the air on Sunday 3 May - and were promptly hit in the extremely heavy raids that occurred that day. It's likely that they may return in the late summer for some regular Sunday broadcasts, as well as their more usual holiday broadcasts. West London / Middlesex is the main area to tune in to Flashback.

FRESH FM 94·4 FM

Fresh-FM are a split from Time Radio, providing London with a 24 hour a day service of mostly reggae and soul.

////NEWS////////////////////////

Fresh began test transmissions on 14 June, and launched a week later on the 22nd June. As several of the DJs had been on Time Radio just a short while previously. Although they were saying they were on the air 24 hours a day from the start, that was probably a bit optimistic as in the early hours they've been putting out some nice, relaxing silence.

////PROGRAMMES////////////////////

DJs on Fresh-FM include Keith James (breakfast show host), Chris Johns, Mickie D, Doctor Quincy, King Soops, Special K, DJ Blacka, Errol T (host of Night Flight Excursion), Trevor de Coata, Chris Wright, Pat French, J.C., Gemma, Tony T, Doctor D and Lyndon T.

RADIO GEMINI 104·2 FM

Radio Gemini have been off the air since 7 May when they suffered a raid on their studio. It's understood that they do plan to return to the air, once they have sorted out new broadcasting arrangements.

AM/FM LONDON

```
Pop / Local Info

Radio Gemini
  ■ Gaskell St
London
SW4 6AJ

SW London

Weekday evenings
```

GREEK RADIO FOR LONDON
88·4 FM

Another Greek station? That means raids, raids and a few more raids. Despite being in a fairly harmless spot on the dial they still seem to be hit as often as BGCR and LGR. Maybe it's just that the DTI can't tell the Greek stations apart and just raid the lot of them...

Greek Radio for London are on the air seven days a week (ish) from 8AM till 8PM. And they even have time for some programmes between the commercials occasionally.

GREEN ISLE RADIO
90·9 FM

Yesilada (I think that's how it's spelled), which roughly translates as "Green Isle" Radio, is a North London Turkish station, which has been on the air on and off now for around a year. It's thought to be currently off, after being heard several times in April / May. However, it's been reported to us that we may now have now heard the end of the station as their operation did not have much chance of succeeding. But, you never know...

GROOVE-FM 98 FM

Groove-FM have told Radio Today that they hope to return to the airwaves with increased power around August / September. Recently there has only been one broadcast from Groove, as "The Station With No Name" on 2nd May.

```
Soul

Groove-FM
PO Box ■
Roehampton
London
SW15

SW London

Weekend evenings
```

HORIZON RADIO 94·5 FM

Coming from South East London, Horizon Radio is a new group, not connected with the Horizon Radio of old. Horizon managed a stretch of several weekends back in April, and were also thought to be heard one Saturday in June. The format (as if you hadn't guessed) is soul mostly of the jazz/funk kind.

RADIO INTERFERENCE 106 FM

Radio Interference is a new anarchist station, broadcasting once a week to South / Central London.

////NEWS/////////////////////////

Radio Interference were first noted on the 20 March, and since then have made fairly regular broadcasts on Friday evenings, although the full hour's programme hasn't always gone out. This is thought to be mainly technical problems, although Interference reported that they were 'visited' by Police on 5 June, and were

raided on 26 June by the DTI when two people were arrested.

////PROGRAMMES//////////////////

Programmes mainly consist of comments on current events, "what's on" information, personal anecdotes and alternative music. Interference also organises benefit gigs in Brixton to support the station, and also appeals for taped contributions to their programmes. (And they've also made a reasonable job of plastering stickers over the Northern Line).

```
Anarchist

Radio Interference
BM-■
London
WC1N 3XX

South / Central London

Friday 6-7PM
```

JBC 105 FM

JBC is Brent's black community station, on air 24 hours a day with local programming.

////NEWS/////////////////////////

Sitting in front of me I have two other contributors notes. One says just "Unstoppable" and the other "On every day that I have listened". Well, not quite. JBC were busted on Tuesday 19 May at 6.50AM. The DTI smashed down both the front door and the door to the studio and completely stripped the studios. They were back on the air within 48 hours.

////PROGRAMMES//////////////////

SATURDAY

12AM H.G.
3AM Oppa
6AM Wicked Uncle
9AM Lady V
12PM Steve Bernard
3PM Oppa
5PM Phil Allen
7PM Smokey T
9PM Desmond Roots
11PM Soca B

SUNDAY

1AM Challenger

LONDON

AM/FM

```
 6AM H.G.
 9AM T.C.
       Gospel
11AM Soca B
       R&B
 1PM Patricia
       Irish Profile
 2PM Kenny J
       Jazz
 3PM Melita Ray
       Carribbean Connection
 5PM Smokey T
       Gospel
 7PM Steve Barnard
 9PM H.G.
```

```
Black Community Radio

JBC
      ▆ Roundwood Road
Harlesden
London
NW10

NW London

24 Hours a day
```

WEEKDAYS

```
12AM H.G.
 6AM Amion Zee
 9AM Challenger
12PM Master B
 3PM Princess Asha
 6PM Lady V
 8PM Soca B (Mon)
       Mr D (Tue)
       Wicked Uncle (Wed)
       Soca B (Thu)
       Steve Barnard (Fri)
10PM Dimples (Mon-Thu)
       Soca B (Fri)
```

SATURDAY

```
 7AM Dean Savon
 9AM Dennis O'Brian
11AM Gordon Mac
 1PM Norman Jay
 3PM Jonathon More
 5PM Davey J
 7PM Colin Favers
 9PM Richie Rich
11PM Colonel Crashbeat
```

SUNDAY

```
 1AM Sammy LR
 7AM Davey J
 9AM DJ Andre
11AM Tim Westwood
 1PM Mad Hatter Trevor
 3PM DJT
 5PM Steve Jackson
 7PM Tosca
 9PM Jerry Jay
11PM Dean Savon
```

```
Soul / Dance Music

Kiss-FM
   ▆ Grand Parade
Green Lanes
Haringey N4

Londonwide

Saturday 7AM -
Monday 1AM
```

KISS-FM
94 FM

Kiss-FM is London's weekend soul station, with soul, hip-hop, house and more from some of the Capital's top underground club DJs.

Kiss-FM are now going strong again after a few problems following their return to the airwaves in March. Some DJs left the station at this point, apparently unhappy at having to pay to do a show to help keep the station on the air. There was also talk of jocks leaving to join another station en-masse. However, in the end this wasn't to be, and Kiss survived to broadcast another day. Bring back the silly adverts though!

LASER
HOT HITS

Here on the assumption that we will actually hear something from them again. The boat is reportedly going through another refurbishment off France and a large amount of money is being invested in it by the new owners. And the new boss is apparently someone we've heard of before offshore. Hmmm...

```
Pop

Laser Radio
21 Floor
515 Madison Avenue
New York
10022 USA

Southern England

7 Days
```

LONDON
COMMUNITY
RADIO
92·2 FM

A new name on the airwaves from the people who brought you South West Sound. LCR is aiming to provide a local service to the people of SW London, with local information, news on the air, sports round-ups and a mixture of soul and pop.

Kick of date was supposed to be at the start of July, but a few delays occurred on the technical front. However, we expect them to be on the air by the time you read this.

```
Pop/Local info, news

London Community Radio
PO Box ▆
Roehampton
London
SW15

SW London

7 Days a week
```

LONDON
GREEK
RADIO
105 FM

LGR is the longest establi-shed Greek station in London, with a wide range of Greek lan-guage programmes.

After being raided just about every other day since the start of the year, LGR moved transmission sites in June in the hope that this would see rather less DTI action - they were also being hit due to the interference problems over the LEB relay mentioned earlier. Although things improved a bit for a while, they recently faced major raids and lost four studios in a row. LGR have also had a much reduced signal - a far cry from when they could be heard booming in at Northampton.

Programmes normally go out daily between 8AM and midnight.

AM/FM LONDON

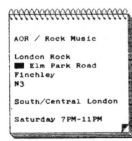

Greek Community Radio

London Greek Radio
PO Box ▮▮▮
London
N19 4SW

North London

7 Days
8AM-12AM

LONDON MUSIC RADIO
94·5 FM

Old names never die, they just get adopted. LMR is a new group from South London, putting out programmes the first Saturday of the month at midnight.

////PROGRAMMES/////////////////

12.00AM Vox Populi
 Magazine programme
12.45AM Music programme
1.00AM Meltdown Show
1.15AM Music programme part 2
1.30AM Close

LONDON ROCK
104·2 FM

London rock are on the air every Saturday with AOR tracks to South and Central London. The station has now settled on 104.2 after trying out several other frequencies around the band over the past few months. Unfortunately we don't have a programme schedule or any DJ details as yet.

AOR / Rock Music

London Rock
▮▮ Elm Park Road
Finchley
N3

South/Central London

Saturday 7PM-11PM

LONDON TOWN FM
98 FM

LT-FM is on the air every weekend with a high quality pop service to North Surrey / South London.

////NEWS////////////////////////

London Town FM was launched in May after several test transmissions. The station is made up of mostly ex-Skyline jocks and puts out a high standard of programmes, which puts many of the other pirate efforts to shame.

Pop Music

London Town FM
PO Box ▮▮▮
London
SE25

N Surrey / S London

Fri 5PM - Mon 1AM

LWR
92·5 FM

LWR brings a wide range of black music to London's airwaves, 24 hours a day, 7 days a week.

////NEWS////////////////////////

Mixed success for LWR recently. After some months of successful broadcasting they dissolved in May and June into a mass of problems, mostly technical. At one point their transmitter was relaying taxi conversations and then at the start of June Radio Caroline for a time. This led to a report on Radio Netherlands that FM transmissions had started from the Ross Revenge. Never knew it was moored in Crystal Palace.

////PROGRAMMES/////////////////

SATURDAY

12AM Jerry Francis
 3AM Don P
 6AM Scully

 9AM Chris Collins
11AM Patrick Meads
 1PM Peter G
 3PM J.J.
 5PM Cliff Ringwood
 7PM Ron Tom
 9PM Yomi

SUNDAY

12AM Maxi Jazz
 3AM Jerry Francis
 6AM Ian Easton
 9AM Chris Collins
11AM General Lee
 1PM Steve Edwards
 3PM J.J.
 5PM Neil Charles
 7PM Fuzzy Dee
 9PM Camilla

WEEKDAYS

12AM Trevor SF (Mon,Fri)
 General Lee (Tue)
 Carl Cox (Wed)
 Angie D (Thu)
 3AM Wayne Turner/Brian B
 6AM Lone Ranger
 9AM DJ Elayne
11AM Zak
 Ever noticed how it sounds
 like he's going to fall
 asleep between words?
 1PM Jasper
 3PM Jigs
 5PM Steve Harris (Mon)
 Brian Bell (Tue)
 Richard Taylor (Wed,Fri)
 John O'Bell (Thu)
 7PM Daddie Ernie (Mon)
 Steve Harris (Tue)
 Daddie Ernie (Wed)
 Wayne Turner (Thu)
 Fuzzy Dee (Fri)
 9PM Barry B (Mon)
 Jazzy M (Tue,Thu)
 Mr Vader (Wed)
 Yomi (Fri)

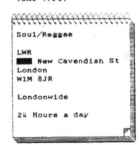

Soul/Reggae

LWR
▮▮ New Cavendish St
London
W1M 8JR

Londonwide

24 Hours a day

MELODY FM
102·4 FM

A recent arrival on the London radio scene, operating in the SE London area with a soul format. Although initially a Sunday only station, Melody has now expanded to take in much of Saturday as well. Only problem is a slightly dodgy frequency - there's a rather large police transmitter in Kent on 102.1...

LONDON AM/FM

RADIO MEMPHIS 1260 AM

Radio Memphis is London's only rock 'n' roll station, broadcasting to North London most Sundays for two hours.

////PROGRAMMES////////////////////

Just one and a half years after we first began listing them, we've finally got their programme schedule (thanks Ken).

10.30AM Memphis Mick
11.30AM The Superman Show
12.30PM Close

MRS-FM 94·2 FM

MRS-FM were on the air in April and May, but have not been on the air recently and may now have closed down. The station had several transmitter problems, which led to them being able to be received on an assortment of frequencies up the band - no doubt resulting in a rapid visit from some keen listeners.

```
Black Music

MRS-FM
■ Holland Road
West Ham
London E15

East London

Weekends
```

NETWORK 21 89·6 FM

Network 21 'The Radio' is on the air twice a week with a wide variety of alternative and orig- inal programming.

////NEWS////////////////////////

Broadcasts from NTW21 have been a bit erratic of late, after a close shave with the DTI. However, they planned to be back with regular broadcasts at the start of July.

////PROGRAMMES////////////////////

Programmes vary from week to week, with a large number of guest presenters. So, here's a taster of some of what's available...

THE MONGOLIAN HIP-HOP SHOW: Hosted by Mix Master Morris, the second Saturday of the month at 8PM.

WORLD SERVICE: Featuring North American, Australian and New Zealand releases, last weekend of the month.

BLEACH BOYS: 40s and 50s oldies, alternate Saturdays 2AM.

STIFF: Alternate Fridays 2AM.

SOPHIE: New releases and current tracks, alternate Saturdays 2AM.

TONY SMITH: 50s and 60s R&B, alternate Saturdays 11PM.

```
Alternative

Network 21
Chesham House
■ Regent St
London W1

South/Central London

Fri,Sat 8PM-5AM
```

PHASE ONE 90·9 FM

Phase broadcasts black music to South London.

////NEWS////////////////////////

After several false starts, Phase One now sounds quite established. They first took to the air in April, but had a number of problems - most notably from a rival station who kept on stealing their transmit- ters (looking for some higher quality equipment perhaps?). Requests can be phoned in to a cellular phone in the studio - bit dangerous as the controlling computers can fairly accurately pin-point the location of the phone.

```
Black Music

Phase One
■ Oval Place
London
SW8

South London

7 Days a week
```

QUEST FM 90 FM

Suffering heavily from raids the past few months. However, the DTI haven't always managed to get it right - on one occasion they turned up at what they thought was Quest's transmitter site complete with warrant and everything, only to find they'd moved...

```
Soul

Quest-FM
■ Lauriston Road
The Ridgeway
Wimbledon
London SW19

South West London

24 Hours a day
```

RFM 94·3 FM

RFM are London's leading rock station, on the air throughout Sunday and soon all weekend.

////NEWS////////////////////////

RFM have settled down into a fairly regular broadcasting routine for their Sunday (and other) broadcasts. New to the station since the last issue are Phil Thomas, Mike Adams and Steve Zodiac (who I'm sure used to be known as Ian Roberts on Hard Rock Cafe). Only problem for the station is the popularity of the 94-94.5 part of the band, which has recently seen City Radio (see UpFront), Fresh-FM, Starpoint Radio, MRS-

AM/FM LONDON

FM, Asian Community Radio and others all in the same vicinity. RFM have recently upped their power in an effort to try and drive off the opposition, but this doesn't always seem to work - some of the smaller stations don't seem to actually listen to their transmissions.

////PROGRAMMES////////////////////

SUNDAY

9AM Philip Thomas or guest DJ
11AM Steve Zodiac
1PM Dave Fuller
3PM Mark Rogers
5PM Monty Zero
7PM Claire Mansfield
9PM Dana Jay
11PM Wolffe
12.30PM Close

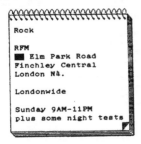

Rock

RFM
■ Elm Park Road
Finchley Central
London N4.

Londonwide

Sunday 9AM-11PM
plus some night tests

RJR
90 FM

RJR is North London's black community station, broadcasting to Haringey, Hackney, Islington and beyond.

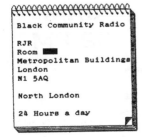

Black Community Radio

RJR
Room ■■
Metropolitan Buildings
London
N1 5AQ

North London

24 Hours a day

RADIO
SHOESTRING
91·9 FM

Back on the airwaves of East London again. Shoestring

suffered a raid on 5 May, but are thought to have returned not long after. When we were last in contact with the station they were broadcasting on Monday, Wednesday and Friday evenings, but were hoping to begin transmissions all weekend from Friday to Monday - hence Shoestring-FM. DJs on the station come from the Shoestring of old, plus a couple of ex-Skyline jocks and play an across the board mix of music. Oh, and they were last broadcasting on 94.4 (forgot to change the title).

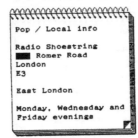

Pop / Local info

Radio Shoestring
■ Romer Road
London
E3

East London

Monday, Wednesday and Friday evenings

SINA
RADIO
91 FM

Sina Radio provides Asian programming for the communities of West London.

////NEWS/////////////////////////

Sina Radio have recently upped their power, and are coming through much stronger across the West side of the Capital. The station is on the air 24 hours a day, with a mixture of English and Hindi programming.

SKY-FM
91·7 FM

Sky-FM provides a black community radio service for Central South London.

////NEWS/////////////////////////

Sky have been on the air now since the end of March, and seem to be staying around despite some problems from the powers that be. Although the presenters sound somewhat inexperienced at times they have a lot of enthusiasm, and make a change

from some of the club DJs on other stations. Given a bit more time, they could have the potential to turn into a South London JBC.

Sky have been running AIDS awareness and anti drugs campaigns. Advertising from local businesses is increasing - but be warned, you may still hear Mark Damon voiceovers!

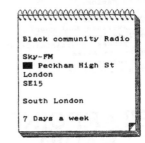

Black community Radio

Sky-FM
■ Peckham High St
London
SE15

South London

7 Days a week

SOLAR
RADIO
93 FM

Solar Radio 'The Best FM' is on the air with the softer, classier side of soul every weekend.

////NEWS/////////////////////////

Solar seem to have hardly missed a weekend for ages, and have certainly re-established themselves as one of the London radio leaders. To regain the top position in London, though, they really need to get back to 7 day a week operation, something they don't seem very willing to do. They have also recently had a split in the station, with several DJs leaving to join other stations.

Soul

Solar Radio
Unit ■
■■■ Wells St
London
E9

North London

All Weekend

////PROGRAMMES////////////////////

SATURDAY

6AM Andy Bailey
9AM Jim Colvin
 With the American Radio

LONDON AM/FM

```
        report at 11AM
11.30AM Mark McCarthy
  2PM Graham Gold
  5PM Jez Nelson
  7PM CJ Carlos
  9PM Adrian Sykes
 11PM Les Adams
  1AM Robert Allen
  4AM Hector Selector
  7AM Clive R
        Gospel
  9AM Tony Monson
 11AM Dave Collins & Barry Stone
  1PM CJ Carlos
  3PM Brian Hurst
  5PM Mark Wells
        American soul chart
  7PM Jude James
        Echoes Streetsales Chart
  9PM Robert Allen
        Reggae
 11PM Nicky Lawrence
```

STARPOINT RADIO 94·3 FM

Starpoint Radio have recently returned to the air after several weeks off after a few financial and technical problems. They're now aiming to operate weekends only, although their first few attempts doing so saw several breaks in transmission and rather a dodgy signal at times. Let's hope they manage to get their act together again as they've always managed a much wider range of music than some of the other stations.

```
 Black Music

 Starpoint Radio
 █ Stockwell Road
 London
 SW9 9SJ

 Londonwide

 Weekends
```

STUDIO ONE 92·8 FM

Studio One provides North London with a soul service.

////NEWS/////////////////////

Studio One were having a few difficulties earlier in the year, with several heavy raids

at the station, including one at their studio when the DTI reportedly turned up with what seemed like half of North London's police force! The reason for this concentration of activity on them was apparently that they were interfering with aeroplane communications in the area. More recently they seem to have been on the air with a better signal, hardly missing a day. Musically they seem to have gone overboard on rare groove when I've been listening, and put out material that's often different to what the other stations are currently doing.

```
 Soul

 Studio One
 █ Hayling Close
 Stoke Newington
 N16

 North London

 Mon-Fri 6PM+
 Weekends 24 Hours
```

TIME RADIO 103·7 FM

Time Radio broadcasts black music to North West London 24 Hours a day.

```
 Black Music

 Time Radio
 █ Harlesden High St
 London
 NW10

 North West London

 24 Hours
```

TKO 90·6 FM

TKO broadcasts soul to London, 24 hours a day.

////NEWS/////////////////////

Despite the best efforts of Radio Three listeners, TKO is managing to keep up a 24 hour schedule with little difficulty.

The presentation quality these days is rather higher than it used to be, including a few names from the past. Raids at the station don't seem to have been very frequent recently, and when they do happen, the station usually manages to get back on the air within a very short space of time.

////PROGRAMMES////////////////

SATURDAY

```
  9AM Kevin Wilkin
 11AM Keith
  1PM Andy Smith
  3PM Dave Stewart
  5PM Danny Mac
        Pick of the chart show
  7PM Paul Dodd
  9PM Aitch
 11PM Melodie
```

SUNDAY

```
  9AM Kevin Wilkin
 11AM Keith
  1PM Andy Smith
  3PM Aitch
        Jazz
  5PM Louie St Clare
  7PM Nick Chemist
  9PM Melodie
 11PM Sister J
```

WEEKDAYS

```
  7AM Mark Sebastian
  9AM Mike A
 11AM Mike G
  1PM Sean Lewis
  3PM Ray Bradshaw (Mon,Wed,Fri)
        Louie St Clare (Tue,Thu)
  5PM Roberto
  7PM Tony Bevins
  9PM Danny Mac / Nick Chemist
 11PM Mr Magic/LJ/Funk Frank
```

TRAFFIC JAM 98 FM

AKA Traffic Radio, with reggae for NW London.

////NEWS////////////////////////

Traffic took to the airwaves on the weekend of 4/5 April on 106MHz. Towards the end of April they then moved to 97.9. Since then they've been on nearly every day - not a bad record. Musically, Traffic plays mostly reggae, although they do throw in some of the softer soul tracks. Recommended on a Sunday is their jazz programme between Midday and three. Also, Saturday nights are presented by female DJs under the title 'Ladies in the Groove'. Unlike just about everyone else, Traffic is, so far, commercial free.

AM/FM LONDON

```
vvvvvvvvvvvvvvvvvvvv
Reggae

Traffic Radio
■ Goodrich Road
London
SE22

NW London

24 Hours a day
```

RADIO VICKY 105·2 FM

Not heard recently - with the raid on neighbours Radio Gemini, it seems like they may be keeping their heads down. Broadcasts in the past were on Tuesdays from 6PM til 8.30PM to South West London. DJs on the station include Marty D, Terry and Scotty G. Musically, Vicky plays everything from the fifties through to the latest Top Forty.

VOICE OF LONDON TURKISH RADIO 1611 AM

The Voice of London Turkish Radio has been on the air for a couple of years now, with seven day a week Turkish programming to the North London area.

WLFM 106 FM

West London FM broadcasts to West London / Middlesex on Tuesday nights with a pop music format.

MERSEYSIDE

Radio Atlantis	936 AM
CD-FM	105.5 FM
Central Radio Intnl	1404 AM
Concept Radio	104.3 FM
Decibel Trans Intnl	106.1 FM
Horizon Radio	105.3 FM
Radio Julie	104.8 FM
L'pool Pirate Radio	1404 AM
Radio Merseyland	1395 AM
Mersey Sound FM	105.5 FM
Radio Merseywaves	1242 AM
Network 9	90.2 FM
Radio Scott	102.3 FM
Slag Off Intnl	105.2 FM
Radio Veronica	104.6 FM

It appears that the DTI squads are often these days alternating between Liverpool and London - while all is calm in London, Liverpool is getting it. Atlantis were aiming to broadcast 7 days a week, but after a raid are back to a long weekend operation. Radio Merseywaves continue as the country's leading Medium Wave pirate, and with a high standard of programmes. The rest of the stations are, on the whole, less predictable in their broadcasting habits.

NORFOLK

A report just in tells us that there's a pirate station now operating in Ipswitch - oh **** that's in Suffolk isn't it! Erm, well we don't know what they're called anyway.

NORTHANTS

Radio Ditchford	107.0 FM
Radio Susan	102.5 FM

Radio Susan has been on the air for some time now to Wellingborough each Sunday from 10AM till 8PM. Radio Ditchford is a recent arrival - no more details are known.

SALOP

Wrekin Radio	105 FM

Wrekin are off the air until the end of August for summer holidays. They broadcast on Sundays from midday till three.

SOUTH YORKS

Monica Sound	105.5 FM
Music Weekend Radio	105.0 FM
Radio Nemesis	107.0 FM
Ocean Sound	106.3 FM
Rebel Radio	105.3 FM
Z-FM / Radio Julie	102.4 FM

A sudden surge of activity in this area. Monica Sound are broadcasting in the Barnsley area with a mixed format. Music Weekend Radio play mainly oldies on a Friday night from 10 till 12.30. Radio Nemesis broadcast with a soul format on Saturday afternoons. Ocean Sound have recently returned after closing down temporarily to avoid people with radios tracking them down all the time and giving them heart attacks! Rebel Radio are the most recent addition, so recent we don't know anything about them at all. Radio Julie, formerly Z-FM, have not been heard for a while after being picked up at the start of June.

STAFFORDSHIRE

AD87	106.0 FM
Soul City Radio	103.3 FM

A slightly more original name than some, AD87 are broadcasting on a Friday night in Stafford. Soul City Radio (yucky name) are now broadcasting alternate Sundays to Stoke on Trent and the surrounding area.

WEST MIDLANDS

Cont Music Radio	94.2 FM
PCRL	103.3 FM
Second City Radio	93.0 FM
UK Radio	105.3 FM

Second City Radio is new to the airwaves, broadcasting reggae and soul to Birmingham, currently weekends only. The signal is reported to be rather better quality than PCRL - the longest running black station in Birmingham. Continuous Music Radio is even more recent and, surprise surprise, plays only continuous music. The station features mainly rock music with a fair sprinkling of heavy metal.

WEST YORKS

ABC-FM	94.6 FM
Music City Radio	90.4 FM
Radio Radar	104.5 FM
Radio Veronica	104.8 FM

ABC-FM are now on the air to Leeds 7 days a week, usually in the afternoons only during the week, although they've started to edge towards the mornings now as well. Music City Radio have also extended their hours, with the competition from ABC-FM. Both have black music formats. Pop music in the city is from Radio Radar, whose broadcasts are a bit more intermittant than the rest. Radio Veronica from Bradford broadcast each Sunday evening, with a mixture of chat and music. Makes a change these days - whatever happened to the art of conversation... They've also recently added a medium wave frequency as well, on round about 1008KHz.

Special thanks go out to the following for helping with this report: Neal West, Eric Smith, Radio Delta, Keith Stafford, Ken, Clive and Anoraks UK.

UK AM/FM

Travelling or live outside London? Well, this section of Radio Today is designed to tell you what's available on the illegal airwaves throughout the rest of the country. Any additions to the list, or extra details, are greatly appreciated. Call them in on 01-400 8282 or write to AM/FM, Radio Today, BCM Box 225, London, WC1N 3XX. For the next issue we hope to expand this section further. The editor has also been given a geography edition since last time - Scunthorpe in North Yorkshire indeed!

CO ANTRIM

B-96	96 FM

Broadcasting to Belfast with a mixed format of music.

AVON

Radio 103.5	103.5 FM
BAD Radio	106.5 FM

Radio 103.5 continues with its mixture of comedy programmes and a rock service. Bristol Amalgamated DJs is a new black music station.

BERKSHIRE

Radio RS	104.2 FM

Some action in Reading again, from Radio RS with a soul format, broadcasting occasional evenings.

CHESHIRE

Chester CR	104.2 FM
WFM Widnes	??? FM

More information on these, or any other stations is always appreciated.

DERBYSHIRE

Radio Freedom	105 FM/1242 AM
N Midlands Radio	104.9 FM

North Midlands Radio broadcasts on a Sunday morning from 9.30 till 12.30PM. Although the frequency is announced as 104.9, they were heard by our reporter on 105.5. The format is mostly oldies. Radio Freedom from Derby broadcasts on a Sunday afternoon and have recently added an FM outlet. The station has a rock format and hours are from 2PM till 6PM.

DEVON

Radio Insomnia	103.0 FM

What seems to be the lone pirate in the South West, broadcasting every evening with a wide variety of music.

EAST SUSSEX

ABC Radio	97.8 FM
Radio Atlantis	105.0 FM
Radio Orion	105.3 FM
Sky-FM	105.6 FM
Southdown Radio	105.6 FM
Radio Sovereign	105.0 FM

ABC Radio have made a move to 97.8MHz, and so far seem to have been left alone more on this frequency. Mondays from 7PM is the time. Radio Atlantis are back on the air once more from 7 till 9 on a Sunday evening. Orion hope to return, following a recent court case. Sky-FM are new, keeping the same hours as Atlantis.

ESSEX

Canvey Radio	93.1 FM
Culture-FM	105.5 FM
Radio Galaxy	90 FM
Hot-Wire Radio	105.8 FM
ICR	?? FM
Radio Lola	105 FM
Music Machine	104.8 FM
Power 105	105 FM
Rainbow Radio	105 FM
Southend CR	92.8 FM
Sunshine Radio	90.8 FM

Quite a hive of activity in this part of the world these days. Canvey Radio have suffered from a lot of DTI problems, but managed a lucky escape when the DTI turned up with a warrant for the wrong address (what, again?). Hot-Wire has closed down temporarily. ICR, who've been off the air for quite a number of months, hope to return soon. Rainbow Radio make occasional broadcasts, as they have done for a couple of years now. They used to be more regular until a nasty experience with some people from the nearby BBC training centre. Radio Lola were heard broadcasting as CFM recently, whether they'll stay under this new name isn't known. Music Machine are testing at odd times, also on 1566AM at times. Power 105 hope to return after a court case following a raid in March. Finally, Southend Community Radio and Culture-FM are two newcomers to the air.

GLASGOW

Radio Mercury	96.3 FM
Neon Radio	98.5 & 99.4 FM
Radio Unicorn	103.2 FM

Radio Unicorn are new on the air, thought to be with a general pop format, and with a signal blasting out across the city. Radio Mercury are on the air at various times, usually Sundays and Wednesday evenings. Mercury is the longest established of the stations, having now been on the air for several months. Neon Radio is lower powered, but usually uses several transmitters operating in different parts of the city.

HAMPSHIRE

Radio Delta	95.4 FM

Radio Delta broadcasts to the NW Surrey / NE Hants area on Sundays between 2 and 4PM. The station hopes to expand the hours and bring in live programmes once they've sorted out a suitable transmitter site - rather a shortage of tower blocks in the area! They're also interested in hearing from any other broadcasters in the area - we'll pass on your letters if you write to us.

HERTFORDSHIRE

FAS	105.5 FM
Radio Fiona	1584 AM
Radio Neptune	1566 AM
Newtown Radio	90.9 FM

Radio Fiona continue to make occasional Sunday morning transmissions. Radio Neptune were also back recently for a one-off broadcast. Newtown Radio continue regular Sunday broadcasts, from around 10AM though to 8PM with a mixture of music from soul to pop to rock in Stevenage. The signal these days manages to stretch over quite a wide area of Hertfordshire, only hindered by the fall-out from TKO and Phase One. FAS - Funk And Soul - are on the air most Sunday evenings from 5PM, though less regular of late.

HUMBERSIDE

WLNG	104.9 FM

Right county this time. Broadcasts go out on Tuesdays with programmes, mostly chart material and oldies but incorporating local music and news.

KENT

Radio Atlantis	103.7 FM
Reel To Reel	105.3 FM

Radio Atlantis continues to broadcast most Wednesday evenings in the Maidstone area. Reel To Reel have recently been heard on Short Wave too, despite a rather close shave with the DTI not long ago.

MANCHESTER

IBC	104.4 FM
ICR	103.5 FM
Sunshine-FM	91.8 FM

Sunshine Radio broadcasts every Saturday night for three hours from 8PM. IBC have made a few test transmissions, though nothing much seems to have come of them so far (funny how the stations that make the most noise have the least to offer). Independent Community Radio make it to the air most weekends.

TX16: NOVEMBER 1987

NEWSDESK

Pirate Boss on Menaces Charges

The boss of Prime Time Radio has been sentenced to 200 hours community service by Isleworth Crown Court for demanding money from a former DJ on the station.

The offence occurred after the station suffered two DTI raids and equipment worth £1,200 was seized. Prime Time's boss jumped to the conclusion that one of his DJs tipped off the DTI about the location of the station.

The DJ claimed that he was dragged into a car and taken to the station's studio at a flat in Southall where he was attacked with a rolling pin and a demand for £1,200 to replace the confiscated equipment was made. The DJ also alleged that he was threatened with being shot in the legs if the money was not handed over.

Prime Time's owner denied all the charges and said the DJ went voluntarily to the flat to discuss posters he had agreed to design.

He was found guilty of blackmail and demanding money with menaces, but acquitted of abduction and false imprisonment.

Hurricane Strikes London Radio

Many of London's stations were taken off the air in the gales of 15 / 16 October.

LBC was worst hit when the cooling system on the station's emergency generators failed and they had to resort to broadcasting from a temporary studio outside their headquarters. Telephone lines were also out of action causing further problems. Capital was the only station on the air throughout, though there were breaks on VHF along with LBC who share its Crystal Palace transmitter site. Radio London opened early at 5.30am with its Rush-hour programme.

London's pirates were also hit, mostly due to power failures at both studio and transmitter sites. Direct Line Radio and London Rock both had their aerial masts split in two. RFM only managed to repair its aerial system a few hours before the start of their usual Sunday broadcasts. Almost all stations were back on the air by Sunday.

Radio Ships The MV Ross Revenge and MV Communicator were subjected to winds of over 120mph and seas rising to over 70ft. Some damage was caused to the boats, and Caroline was forced to abandon broadcasting when its transmitter kept tripping out due to the large spray.

Update

- A Survey into what listeners want from radio has shown little interest from the general public in community radio, except for ethnic stations.
- The DTI have reported that there are problems with the increasing use of 'link' transmitters by unlicensed stations. They say that these only come to light when they cause interference to other services
- New independent stations are on the cards in 13 areas throughout Britain, including Aylesbury, Milton Keynes and Hertford & Harlow.
- Country music is planned for an after midnight service on Radio Caroline's second transmitter, shortly to move from 963KHz to a clearer channel.
- Turkish Community Radio had a successful special event broadcast at the Enfield Show in August. The Home Office licensed a 50 milliwatt transmitter for the duration.
- Solar Radio hopes to begin 7 days a week programmes as soon as is practicable.
- London's hip-hop fans, get a better deal from the radio when Ice House, 'your chillin' centre', launches in November.

DIARY

Sunday 2 August TKO are taken off the air when reportedly they have their aerial ripped down and transmitter stolen by an unknown group. Faze1 has their transmitter stolen just before 9am, the link receiver being dropped in the hurry to get away.

Friday 7 August Starpoint Radio returns to the air, fearing that they won't be able to find a frequency if they delay the return any longer.

Saturday 8 August London Rock begins relaying its programmes on 94.3 via RFM's transmitters. Tests in the week with DJs from the stations conversing over the channel lead to complaints from other stations.

Tuesday 11 August Faze One lose their studio and transmission equipment and have their aerial mast taken down, with a large Police presence. Sky Radio also lose a studio.

Friday 14 August To commemorate the 20th anniversary of the Marine Offences Act, Flashback '87 broadcasts an eight hour special looking at the pirate radio from the fifties to the present day. Sky Radio is raided again.

Monday 17 August Solar begin their long weekend broadcasts, with programmes now running from the early hours of Saturday through to the early hours of Tuesday. Greek Radio Of London is raided.

Tuesday 18 August Quest FM is raided at 10.50pm by three DTI officers with no police present (too busy training for the next football match?). London Asian Radio begins testing on 104.2MHz.

Saturday 22 August Lightning strikes Quest FM's transmitter, hitting one of their DJs who was holding it at the time. Raiders FM, an off-shoot from the short-lived London Town FM, is launched with pop and specialist music programming.

Sunday 23 August Raids take place at Solar 93, Kiss FM, Studio One, City Radio, Fresh FM and WNK. Quest FM returns at 6.30pm.

Tuesday 25 August Quest FM is raided yet again. Girls FM returns on 96.9MHz.

Thursday 27 August RJR and City Radio are both raided again.

Friday 28 August Solar and Kiss FM both switch on early for the Carnival weekend. They are both raided, along with British Greek Community Radio.

Saturday 29 August Solar and Kiss FM both return. On the air especially for the Notting Hill Carnival is TPA, as well as a live broadcast from DBC.

Tuesday 1 September Late night raids at Quest FM and TKO.

Friday 4 September Horizon '87 mutate into Chicago '87 with a return to the airwaves with 7 day a week programmes.

Monday 7 September More late night raids, this time at Solar and Rock 2 Rock.

Thursday 10 September Sina Radio boost their signal bringing their Asian programming on 90.8 to more people.

Friday 11 September The DTI spend part of the day in court nailing jocks from Studio One. When the case has to be adjourned they go off and raid RJR, Faze 1, Kiss FM, City Radio and Studio One.

Saturday 12 September Girls FM returns on 97MHz. BGCR is busted. TKO moves back to their original frequency of 102.4MHz.

Tuesday 15 September A trip out to West London for the DTI where Radio Badger is busted.

Thursday 17 September And back to North London and WNK.

Friday 18 September Lightning strikes at Studio One and Kiss FM.

Monday 28 September First reported hearing of new soul station Touch FM. WNK and BGCR are raided.

I SPY

'It's ten past eight on a sunny Sunday and you're listening to the big one across London Town, with sssssssssssssssssss'

How many times has that happened to you? There you are, happily listening to your favourite pirate station when it suddenly vanishes from the airwaves. Another victory for the Government's Radio Police, the DTI. But why are they taking off the air the station you love, and what will be happening behind the scenes?

Well, it all begins a long, long time ago, back in the days before Tony Blackburn discovered sex. In those days, the only way that people living in the UK could get the music they wanted was by DJs sitting in a boat three miles off Frinton (best place for them said some people) and getting seasick. This angered the Government (and the cleaners) and so they brought in the 1967 Marine Offences Etc. Etc. Doing Things With Strange Looking Boats In The North Sea Act.

Then, one day an electronics freak came along and decided that if you could broadcast from a boat, then why couldn't you broadcast from a bedroom. You didn't get seasick, it was much cheaper, and you didn't have to feed your staff, just buy them an occasional pint down the pub.

SUBVERSIVE

However, the Government in its infinite wisdom had come along some time previously and brought in a law called the 1949 Wireless Telegraphy Act. They'd reckoned that if they weren't careful, everyone and their dog would soon try and start up a station, leading to potential anarchy on the airwaves. Even worse, some subversives might try and use radio to put across their political views and bring about the downfall of the Government and possibly the end of civilisation as we know it!!!

And so, the 1949 Act was introduced: 'No person shall establish or use any station for wireless telegraphy except by the authority of a license granted by the Secretary of State, and any person who establishes or installs or uses any station for wireless telegraphy, except under and in accordance with such a license, shall be guilty of an offence under this Act'. (Translation: if you haven't got a license, we shall be forced to do horrible things to your bank balance.)

Several decades and two botch jobs on the original act later (including fixing a gaping loophole that prevented it working), we arrive in 1987. Instead of the General Post Office, we have the Department of Trade and Industry's Radio Investigation Service spending a large amount of time and effort trying to silence a growing army of unlicensed broadcasters. With only four main investigators to cover London - Eric Gotts, John Garlic, Brian Holder and David Mason - they're having their work cut out to do so. As fast as they plug one leak, another opens. Against all odds, their work goes on...

YOU'RE BUSTED!

If you're a regular reader of Radio Today, you'll know by now that most stations use remote transmitters at unmanned sites (either rented premises or on top of council tower blocks) with a complex series of hidden links to a secret studio. In most raids the DTI just take the main transmitter: quick, painless and cheap. Finding studios usually requires slower, more complex (and expensive) investigations. All this leads to most raids fitting into standard patterns...

LIGHTNING RAIDS

Ah, a nice quiet Sunday. Sitting in the garden reading the Sunday paper and listening to some of your favourite music on the radio. Until the station vanishes. You retune. And that vanishes. You retune again. And that vanishes too. Yep, the DTI are out there dashing round London carrying out a series of lightning raids.

While you're relaxing, two teams of three investigators each are attempting to clear as many naughty stations as possible off the band. They'll have been up at 8am (yes, it does exist on

Sundays), and one of the teams may have collected Mr Gotts' favourite toy: an eighty foot crane. This he uses to remove stations aerial masts - which due to their height are tricky to take down manually.

SMASHING UP AERIALS

When they've got the crane with them, the other team will concentrate on stations broadcasting from council tower blocks. This is a nice easy task for them: they don't even have to get warrants as they are public property. It's simply a matter of parking outside, going up in the lift (or walking up as it probably isn't working), opening the door to the roof (made easier as all the locks are the same for fire brigade access), picking up the transmitter, smashing up the aerials and departing. 15 minutes at the most. (They're supposed to leave a receipt, but we won't quibble over procedures.)

By late evening the airwaves will seem quite empty - how else could they can get you to listen to Robbie Vincent!!! The only stations left will be those they consider 'sensitive' to raid, or are too difficult. For example, if they've got to raid a studio in an inner city trouble spot to get the main rig they won't usually bother.

F O R

INTERFERENCE RAIDS

Especially if you live nearby, you've probably noticed that a few stations aren't only broadcasting on the frequency they're giving out... you can also pick them up in regular intervals all up the band!!! Or they might be so loud that tuning in to the station next to them you can still hear the rhythm of the music they're playing in the background. They might also be causing problems to transmissions you can't pick up on a normal radio.

All these result in rather more attention being focussed on a station than is usual, particularly if the interference is being caused to emergency services or aircraft. Most of the one-off raids that take place during the week are because of interference problems.

STUDIO RAIDS

The music quickly fades. There is a silence. Then that too is replaced by a hiss. A raid on a pirate station's studio has just silenced it from the airwaves.

RADIO TODAY REPORTERS EXPOSE THE GOVERNMENT'S RADIO POLICE

The DTI have never been tremendously good at finding stations' hidden studios, relying mostly on sitting around in cars for long periods of time, hoping to recognise a face. The secret links from studios to transmitter sites are usually complex enough to make this the only way they can locate them. Sometimes they'll be lucky and find a station using an easily traceable UHF link, or with the transmitter sitting next to the DJ - but not often.

T H E

Eric Gotts and Mr Davies, the DTI's prosecuting counsel emerge after taking a break from their hectic schedule.

RECORDS NOTED

Having eventually located a station they'll want to make sure they can successfully prosecute the people they'll find. Usually four, but sometimes three, of the investigators will sit in a car near the studio for up to an hour before they make a move. All the records and commercials played on the station will be noted down during that time (they've yet to strike during a rare groove show).

When they do decide to make a move, one of the investigators will remain outside, while the others go in with walkie talkies on standby so they can radio for help if necessary. At some stations they will take the precaution of always having police with them. They'll usually knock on the door first, but if there isn't a rapid answer the occupant my find the door being smashed down.

Once inside, one of the investigators goes for the mixer and turns down all the channels, and then begins switching off the equipment. Meanwhile, another will caution station staff and show the warrant which entitles them to search the premises. Stations being raided for the first time may find that the DTI have forgotten to bring a warrant with them. Occasionally, it may be for the wrong address. If so, then they are entitled to turn them away - though in the past it has sometimes taken a complaint to Police officers present to get them to do so.

Entrance over, and realising there is not going to be any trouble, the DTI usually relax slightly. One of them, usually smooth-talking Eric Gotts, then begins asking questions. Although the DJ may not realise it, thinking it's a casual conversation, notes are written up afterwards and used in court as evidence. 'Those the adverts over there? How many of those do you play an hour? What DJ's on after you? That the station's schedule?' Countless DJs against whom the evidence would otherwise be slim, have talked themselves into being guilty.

PHONES CONFISCATED

The DTI are entitled to take anything that could possibly be connected with running a radio station, now or in the past. This effectively entitles them to take everything (they especially love non-BT telephones - sometimes it's better to rent). They will make a particular point of finding the records they have heard played in the time up to when they decided to strike.

The equipment will all be labelled and a receipt given to the DJ - though some stations have found that it needs to be checked carefully to make sure it does include everything... One empty room later, and the DTI depart: 'See you in court'.

IN COURT

Many weeks later, a summons will arrive at the DJ's home - they must press charges in six months or they have to give back all the equipment and drop the charges.

Unlicensed broadcasting is a summary conviction, taking place in a magistrates court (except in certain circumstances). The DTI have to try and prove that the defendant has installed or used unlicensed transmission equipment, assuming they haven't pleaded guilty. Usually this will be through finding them in the vicinity of a transmitter without a reasonable explanation, but it's not always that simple. The truth may also get a bit distorted along the way in their attempts to try and get a conviction...

If they are successful (and courts usually take their word against the defendant's) then the defendant faces a maximum fine of £2000 and/or a three month prison sentence. The DTI will also press for costs. Most courts only award legal costs and, despite pressure from the DTI, have refused costs for the time spent in carrying out the investigation. However, in two recent cases they finally succeeded, the defendants footing pretty hefty bills at the end of the day.

The size of fines varies from court to court. Highgate and Camberwell are probably the toughest in the country, seeing the largest numbers of pirates through their doors. What equipment is confiscated also varies. Records and tapes MUST be returned, studio equipment SHOULD be returned (it may take an appeal) but transmitter equipment will NOT be returned.

D T I

And while all this is going on... back at the station, broadcasts are continuing again. New equipment is installed at a new location and everything is happily ticking along.

So, next time your favourite pirate station suddenly goes dead, think about all that could be going on behind the scenes in another part of town. But don't worry... they probably won't be away for long.

LIKE CLOCKWORK

ALEKS WRIGHT TURNS THE SPOTLIGHT ON TERRY ANDERSON AND DAVE BIRDMAN

The Clockwork Wireless Broadcasting Company has been on the air for over 10 months. But its history goes back a lot further than that.

The two main presenters, Terry Anderson and The Intrepid Birdman, have been in the pirate radio game for the last decade.

· TERRY ANDERSON

Terry - tell me about the show. It's very different from anything else on the radio.

Yes, it's very difficult to say how it come about really. I start with a blank sheet of paper and it goes on from there.

I heard Maureen Lipman, the actress, on the radio the other day. She was saying about how when the deadline approaches she finds herself on the very morning that the thing has got to be in she gets this panic attack. I have a sort of minor one each week, thinking that

I just am not going to be able to do this, and the in all sort of seems to flow when you know that time is running out.

How would you describe the show? Is it comedy, topical comment, is it a music show with chat?

Mmm, it's probably all of those things together actually. It's really a pot-pourri and that's probably the best description. The music is quite important in its own right, though. I think that an hour of stream of consciousness would probably not be all that edifying. The comedy is quite difficult, when you have to come up with the whole show virtually by yourself. Coming up with comedy or funny bits each week can be quite hard going.

I feel - I know it's a cliche - that it's an exaggerated version of the way I am. I just come in and do an hour of how I am in real life. Exaggerated and pushed up a bit, but not really anybody else's ideas.

I hope it's different from anything else that you can hear. It does take quite

an amount of work to do, although perhaps it sounds very thrown together. I find that each Sunday at eight, when my programme finishes, that I'm already thinking about what on earth I'm going to do next Sunday. I start thinking of ideas right through the week. The good thing is now that it's been running for a year it's taken on a being of its own - not that it runs itself, but that there is a sort of structure running through it.

Who would you describe as your influences?

I don't honestly think that I've been influenced by any other broadcaster directly - there may be sub-conscious influences and perhaps I'm not the person to gauge who they are. People I respect, and possibly draw from, are people who are good at what they do - not necessarily in broadcasting though. People like Tony Hancock, Kenneth Williams, great British comedians, people with a real skill.

What are your ambitions - how do you see your show developing?

That's a difficult question. I think that the show has developed from the very first weeks on Clockwork, but it hasn't developed to a plan. As I said before, it almost has a mind of its own. It tends to flow, changing slightly week by week - a nuance here, a nuance there. It changes as it goes, rather than being part of a five year plan or something.

What kind of music do you like?

I really do have quite catholic tastes. At the moment I like quite a lot of the bands that turn up in the independent charts but don't find their way into the Top Forty. I think that there is a need for exposure of those bands because they're caught between two stools. They don't make it to Radio One / Capital Radio daytime type programming and they're not weird enough for John Peel. In between there's an opening for these sort of bands. There are some very good bands around not getting the exposure.

Also I quite like a lot of opera and classical music... Handel, Mozart particularly - that's what I listen to at home.

Terry Anderson at work in the clockwork Studio

It's about great performers, it's what we were saying earlier about comedians and actresses. I like people who are good at what they do, Prima Donnas in the true sense of the words.

I have a sort of minor panic each week

I like contemporary bands, my all time hero is Todd Rundgren. I think he's very underrated... he's never had the exposure or acclaim that he's deserved. Joni Mitchell, Suusanne Vega, Rikki Lee Jones, people like that. People who've maintained a high standard in their art over a number of years really. They give it that unidentifiable something that gives you a feeling that perhaps you don't get from Bananarama or Pepsi and Shirley.

What is your most memorable moment on pirate radio?

You know how when someone comes into a lift you move out of the way to let them in? Well, I was in a tall building, I can't quite remember why now. I was coming out of the lift with somebody else and as I walked out, other people were coming into the lift. Well, I recognised them but to my relief Mr Gotts didn't recognise me. He was going up as I was going down, we just passed each other in the lift with a smile. Fortunately we haven't met again since.

What happened to Uptown Radio?

It didn't die really, it just faded away. It had gone as far as anyone could take it and it had got to the point of turning up on a Sunday and saying 'Well, here we go again'. It ended at the right time really, there wasn't any further for it to go within the structure that it had. There were more things that I wanted to do, but because of the restrictions of clandestine radio at that time, you simply had to face up to the fact that you couldn't do them. You couldn't risk having live guests in the studio, not people you wanted anyway. By then I'd been doing programmes for 4-5 years without a break and it just reached its natural time to fade away and did. I still see some of the people that were involved though.

THE INTREPID BIRDMAN

Birdman, what inspired the start of Clockwork?

Lethargy and boredom basically. Didn't have anything to do on Sundays.

So you thought you'd start up a radio station?

Well it was either that or commit a crime. Thought we'd settle for that really.

How would you describe the station... how would you describe the sound of Clockwork Wireless?

Dubious at best, brilliant at worst. It's a pot-pourri as someone once said of it.

How would you describe your show?

It defies description really, it doesn't fit into any of the established catagories. You could say that it was thought provoking - or you could say that it was totally lunatic. That's how I think of it, just lunacy.

When you do your show, do you see a listener that you aim at?

No, not really. On the odd occasions when I've met listeners I've been profoundly disappointed.

Most of us first heard you on Thameside Radio. What happened to Thameside?

I think it died in the terminal throes of apathy. It had gone on for too long. It was a jolly good station but it ran out of ideas. It also started getting badgered rather too much by the authorities and when they'd finished badgering us the internal struggles were becoming pointless. It just died.

I just like to hear my voice on the wireless, that's all

How about you? Tell us about the other side of the Birdman.

There isn't another side. This is it.

What about your motorcycles?

Well I motorcycle a lot and to that end I have a Triumph for when I'm feeling terribly enthusiastic and really into motorcycling and a BMW for when I actually want to get somewhere without being smothered in oil.

What does the Birdman eat?

Anything that comes to hand. Inconvenience foods mostly - I eat an awful lot of pizza, a ridiculous amount of hamburger and occasionally when I really want to treat myself, a steak.

What kind of TV do you watch?

Anything really. Mostly old 1950s science fiction movies. If I can't get those then old 1950s horror movies which are even better.

What do you listen to on the radio?

Nothing.

The Intrepid Birdman gets ready to fly again.

I eat an awful lot of pizza

You don't like radio?

No, radio is wonderful. It's the best possible medium because it does allow the mind to work; but unfortunately a great many of the stations are not using it to its fullest potential - with the possible exception of Radio Four.

There's really not much going on out there. Capital has become a meaningless string of things to put between commercials. Radio One is a meaningless string of things to put between adverts for Radio One. They don't actually have adverts at the moment so they settle for promotions instead.

What are your ambitions - how would you like to see the station develop?

I'd like to see it develop into a multi-million pound exercise where we're all being paid huge sums to drive around in Porsches, but realistically I recognise that this is not going to happen so I suppose... It's a bit of an odd question really.

You're happy with it as it now is?

Yeah, it's just an ego trip.

You're happy with the two hour format?

I just like to hear my voice on the wireless, that's all.

I recognise that no-one else is going to employ me so I have to buy my own radio station to put my own voice out. It's tragic really, I mean I love my mother and... do you really want to hear any more?

Clockwork was one of the first in a resurgence of Rock stations. How do you feel about that?

I'm extremely happy. I feel that the other lot have had it all their own way for far too long. As to whether we had anything to do with the resurgence, I don't know, but it's quite a remarkable coincidence really isn't it?

It's been said that the Birdman sounds like Steve Wright or Kenny Everett.

Yes, I'm quite insulted by that. I rather fancy that Kenny Everett stole one or two of my better ideas and has been making a fool of himself with some of his own ever since. Steve Wright has never particularly enchanted me. He's a

DJ that was killed by having to produce too much in too short a space of time.

What was your favourite moment in pirate radio?

Falling off a tower block. No, my favourite moment was probably when the magistrate was told exactly what it was we were being charged with, theft of electricity, and exactly the amount we were charged with stealing. It was an incalculable fraction of a penny. His eyebrows shot to the ceiling, his face fell and he gave a little speech on how much it costs to bring a prosecution to court and wondered at the incompetence of someone who would bring such a case to court, answering the charge of the theft of less than half a penny of electricity.

Special thanks to Aleks Wright, Terry Anderson, Dave Birdman and the rest of the Clockwork crew. Photos courtesy of Clockwork Wireless.

Tapes of past broadcasts are available from the station. For more information write to Clockwork Wireless. Suite 14. Creasy House. Tower Bridge Road. London, SE1 4SL. enclosing a stamped addressed envelope.

Clockwork Wireless broadcasts from 7-9pm on Sundays on 90MHz FM. For more information see AM/FM.

Radio Today

For today's listeners and tomorrow's broadcasters

#17: April/May 1988. £1.40

REWIND '87
The events behind the dial last year

VOTE!
Your chance to pick the top DJs and stations in London

CHARLIE WOLF
Writes with his Letter from America

NEW RADIO
What you could be tuning into next year

AM/FM
The complete guide to radio in London: BBC, Independent and pirates

**FREE INSIDE!
PULL-OUT LONDON
TUNING GUIDE**

HYPE!
THE MUSIC BIZ TAKES CONTROL OF YOUR EARS

TX17: APRIL 1988

upFRONT

Caroline off air after laundry basket catches fire! The station was using said basket as part of its temporary aerial system after its 300 foot mast collapsed when it caught light. **A**nother **Lenny Henry** series at the **Brixton Broadcasting Company** is in the pipeline. Will the former **JFM** theme crop up as background music in this one too? **F**ed up with the usual car stickers and T-shirts that all radio stations sell? Latest promo from the States is a radio set on your station's frequency that can't be tuned. **T**he result of *that* **LWT** programme 'exposing' the pirates: the airwaves even fuller than before and lots of record companies interested in getting their records powerplayed. **N**ew **Capital** recruit **Pat Sharpe** was hiding his marriage to 'protect' his career. The powers that be didn't want a teenagers' idol that was happily married. **D**id you know **CFM** was a illegal? We've had our doubts confirmed: it was listed in a recent survey of pirates in

> *"Starforce will be on the air in two weeks"*
> **Starforce spokesman on far too many occasions to remember**

the **Independent**. **B**est competition was the one held by **Nick Power** on **Kiss-FM** to guess the name of **Michael Jackson**'s new album. "Send your answers to **BAD** competition at..." **P**epsi-Cola want to sponsor the **Top Forty** as used by **Radio One**. The BPI want the deal to go ahead, but the **BBC** say no as it would mean plugs for Pepsi on the Sunday countdown. **L**WR have launched their own version of New York soul station **Kiss-FM**'s famed **Mastermix Dance Party**. The **Saturday Night Bust-Up** will take place on 92.5 from 7pm. **I**n January, **LBC** had a second late night discussion for a couple of hours on the future of radio with **Tony Blackburn, Bob Harris** and **Clive Bull**. The last time they did this, they started at 11 and didn't finish till 3! **T**here are rumours of a **Country and Western** pirate station in London soon.

> *"As we didn't decide to come on the air until this afternoon, we've probably only got one listener"*
> **SW Sound jock showing amazing restraint for a DJ**

‹‹‹Rewind 1988 (Actually 1987...)

January

DBC returns to the air... **Greek Radio For London** is formed after a split at **LGR**... The DTI use a crane to remove stations' transmitting aerials, hitting **Kiss-FM, LWR, TKO, LGR, GRFL** and also raiding **DLR, Studio 1, Twilight, RFM, CDR, Quest-FM** and **RJR**... Three LWR DJs are fined a total of £1400... A raid on **JBC** is filmed for TV... A JBC DJ is fined £185... More raids at the end of the month...

February

Further tests from the non-starter **Hits-FM**, promising 24 hours of Hot Hits for London... **Girls-FM** makes preparations to take to the air... **Kiss-FM** leaves the air for several weeks after the departure of their engineer... **Clockwork Wireless** begins regular weekly transmissions... New Arabic, Greek and Turkish stations... Another set of heavy raids at the start of the month, with small stations badly hit...

March

Fame-FM returns - but not for long... **TKO** finally begin live programmes... **Sky Radio** launches as a Black community station for South London... **Traffic Jam** takes to the air with its heavy reggae... A **Starpoint** DJ is caught changing the programme tapes at their transmitter site... Internal problems at **Kiss** with DJs reported to be unhappy at having to pay to do shows to keep the station on the air...

April

A good month for new stations... A new Anarchist station, **Radio Interference**, begins broadcasting... **London Town FM**, made up of mostly ex-**Skyline** jocks, takes to the air with pop for South London... **Faze1** launches... **Horizon '87** launches... **Radio Shoestring** returns... Heavy raids first Sunday in April, with 10 stations taken off the air and the DTI removing more aerial masts with their new toy...

May

Heaviest raids to have ever hit pirates in London, with numerous raids at numerous stations... Launches for **Caliber-FM** and **Melody-FM**... Bank Holiday special from **Not Alice's Restaurant**... 2 **Starpoint** DJs fined £300 and £850... **Laser's** boat is hijacked by the boss of **Monique**... Someone slashes the tyres on the DTI's car whilst they are raiding **LWR**... LWR suffer a series of heavy raids continuing into June...

June

Faze1 claim they are having their transmitters stolen by **TKO** - who deny it and say it's just the DTI... For the 3rd month running, the DTI are out with the crane on the first Sunday of the month... **Fresh-FM**, a split from **Time Radio**, launches... Hard times for the Greeks who seem to be all raided within hours of returning... **WLFM** with pop for Middlesex and **Asian Community Radio** with for East End launch...

July

Much quieter at the start of July as the DTI crew head off to annoy Liverpool pirates instead... **City Radio**, a split from RJR, takes to the air... Followed shortly after by **WNK**: Wicked, Neutral and Kicking... **London Greek Radio**, after being raided once a week for months have their office raided by the DTI... A few raids at the end of the month - including **LGR** again... **Horizon '87** returns after several weeks absence...

August

Thefts of equipment by person or persons unknown at **LWR, Faze1** and **WNK**... It's 2 all in a football match between **Quest-FM** and the Police... Rumours of the DTI not raiding some stations without large Police back-up... **Raiders-FM** rises from the ashes of **London Town FM**. **London Asian Radio** hits the air briefly... **Girls-FM** returns... **Arab Radio London** launches... Special broadcast by **Flashback '87**...

September

Horizon '87 change their name to **Chicago '87**... **Mainline-FM** launches for a short series of broadcasts... **Solar** start a spell of not managing to complete a broadcast with DTI raids and thefts of their transmitters... Split at **RFM** over 'musical differences'... **Hits-FM** launches with a Saturday oldies service... **Touch-FM** begins testing... A few raids, including small Middlesex station **Radio Badger**...

October

Soul-FM launches... **Radio Duck** returns... **Radio Free London** returns... **Kjazz** returns... **Starpoint** returns... **JBC** is forced to move from its long-standing frequency of 104.7 when Radio One begins test transmissions... Massive storms cause damage at several stations, including **Capital** and **LBC**... **Kjazz** is taken off the air one Sunday by an **LWR** DJ, caught red handed... 2nd birthday for **Kiss-FM**...

November

Solar suffers problems from a high power station **Roots-FM**, who claim to be starting a new reggae service on 93FM... New trainees join the DTI... They raid an advertiser on one pirate station looking for illegal transmission equipment... **Touch-FM** begin live programmes... **Radio London** is threatened with closure... **News Music Radio** launches... **Trax-FM** returns... Greek Radio for London closes...

December

Passion-FM, a split from **Quest**, launches... Raids begin to increase once more... Studios of several stations are hit... **LWR** is busted 4 times in one week... First weekend raids for three months... New Asian station **Sangra Radio** launches... **Caroline's** 300ft aerial collapses taking them off the air - but does anyone notice?... Xmas extensions from **Kiss-FM, Kjazz, RFM, Studio-FM, Melody-FM** and more.

HARD news

Update

Radio Three is to introduce new programmes in an attempt to widen their audience and reach younger listeners.

The first all-day pirate radio news service arrived with the launch of **News Music Radio** on 89.6 FM. The station began broadcasting at the end of last year, but in view of forthcoming licensing and the DTI's efforts to clampdown on pirates NMR has now closed.

DFCM, the new project from the people who started RFM has finally taken to the air on Sundays on 105.5 FM playing heavy rock with a minimum of chat.

While Deptford based **Rock To Rock** were being raided in January, police reportedly sealed off the roads leading to the tower block they broadcast from. The station has been hit continuously since the start of the New Year.

London's most popular rock station **Alice's Restaurant** returned for a special 7th anniversary broadcast on January 2nd and 3rd. Despite an encouraging response they do not have plans to return on a permanent basis.

Tony Blackburn stormed out of the studio in the middle of a recent show on **Radio London**, complaining he could no longer stand the noise of building work in a next-door studio.

The **BBC World Service** has been nominated for a Nobel Peace Prize.

PIRATES FACE £400,000 CRACKDOWN

The Government has announced major new action aimed at ridding the airwaves of unlicensed stations.

DTI minister, John Butcher, announced that £400,000 is to be invested in the Radio Investigation Service, the department that keeps the airwaves free of unauthorised users. He also appealed for pirates to stop broadcasting following the Government's announcement that it is to bringing in new laws to allow the licensing of many new stations.

However, most pirates remain sceptical, especially as it will be at least late 1989 before the first licensed stations come on the air. One station manager told *Radio Today* "That's what we did last time and look what happened: they cancelled the Community Radio Experiment. If they think we'll fall for that one again they've got another thought coming. There's no way we're leaving the air until they come up with an alternative".

ANGER OVER ROUGH ROOTS RETURN

Renegade reggae station Roots-FM has been at the centre of a row over its high power transmissions on the frequency used by Solar 93 since its return a year ago.

Not only have listeners to Solar suffered major interference, but Radio Four has also been blotted out by Roots-FM's back-to-back reggae in many parts of London, leading to a massive protest by listeners.

Solar has also found its transmission equipment sabotaged on several occasions, many people linking this to Roots-FM.

LASER SHIP TO BE SCRAPPED

The MV Communicator, former home of Laser 558, is set to be scrapped in the latest development since the station left the air over two years ago.

After the close of Laser 558 the boat was sold to East Anglian Productions, well known for their offshore radio merchandise. They spent a year renovating the boat before selling it to a Panamanian company who brought the station back on the air as Laser Hot Hits. They then hit financial difficulties after technical failures on the ship meant very few programmes got out.

A new group then became involved, run by an English evangelist who planned to run two services from the boat: Starforce 576 with a Hot Hits format and Harmony 981 with MOR and religious programming. Problems then arose over the deal; a large sum of money from the new project went missing and questions over who actually owned the boat arose. These lead to two boarding parties claiming and reclaiming the boat.

The Communicator was brought in to Harwich on 3 February after supplies of fuel, water and food ran low. Customs and DTI officials visited the vessel and the transmission equipment was made unusable. The evangelist is reported to be selling the boat for scrap, to try and recover some of the money he has lost in the project.

BIG stories

GOVERNMENT ANNOUNCES RADIO EXPLOSION

The Government has announced a massive explosion in the number of radio stations which will be licensed.

There will be 3 new national stations and a large number of new local and community stations under the control of a new radio authority. Stations will be lightly regulated: left to themselves for day to day running unlike existing Independent Radio stations which have to submit plans to the IBA for approval.

A White Paper will be published at Easter which will set out in detail the plans. This will then be presented to Parliament as a Bill in the Autumn and could become law by Summer 1989. The first stations could then be licensed and on the air by the end of 1989.

We take a look at the proposals in more detail on page 8. of this issue.

We take a look at the proposals in more detail on page 8. of this issue.

ARREST WARRANT OVER HORIZON

A warrant has been issued for the arrest of former Horizon Radio boss Chris Stewart over unpaid fines and costs relating to unlicensed broadcasting.

The fines are understood to date back to a court case in 1985, following a raid on the studios of Horizon Radio in the autumn of 1984. At the time Horizon was one of London's most successful unlicensed stations. Chris Stewart is understood to be currently in Spain where he is involved with commercial radio there.

Update

Raiders-FM have increased their power and extended their broadcasting hours. All their DJs, some of the most professional outside the legit system, are now sponsored by small businesses.

Radio Caroline is back on higher power following the erection of a new aerial system.

New black music stations on the air in London since the last issue include PRS-FM, Ice-FM, Classic Radio, Radio Galaxy, Groove Radio, Ram Jam Radio, Passion Radio and Roots-FM. Several more new stations hope to begin broadcasting as we go to press, including **Phoenix Radio** and Good-FM.

Hits-FM threatened to close down after having their equipment continually stolen by another station, but due to overwhelming support from listeners, are now back on the air.

The **Home Office** has announced new rules for special event radio stations, with higher powered AM and FM licenses now available for up to 4 weeks of broadcasting for a specific site at an event.

Recent surveys put up to 70% of listeners tuning in on FM, with AM rapidly dwindling.

Rumours are spreading once more of a new offshore radio station, to broadcast from the **MV Nannell**, now sitting in a Spanish port half equipped for broadcasting.

IBA ACCUSED OF "SCUPPERING RADIO PLANS"

Potential radio operators have accused the IBA of trying to sabotage the Government's plans by letting Independent Radio stations make changes ahead of new legislation.

Stations are to be allowed to broadcast split frequency services, with Capital Radio aiming to operate its Sunday only CFM service 7 days a week by the Summer. Most other Independent stations are also splitting their AM and FM services, afraid that otherwise they will lose one of their channels. In addition, Capital and LBC have both doubled their transmitter power.

The Government were being pressed to stop companies owning more than one station in the same market and to limit the power of stations to more sensible coverage areas. It seemed likely that they would accept these proposals, which would free-frequencies for new stations and make competition between stations fairer.

Many potential broadcasters say that Independent stations should, like them, have to wait until the Government's radio proposals come into effect next year. They feel that these changes will set a precedent, making it difficult to change things afterwards.

EDITORIAL

Stations acting responsibly could find less DTI attention

You can't have failed to notice stories on TV and in the press about violence in the pirate radio world. Although they've made out that this is a far bigger problem than it really is, the few incidents that do occur have far more potential for killing off the pirates than any action by the DTI.

For proof of this you've only got to look back to the sixties. The press, eager as ever for any dirt to pin on something popular, began to print stories of dubious deals, payola and violent incidents. Outside the law and with some stations commanding massive audiences it was inevitable that a few people only interested in making a fast buck would be attracted.

At first people dismissed the stories, but when they culminated in the shooting of the boss of one pirate by a director of another they began to say 'Hey, maybe there's something in this after all'. Finally able to get sufficient public opinion behind them, the Government brought in laws to close the pirates down for good.

If the pirates in 1988 want to stop the same thing happening to them then they have to be whiter than white. Stories which are less than complimentary about the stations are bound to be picked up by the media. The only way they won't is if they don't happen.

Closing down the pirates isn't a priority for the Government – yet. It isn't worth the effort as many of them could be on the air legally in a couple of years. Douglas Hurd even admitted that he hoped they would apply for licenses. However, stories of violence and corruption in the pirate radio world could make the Government change their mind. Let's face it, the DTI are pretty ineffective at ridding the airwaves of unlicensed stations. If the Government backed a real effort then very few would last.

On the other hand, stations acting responsibly could find themselves facing less attention from the DTI in the run up to licensing. This already happens – though of course you'll never get anyone at the DTI to admit it. Surely this is the better choice?

HIT ME!

Ken North tunes in to Hits FM

One of London's most popular pirates that doesn't play soul music is Hits FM. The station began last autumn and although its format is oldies based, surprisingly its DJs are mostly in their twenties.

Tim Stewart is one of the jocks behind Hits FM. He stakes his claim as one of the youngest ever fans of the pirates 'When I was five I was tuning around on a medium wave radio and heard Radio Northsea International. Later I started listening to the landbased pirates, like Radio Jackie, whilst at school.'

He moved to the other side of the dial in 1986, working on Short Wave station Radio Sovereign. 'It was a one-man show, I used the name Tim Stevens at the time. We had loads of letters, including one from a certain Jay Jackson who asked me to change the name of the station. I then met up with Tim Allen and Duck International was born.'

From there he moved via several stations to Hits, helping to mould its format of classic oldies from the sixties and seventies. He was in the original line-up when the station launched one mild Saturday last September.

Hits FM's audience is rapidly growing, pulling in a wide range of listeners. 'We get an amazing response. A lot of people like us and we get loads of phone calls.' There's no hurry for expansion though, 'We'll just see how things go' comments Tim.

AFTER THE IBA

Lawrence Hallett looks at life with a new radio authority. From April 1988.

January 19th was a black day for the IBA. Its worst fears were confirmed when the Home Secretary announced that in his opinion the IBA should lose control of radio and be replaced by a new Radio Authority. (Frantic scurrying in the depths of their headquarters to find the old ITA logos!)

Many people have been arguing for years that the IBA is incapable of running a commercial radio service, let alone community and national radio. Who else could call a system in which more than half the stations run at a loss successful?

Roles

So, assuming the plans don't go the way of the last suggestion, what role will the proposed new organisation have? It would seem from the Home Secretary's announcement that the Authority will be responsible for all UK radio outside the BBC. It will have three major areas of concern: sorting license applications, making frequency allocations and setting programming and technical standards. Doubtless when dealing with London most of its time will be spent on trying to sort out dozens of boring prospective soul stations and attempting to explain to them why playing the same records in a different order does not make for original programming.

So, let's deal with these three areas in turn and look at how the new Authority might deal with them and what problems might arise...

Licence Applications

First off, license applications. If the response to the proposed experiment for just over 20 licenses in 1985 was anything to go by, the first thing the authority should do is buy a large store room and a heavy duty shredder. Last time around, there were literally hundreds of license applications, many of which were simply not worth the paper they were written on. The basic problem was that the Home Office, who were handling the experiment, didn't really have the time or resources to sort out adequate guidelines.

What the authority should really do first is lay out a sensible range of 'Application Notes' to help prospective broadcasters through the licensing process. Granting the actual licenses shouldn't be too difficult, except perhaps in London where chances are there won't ever be enough to go round. Most areas outside the big cities will probably only be able to put together one or two credible applications so the choice shouldn't be too hard.

Frequencies

Like the actual licensing, frequency allocation shouldn't be too difficult outside the major conurbations. I do, however, forsee at least

one possible problem: The BBC. At present the FM band is neatly carved up between the BBC and the IBA. In 99% of cases, the BBC has its little patches and the IBA has the same. All very neat and tidy to the bureaucratic mind, but very wasteful. If community radio stations are not allowed to fill up the gaps between BBC transmitters, there's going to be plenty of empty gaps. And lots of room for pirates to carry on regardless...

Quality Control

I've left the most difficult area till last. Once there are a large number of stations broadcasting, keeping an eye on programming and technical standards will be difficult. Whilst the rules won't be nearly as strict as they are now, the rule of law and 'standards of common taste and decency' (whatever they may be!) will still apply. 'Quality control' will be down to the listener. It will be up to them to make a complaint to the station itself or to the new radio authority, just as listeners can try complaining to the BBC or IBA today. The trouble with this system is that it is open to abuse by organised vocal minorities, like the so-called 'Moral Majority' in the United States.

Technical standards will have to be enforced to prevent interference between stations and to other users. The best way might be to have a system of 'type approval'. Like CBs and cordless phones today, to save having to check every one a manufacturer submits a sample for approval. Unlike the current IBA rules, however, there won't be any restrictions on the type of studio equipment a station wants to use. If someone wants to sound awful by using really cheap studio equipment, that's up to them.

Dark Cloud

There is, however, one rather dark cloud on the horizon. At this very moment the IBA are doubtless busy in the corridors of power persuading MPs and civil servants of the marvel-

lous benefits to be had by simply transferring their radio department to the new authority, lock stock and barrel... a very worrying thought!

To sum up, the new Authority is going to have a big task on its hands. It is going to have to move fast as many groups are impatient to start broadcasting yesterday. It's got to be able to choose the right groups for licenses and its brief will be to add to listener choice. I hope they interpret that as meaning priority is given to community groups who will be able to do something more than copy the existing broadcasters.

Radio Today

For today's listeners and tomorrow's broadcasters

#18: September/October 1988. £1.40

CHART ACTION
The best Deejays and stations in London

ROBOT RADIO
The computer takes over the airwaves

CHARLIE WOLF
Writes with his Letter from America

STEVE WALSH
Farewell to the larger than life DJ

AM/FM
The complete guide to radio in London: BBC, Independent and pirates

FREE INSIDE!
PULL-OUT LONDON
TUNING GUIDE

RADIO NOVA
Inside Britain's first satellite radio station

TX18: SEPTEMBER 1988

RADICAL RADIO ALL FRIDAY,
SATURDAY AND SUNDAY

SAYS THANK YOU TO ALL THE PEOPLE
WHO VOTED US
LONDON'S NUMBER ONE RADIO STATION

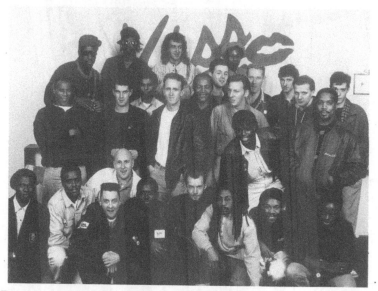

Paul Anderson - DJ Andre - Jazzie B - Matt Black - Daddy Bug
Bobby and Steve - Colin Dale - Colin Favers - Patrick Forge - Eli Hord
Steve Jackson - Joey Jay - Norman Jay - Steve Jervier - Jules - Sammy Lyle
Max LX - Gordon Mac - Mad Hatters' Trevor - Mannasseh - Jonathon More
Nick Power - Danny Ramplin - Richie Rich - Dean Savonne - Jay Strongman
DJ Tee - Dave VJ - Lynsey Wesker

AFTER spending ages ringing the doorbell, **Starpoint** DJ **Chris Philips** was finally forced to throw stones at the window to get let in to the studio. The jock on the air at the time had been irritated by a flashing light in front of him and unscrewed it, not realising it meant there was someone at the door. PRIZES you'd rather not have: one of **John Peel**'s gallstones. He was going to give it away following his illness in May. WATCH out for the first £10,000 give-away on British radio. The **Nova Night Network** will be giving away the dosh to the 50th caller who rings in after identifying 3 records being played in the right order. A caller to a **Chris England** phone-in on **RFM** was followed shortly after-wards by the first caller's probation officer, asking if they had her phone num-ber. PIRATES have hijacked two Independent

Radio stations. **Southern Sound** was hit by pirates broadcasting a half hour of banned records and **Radio Mercury** by a group claiming to be **Radio Jackie.** THE name of the new **Janice Long** show on Virgin's **Radio Radio**: Listen With Mother. AND did you notice the stuttering '**Radio Radio One**' jingle played by **Johnnie Walker** on his last **Stereo Sequence**? WATCH the pirates' ratings rise as **Radio London** says a farewell to soul. Once more they're targetting the 'older listener'. WANT to know how much it would cost to run a new authority to run radio in the UK? A million pounds: about the same as the DTI spends keeping the pirates in check. FIRST new pirate on the medium wave in London for years is **Swinging Radio England**: sixties soul, R&B, ska and fast chat go better on AM.

HARD NEWS

Update

New stations on the air since the last issue... Boys-FM (gay), Brittania Radio (Asian), Capital Gold (oldies), County Sound Gold (oldies), Eurojam International (reggae), Galaxy Radio (reggae) Radio Jennifer (rock), JSM (soul), South London Radio (pop/dance), Strong Island Radio (soul), Sunrise-FM, Swinging Radio England (60s soul), WLIB (black music).

Returned since the last issue... Arab Community Radio, Border Radio (MOR), Confidence Radio (reggae), Fame-FM (soul), Hits-FM 98.3 (pop), Joy-FM (soul), People's Choice (soul), Southside Radio.

Vanished since the last issue... CDR, CFM, Clockwork Wireless, DFCM, Radio Gemma, Girls-FM, London Music Radio, Radio Memphis, PRS-FM, Ram Jam Radio, Roots-FM, Soul-FM, South West Sound.

Capital's news magazine The Way It Is has won the gold award for best news programme at the International Radio Festival in New York.

Hard on the heels of Nova's European satellite service comes Rupert Murdoch's Sky Radio. The station will broadcast non-stop pop - no DJs - and commercials to cable systems around Europe for broadcast in shopping centres, etc.

Accounts published by the Radio Investigation Service show that last year it cost them £10,660 for each person convicted of pirate broadcasting. In the year up to April 1988, £800,000 was spent on enforcement activity against unlicensed broadcasters.

The number of prosecutions for unlicensed broadcasting last year was 77, with 75 convictions. This is nearly half the number of successful prosecutions of 1985.

BBC Local Radio journalists staged a strike on July 13 in protest at cuts in the budgets of local radio stations. News was provided at many stations during the day by station management. 10% has been cut from the budget for local stations, and unions fear that this will seriously affect local news provision.

Government axes radio plans

Radio stations hoping for licences could now have to wait at least another two and a half years before they are successful.

It has been revealed that due to pressure of time, the Government will not now be putting a Radio Bill before Parliament this autumn. A new bill, combined with plans for the future of television, will probably now be scheduled for the session to start in Autumn 1989. The first new radio stations would take to the air in late 1990, at the very earliest.

This delay has further angered prospective station applicants, who have already been let down once over 1985's aborted Community Radio Experiment. A limited number of licences were then promised as an experiment to see how specialist broadcasting could work. However, the experiment was abandoned after worries that stations could be hijacked by extremists.

Speaking to radio broadcasters, Home Secretary Douglas Hurd said that despite this delay he was

"ready to look at any proposals for developing independent radio before the new regime takes effect." A plan has been put to the Home Office for the IBA to license a limited number of stations from next Spring, and has met with interest from them.

Several potential broadcasters say they are being forced onto the air as pirates because there is no realistic alternative. Further delays in giving stations licenses could cause severe financial difficulties for many potential broadcasters.

DTI don't know who they're raiding

The House of Commons has been told that 168 raids have been carried out in London so far this year.

However, a list of stations and how many times they have been raided shows confusion over who they have actually raided. London Greek Radio (88.4) and Greek Community Radio (104.5) are listed together, attracting 20 raids together. They also state that "A further eight unidentified stations have been raided on 27 occasions so far during 1988". This poses the question: how did they know it was the same 8 stations they were raiding each time?

Most raided were LGR/GCR, followed by LWR, Sina Radio, Sangam Radio, TKO and Fazel.

Londoners least satisfied with their legal radio

A survey into radio listening in Britain shows that people living in London are the least satisfied with what's legally available on their radios.

Afro-Caribbeans and Asians were also unhappy with existing radio services. 62% of Afro-Caribbeans and 50% of Asians wanted to see their own neighbourhood stations on the air.

While people throughout most of the UK were generally happy with existing radio services, it would appear that those who have heard new radio services from outside the BBC and Independent Radio

system are less content with what the legal radio system has to offer.

45% of Afro-Caribbeans surveyed said they already listened to unlicenced stations. This was not just for music but also for news and information about local events of interest to them.

The report was commissioned by the Broadcasting Research Unit for the Home Office. Listeners throughout the UK were surveyed, with 2 additional surveys of ethnic groups.

There will be a closer look at the survey results in the next issue.

BIG STORIES

Satellite radio services "could be illegal"

There are fears that new satellite delivered radio services carried by Independent Radio stations could be illegal.

Two services are offered to Independent stations for broadcasting through the night. Nova Night Network promises 12 hours of pop based programming from 6pm - 6am with DJs including Timmy Mallett, Tony Blackburn and Paul McKenna.

Radio Radio, a joint venture between Virgin and several Independent stations is less chart oriented. Presenters include Ruby Wax,

Jonathon Ross, Johnnie Walker and Janice Long with a mixture of chat-based and music-based programmes.

However, Independent stations carrying these services could be in breach of the law. Stations are required to carry a suitable amount of material geared to local listeners. They must also avoid carrying material similar to other stations which is inconsistent with local broadcasting.

So far no action has been taken by the IBA to prevent stations carrying these services.

New name and format for Radio London

In a major shake-up, Radio London is set to adopt a new oldies oriented format and take on a new name, probably Greater London Radio.

The BBC's local station for the Capital is to change overnight to its new format, aimed at over 25s. This will take into direct competition with Capital Gold. However, GLR is likely to have a greater 'journalistic input' in the programmes and cover a wider range of music, with more needletime than previously. Names such as Dave Lee Travis and Andy Peebles have been linked with the new operation.

Update

The **Radio Academy**, an association of 'radio professionals' held its annual Radio Festival on 4-6 July. Most of the major figures in the industry were present for 3 days of lectures, working sessions and socialising. Report next issue.

3 people were arrested on top of a South London tower block on July 17. The DTI allege they were installing unlicensed radio equipment.

Radio Mercury has announced plans for a station to broadcast from Gatwick Airport to provide travel information.

Radio Caroline's 558 frequency is now being occupied by a Dutch station broadcasting from their ship. The Dutch service was to have used another transmitter, but delays in equipping the station with new transmitting masts means they have taken over from the English service "for a few weeks."

A special event radio station has been broadcasting at the London Festival, taking place at Alexandra Palace. **Turkish Community Radio** is broadcasting a mix of programmes from 16 July to 8 August from studios at Ally Pally. Programmes go out in Turkish, Hebrew and English, with 1W of power covering the surrounding North London area.

62% of listeners in an LBC phone-vote on the Brian Hayes programme said they did not want more radio stations in London.

TKO, one of London's leading soul stations for three years is now understood to have closed down. The station was heavily targetted earlier in the year by DTI investigators.

West London community radio project **TW Sound** is in difficulties having had its funding axed. There has also been a further split in its management, leading at one time to two groups claiming to represent the station.

Capital Radio has approached several leading unlicensed radio DJs to see if they would be interested in joining the station. The station is looking to recruit new talent due to its due split-frequency programmes.

DTI given OK to raid stations' offices

Department of Trade and Industry investigators have been given the go-ahead to raid the offices of pirate radio stations.

This follows a test case against London Greek Radio. The station was in court at the start of July on charges of unlicensed broadcasting. The magistrate was asked to decide whether a raid at the offices of LGR could be carried out as part of the DTI officers' investigations.

Following the court's decision, a raid was carried out at the offices and studios of Fazel-FM in Brix-

ton. A large quantity of paperwork relating to the station was removed and two people were arrested. Fazel told *Radio Today* "It looks like that's how they'll be working now."

Many other stations now fear that they too could be targetted. The DTI have been employing a former policeman to work on the business aspects of pirate radio. From the information he has gathered, investigators hope to hit unlicensed broadcasters more effectively. They admit that previous action has not always been effective and stations have not

been deterred, with the prosecution of station staff having little effect on broadcasting.

As well as setting a new precedent, the case against London Greek Radio was the longest ever against an unlicensed station. At Highgate Magistrates Court, staff and companies linked to LGR were fined a total of £13,900 plus £10,550 costs, also a record amount.

LGR plans to appeal against the fine, and continues broadcasting to the Greek community of London every day.

Life At The Top

Aren't most polls around Christmas? Yes, well this one started out that way, but you know how things are. So, here were are in Summer '88 with the results.

One name remained top of the station chart throughout the voting. Ladies and gentlemen, for the second year running, London's number one radio station... Kiss-FM. "We're really pleased about it," Kiss-FM's Gordon Mac told us. "It's good to know radio connoisseurs still appreciate our kind of radio".

It was a tough fight, though. LWR were close behind all the way, chased by big Time Radio. Among the legits, Radio One beat Capital, with Radio London trailing quite a long way down the chart. The number of votes cast in the lower half of the chart was quite small, with not a great deal in it between the stations.

Second year running, the number one station didn't manage to get the number one DJ. This year that honour went to LWR jock Jasper. The Vinyl Junkie's excellent lunchtime show seems to be more popular than ever, with his wide range of music and talent for spotting new hits. Kiss did, however, get the largest number of jocks in the chart with newcomer Matt Black their top DJ. One point to note, though, not a single female DJ made it to the chart.

Thanks to everyone who voted. As promised we've pulled some names from the hat. £10 record tokens go to Steve Sexton, Paul Sawyer, Sarah Redfern, Richard Blake and Malcolm G.

Steve Hamley

Yesterplay

For many years FM has been the poor relation of AM. Despite the superior quality, and easy handling of stereo, radio audiences were weaned on Medium and Long Wave. The first local radio stations came out on FM only, and had virtually no listeners whatsoever. Everybody stuck to AM.

Radio services have correspondingly always broadcast their mainstream programmes on AM, and placed their specialist minority interest programmes on FM. Then, during the 80s the technology got better. Slowly, it had dissolved the problems of flutter and interruption that had previously made FM reception unattractive to listeners on the move or with portables.

It's also easier to broadcast on FM. AM requires 50m long wire aerials, and dozens of earthing rods hammered into the ground. FM only needs a simple aerial, like those used for domestic rooftop reception, and to be high in the air. London is perfect for FM broadcasters with the thousands of Tower Blocks that infest the city. So, that's the band the pirates decided to use during the late 70s, that eventually led to the explosion of the mid-

80s, when hundreds of stations filled the FM band and only a handful actually had licences.

Those that did have licences, such as Capital, still carried on thinking their listeners were tuned to the AM frequencies, so continued to use the FM for specialist minority interest services such as the adult oriented rock CFM.

However, urged on by the better technology, and because of the pirate boom, over a very few years the emphasis has changed. Researchers have alarmingly discovered that less than a quarter of London's radio audience are tuned to AM. This panicked the BBC so much that they opened a London FM service for Radio One 18 months ahead of schedule.

At Capital, they immediately axed their yuppie CFM service, and replaced it with

Eirewaves

I don't know where Mr Eric Gotts - chief pirate buster of the DTI - spends his hols, but I bet it's not Ireland! For Ireland, unlike Britain, has a 'free' system (or non-system) of radio. That might change soon as the government there is again making noises about 'outlawing' the pirates, but at present virtually anyone can start their own station without hindrance from the state.

The progress of Irish radio from the days of state monopoly to the present time when, owing to a loophole in the law, there are around 90 independent stations, is charted by Peter Mulryan in this history of Irish broadcasting. History can be boring, but Mulryan brings it alive in the first chapter. Later he shows why Ireland's young people voted with their ears for the pirates, when the buccaneer broadcasters appeared in a big way in the seventies.

The 'super pirates' such as Nova and Sunshine are covered, but the smaller ventures, some of them run as a hobby, are remembered as well. We also see that there's more to unregulated broadcasting than music and fun - especially when hard-nosed businessmen get involved.

Unfortunately, Radio Radio shows signs of hasty editing with several errors of fact. Nevertheless, it is attractively laid out with many photographs. I recommend it to any non-technical enthusiast.

Roger Tidy

Radio Radio - The Story of Independent, Local, Community and Pirate Broadcasting in Ireland by Peter Mulryan. Borderline Publications, Dublin. £5.95. Available by mail order from Anoraks UK.

Winkies' Radio

Listening to pirates in London, you could be forgiven for thinking they were exclusively for young people. But, take a listen to Border Radio and you could be surprised.

Up till recently, the station broadcast on the same frequency as JBC. Geographically, there were about eight miles between the stations; culturally they are light years apart. Border Radio, and in particular its founder Harry Marshall, appeal to an older, 50+ age group living in the suburbs of South West London. Harry's request show, consisting of music from films and shows as well as 'standards' from the fifties and sixties, conveys a marvellous sense of friendship and compassion between presenter and listener.

The concept of Border Radio represents a unique approach to community radio, appealing to a group of listeners that are totally neglected by other stations in London. The style of presentation and music probably don't appeal to most *Radio Today* readers, but do take a listen to the station if you are in their area. It'll open your ears to a completely different aspect of pirate radio.

Ken North

Border Radio broadcasts on 105.3 FM to West London every Sunday night.

more mainstream pop. Research also indicated that it was the youth listening to FM. Capital responded by increasing the dance music content of their service presented by younger DJs.

Across the country, the search was on for something to put on the AM transmitters that didn't require the high quality or stereo of FM.

It was the older generations that were tuned to AM, so they must be the target audience, programmers thought. Since most people over the age of 25 generally become pre-occupied by the 'good old days', tending to dislike anything new or innovative, they must be played old music. To still be able to sell advertising, the audience couldn't be too old. Older folk don't buy a lot of the products the

commercials have to offer. No, to make money, the target audience had to be under 45.

Twenty years ago, this would have meant playing big bands, swing orchestras, and reminders of the 1930s and 1940s. An audience well catered for by the BBC on the Light Programme of 20 years ago, and Radio Two subsequently. Despite a slight glitch, Radio Two has stuck firmly with the same audience since 1967, and now broadcast to pensioners who wish to continue reliving their 'good old days'.

The 'good old days' of the 25 to 45 year olds means the pop music of the 1960s and 1970s. Interest in this time also extends to the younger generation, who have had it pushed down their throats by those in the music

business who haven't changed since the 1960s. Apart from the many thousands behind the scenes who all started together in the 60s, there are the stars like David Bowie, Paul Macartney, Alan Freeman, and Tony Blackburn. Apart from all having their roots firmly attached to the 60s, they constantly seem to harp back to those days in public. This, of course, rubs off on the youngsters of today, who have all become caught up in the 60s fever.

So, there you have it, an ideal solution is to play 'oldies' and get not only the older, but also the younger generation tuned in. The only problem now is: What if the oldies service becomes more popular than the mainstream service?

Chris England

Rank	(Prev)	Station	Frequency
1	(1)	KISS-FM	94FM
2	(3)	LWR	92.5FM
3	(-)	TIME-FM	103.9FM
4	(4)	STARPOINT-FM	93.2FM
5	(7)	SOLAR 93	93FM
6	(-)	RADIO ONE	104.8FM
7	(5)	JBC	104.3FM
8	(-)	CAPITAL RADIO	95.8FM
9	(10)	TKO	102.4FM
10	(-)	STUDIO-FM	92.7FM
11	(-)	FAZE1-FM	90.9FM
12	(-)	HITS-FM	105.5FM
13	(-)	FRESH-FM	103.3FM
14	(-)	RADIO LONDON	94.9FM
15	(-)	RJR	90FM
16	(-)	CAROLINE 558	558AM
17	(-)	SKY RADIO	91.7FM
18	(-)	RFM	94.3FM
19	(-)	PASSION RADIO	90.6FM
20	(-)	CLOCKWORK WIRELESS	90FM

THE CHART

Rank	(Prev)	DJ	Station
1	(11)	JASPER	(LWR)
2	(-)	MATT BLACK	(KISS)
3	(6)	CJ CARLOS	(TIME)
4	(2)	JONATHON MORE	(KISS)
5	(5)	TIM WESTWOOD	(CAPITAL)
6	(4)	YOMI	(LWR)
7	(3)	NORMAN JAY	(KISS)
8	(-)	CHRIS NAT	(TIME)
9	(17)	CHRIS PHILIPS	(STARPOINT)
10	(7)	GORDON MAC	(KISS)
11	(-)	JUDE JAMES	(SOLAR)
12	(-)	STEVE WRIGHT	(ONE)
13	(14)	NICKY LAWRENCE	(SOLAR)
14	(16)	LOUIE ST CLARE	(TKO)
15	(-)	GILLES PETERSON	(LONDON)
16	(-)	DJ WILBUR	(STARPOINT)
17	(-)	PETER PHILLIPS	(CAROLINE)
18	(-)	LARRY JAZZ	(STUDIO)
19	(-)	MARCONI	(HITS)
20	(-)	JOHNNY WALKER	(ONE)

SUNDAY

6AM	Clive R	Solar 93
	Gospel	
8AM	Jay Dee	RTR 90.2
	Soul, funk & jazz	
11AM	Jay Strongman	Kiss 94
	The Warehouse Sound	
12AM	DJ Wilbur	Starpoint 93.2
	The Killer Groove Show	
1PM	Tim Allen	Hits 105.5
	Oldies & loadsa jingles	
2PM	Casey Kasem	Chiltern 97.6
	American Top Forty	
4PM	Chris Nat	Time 103.7
	Hip Hop	
7PM	Anne Nightingale	One 104.8
	Requests	
9PM	Charlie Gillett	Capital 95.8
	World Music	
11PM	Nicky Horne	Radio Radio
	Classic rock	

MONDAY

6AM	Ron Brown	County Gold 1476
	Oldies, news & travel	
10AM	George Power	LGR 88.4
	Greek music and chat	
3PM	Steve Wright	One 104.8
	Pop, true stories & more	
9PM	Barry B	LWR 92.5
	Live mixing	

TUESDAY

7AM	Dave Sebastian	Passion 90.6
	Soul	
1PM	Tony James	210 97.1
	Pop	
8PM	Max Rheinhart	Classic 105.5
	The global jukebox	
10PM	Gilles Peterson	London 94.9
	Jazz	

WEDNESDAY

12PM	Chris Johns	Fresh 103.3
	Soul	
4PM	Chancellor D	RJR 90
	Reggae	
10PM	Neil Fox	Capital 95.8
	Late night pop	

THURSDAY

7AM	Noel Callender	Time 103.7
	Soul	
1PM	Jasper	LWR 92.5
	Soul, funk, rap & house	
10PM	Peter Philips	Invicta 103.1
	Late night pop	

FRIDAY

1PM	Nicky Lawrence	Solar 93
	Soft soul	
4PM	Jonathon More	Kiss 94
	The Meltdown Party	
8PM	Larry Jazz	Studio 92.7
	Funk	
10PM	Bob Harris	LBC 97.3
	Nightline phone-in	

SATURDAY

12AM	Tim Westwood	Capital 95.8
	Hardcore rap	
7AM	Tony Blackburn	Gold 1548
	Oldies	
11AM	Gordon Mac	Kiss 94
	The Saturday Stuff Show	
2PM	Roger Scott	One 104.8
	The Stereo Sequence	
7PM	Saturday Bust Up	LWR 92.5
	The non-stop dance party	
6PM	Pete Tong	Capital 95.8
	Soul	
9PM	Brian Anthony	CD/93 93.2
	CD music	

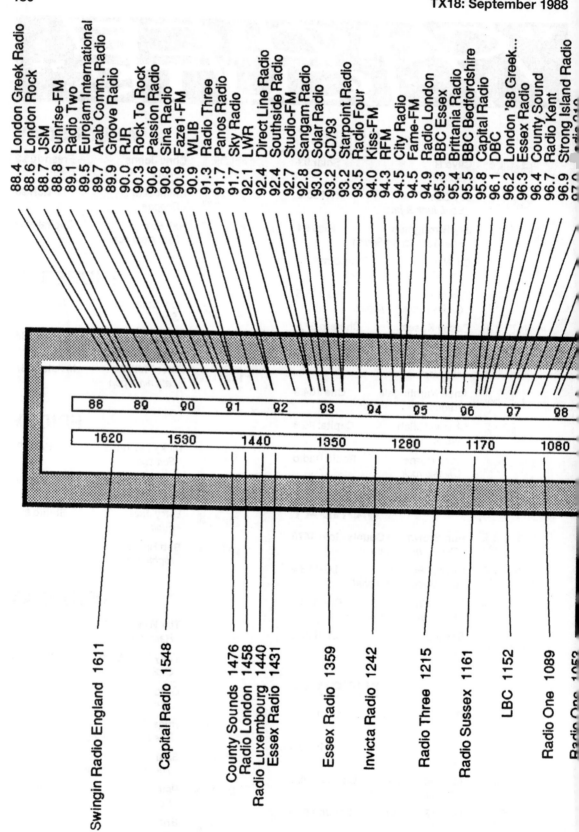

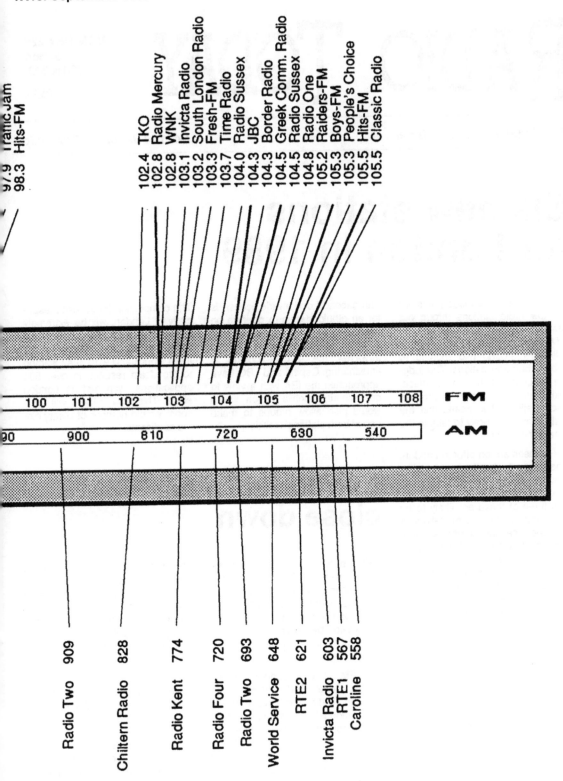

97.9 Traffic Jam
98.3 Hits-FM

102.4 TKO
102.8 Radio Mercury
102.8 WNK
103.1 Invicta Radio
103.2 South London Radio
103.3 Fresh-FM
103.7 Time Radio
104.0 Radio Sussex
104.3 JBC
104.3 Border Radio
104.5 Greek Comm. Radio
104.5 Radio Sussex
104.8 Radio One
105.2 Raiders-FM
105.3 Boys-FM
105.3 People's Choice
105.5 Hits-FM
105.5 Classic Radio

100 101 102 103 104 105 106 107 108 **FM**

90 900 810 720 630 540 **AM**

Radio Two 909
Chiltern Radio 828
Radio Kent 774
Radio Four 720
Radio Two 693
World Service 648
RTE2 621
Invicta Radio 603
RTE1 567
Caroline 558

RT1: January 1989

RADIO TODAY

BCM Box 225
London
WC1N 3XX

01-400 8282

The Radio Today Newsletter

No. 1: 4 January 1989. 45p

Six new stations for London in 1989

The IBA has announced plans for 20 new radio stations throughout Britain. The first licenses will be advertised on January 9th. Groups will have around two months to submit their applications. The judging process will then take place, taking around a month to process each station. This means that the first stations are likely to take to the air around March.

Six licenses are on offer in London. There are to be four community stations, serving Brixton, Highgate, Hounslow and Thamesmead. The first three of these are likely to be predominantly ethnic-based stations, serving perhaps Afro-Caribbean, Greek and Asian communities respectively. The Thamesmead license is almost certainly to go to Radio Thamesmead, which currently operates a service over the area's cable system.

There are two Londonwide licenses. The first of these is for a Community of Interest station, broadcasting on FM. This is likely to have the strongest competition out of all the licenses. Groups seeking this license include several former pirate stations, including Kiss-FM, LWR and Alice's Restaurant, as well as many major corporations. These include Hanson, who plan a sweet music service for the over fifties, and the hotly tipped Classic Radio, who want to run a classical music station.

The second Londonwide license is for an ethnic station to operate on AM. To allow as many groups as possible to have access to the airwaves, the IBA is looking at timesharing. Capital and LBC have approached the IBA with a view to co-ordinating such a station, which would also allow groups to make use of both stations' facilities.

The competition for licenses, especially in London, will be extremely tough. The response to the IBA's initial request for groups to tell them where and what they wanted to broadcast resulted in over 500 applications, with 181 in London alone. This means there will be a considerable number of disappointed applicants.

London pirates close down

1989 sees London's airwaves minus many of its most popular unlicensed stations. In order to apply for licenses, and avoid a five year ban on pirate staff being employed by licensed stations, many of London's pirates have left the air.

Kiss-FM, LWR, London Greek Radio, Solar, JBC, WNK, South London Radio and Crystal Radio are amongst the stations which have decided to close down. All are now concentrating their efforts on winning a license, so they can provide their successful services legally.

Most stations closed down on New Year's Eve, the day before a new Government ban came into effect.

This makes it illegal for licensed stations to employ anyone convicted of unlicensed broadcasting for five years. The effectiveness of this ban has yet to be tested, with only a tiny minority of the people involved in unlicensed broadcasting ever getting successfully prosecuted.

However, the DTI have said that they will consider all stations left on air as not being interested in applying for licenses and will treat them accordingly. This is widely taken to mean that there will be an increased effort at ridding the airwaves of pirates. In recent months there has been little action against illegal transmissions, except where interference is being caused to other services.

Editorial

So what's happened to Radio Today then?

Well, the truth of the matter is this. Due to a combination of financial difficulties and a lack of time to spend on the production of Radio Today, our full magazine has had to be put on hold for the time being.

In its place for now we'll be running a series of newsletters like this, to keep you up to date with events on the London airwaves. We hope to be publishing approximately every three to four weeks.

For Radio Today we are looking for backing to establish the magazine as a proper publication, with full distribution, monthly publication and improved production.

However, this will take time. We hope that these Radio Today Newsletters will provide an acceptable substitute for now. If you would prefer to have the money remaining from your subscription returned to you, then please write and we will be happy to refund you.

Best wishes for 1989,

Steve Hamley, Editor.

TX Services

- Back issues of TX Magazine #5 - 12, price 75p and Radio Today #14 - 18 price £1.00 are still available. Cheques should be made payable to TX Publications at BCM Box 225, London, WC1N 3XX.
- Radio Today listings are available for use in other publications. Please contact us for details.
- Available soon will be comprehensive listings of London radio stations with contacts, addresses, telephone numbers, DJs and formats for use by PR companies, record pluggers, etc. We are also working on a fact sheet explaining the current laws relating to pirate radio.

New plans to kill pirate stations

DTI minister Robert Atkins has announced new plans to help in the fight against unlicensed stations. As well as setting up many new radio stations, this autumn's Broadcasting Act will also include tough laws against pirate stations.

It will be an offence to advertise on pirate stations, or supply them with goods or services, including records and tapes. Fines will be massively increased, with a new top fine of £25,000 being looked at.

In his speech, Robert Atkins also condemned the Lenny Henry Show. He claimed that it glamourised pirate radio and encouraged people to imitate the show and start their own stations.

The BBC have pointed out that Delbert Wilkins did in fact get a job on the BBC World Service at the end of the last series. A new series is not being planned. However, the DTI say that unless something is done they will consider taking matters up at a higher level. They are also understood to be unhappy at Lenny Henry's links with former unlicenced station Kiss-FM, where he is President.

Sunday Sport plans radio station

Sunday Sport are making moves into UK Radio. The paper's publisher, David Sullivan, has already acquired a number of shares in Independent Radio stations. Now he is considering plans to start a station programming a mix of top forty music and the sort of news stories that have made Sunday Sport famous.

Needletime restrictions axed

Restrictions on how much music stations can play are to be removed. A report by the Monopolies Commission says that stations should be allowed to play as much music as they like, and that the copyright fees should be in proportion to the size of a station's audience.

Independent stations are already allowed to play more music, as a result of a separate deal with PPL, the group which collects royalties on behalf of record companies. However, so far not all of the stations appear to be programming more music. It has been suggested that after years of using their DJs to fill up the airtime, they now can't get them to shut up...

Capital attacks pirates

Capital Radio Chairman Richard Attenborough has demanded further action to be taken against pirates in the station's annual report. He also welcomed the new rule banning anyone convicted of unlicensed broadcasting from working on a licensed station for five years. Capital currently employs five DJs who have moved from unlicensed stations less than five years ago.

Surveys

Since November we've been running surveys on the Radio Today phoneline, where you get the chance to vote on topical news stories.

For our first survey we asked callers what they thought of Greater London Radio. In an overwhelming thumbs down, just 4% of callers said they liked the new programmes. 76% said they'd much rather have back the continuous music the station was playing in the run-up to its launch. 12% wanted to see Radio London back on the air and 8% said they thought the station should close. A large number of callers told us they thought that there was too much chat on the station. Many were also disappointed that the new station didn't live up to the hype. Several said that unlike Radio London it offered nothing to black listeners. We'll be finding out your views on the station again once it has had more of a chance to settle down.

The biggest response was for a poll on whether Essex Radio was right to ban acid house from the station. 60% said they thought the decision was wrong, 40% thought it was right. There were a few house fans though who thought the ban was right as it would take the music back to its underground roots. Altogether, 189 people voted.

In our last survey of '88, Radio Today callers gave the thumbs up to Capital Gold. 62% said they would be tuning in to the station, with 38% saying they wouldn't. Not surprisingly, most of the people who said they liked the stations were over 30. However, there were quite a few younger listeners, the youngest being 14. The biggest complaints about the stations were that there was too much music from the fifties and sixties, too much chat and the low quality of sound on FM.

More polls are planned for '89, we'll be bringing you the results in future Newsletters.

Airwaves

Arrivals

Radio Argus 98.4, promising rock for SE London from early '89.

Big Apple Radio 102.5FM, with soul music.

Breeze-FM with soul music. Not known if on air yet.

Broadway-FM 106.1FM, with soul to SE London.

Capital Gold 1548AM, with 24 hour a day oldies.

Channel Radio 105.5FM, with soul music. Not known if still around.

Cityside Radio, a name change for the top forty Hits-FM.

Friction Radio 91.05, with a soul service.

IBMS 97FM, with a reggae service. Fronted by former Radio London reggae presenter Tony Williams. Thought to now have closed.

GLR 94.9FM/1458AM, with soft rock and chat during the day and specialist shows in the evenings and through the weekend.

Laser-FM 95.4FM, with a pop format over Christmas.

Laser-FM 94FM, with soul music.

LNO 98.3FM, broadcasting evenings and weekends. After a few technical problems it is not known if the station has continued.

The MusicBox 99.6FM, broadcasting every Sunday to North London with a hit music service. Just one full broadcast has gone out, due to operational difficulties.

People's Radio 103.7, with a reggae service.

Pioneer Radio 105.5FM, with a soul service to South London. Yet to return from a raid following interference to Gas Board emergency communications.

Q-102 102.4FM, kicking off on New Year's Day. The station features DJs from CD-93 and Solar, with a rock service during the day and soul and jazz in the evenings.

Stage-FM 98.0, with a soul service.

Switch-FM 98.1, with soul and reggae from former Faze1 DJs.

Radio Veronica 101.8, with an oldies service every Sunday afternoon and evening.

Departures

BCCR 88.6, after a few weeks of soul and Bengali music programmes.

CD-93 93FM, following a split between the station and Starpoint, some of its DJs going on to form Q-102. Starpoint continues.

Crystal Radio 92.4FM, to apply for a license.

Radio CTN 106.3FM, with Gospel Music after a short spell of operation.

Hits-FM 98.1FM, due to having their transmission equipment stolen on several occasions. Station DJs have now split 3 ways, to Radio Veronica, to The MusicBox and to RFM. Or combinations of all three...

JBC Radio 104.3, to apply for a license.

Kiss-FM 94FM, to apply for a license.

London Greek Radio 88.4FM, to apply for a license.

LWR 92.5FM, to apply for a license.

Raiders-FM have now relaunched as an FM oldies and album tracks station called Magic-FM.

Red Hot FM 98.1FM, after just one broadcast and despite strong backers. The station may still return to the air.

WNK 102.8FM, to apply for a license.

Errors and ommissions? Let us know on 01-400 8282 and we'll correct them next issue.

Asian Community Radio 103.3FM
Asian programming to North West London, 7 days a week.

Radio Bedfordshire 95.5 FM
The BBC Local Radio station for Herts, Beds and Bucks.

Big Apple Radio 102.5 FM
Black music to South London 7 days a week.

Breeze-FM 94.0 FM
Soul music to South London every weekend.

Broadway-FM 106.1 FM
Soul music to South London every evening.

Greek Comm. Radio 104.4 FM
Greek Radio to North London 24 hours a day.

Capital Radio 95.8 FM
24 hour a day pop to London and surrounding counties.

Radio Caroline 558 AM
Live from the North Sea with current hits and classic oldies.

Chiltern Radio 97.6 FM
Non-stop hits to Herts, Beds and Bucks, 24 hours a day.

Cityside Radio 98.4FM
Back to back top forty hits 24 hours a day

Classic Radio 94.3 FM
Black music to South London 24 hours a day.

County Sound 96.4 FM
Independent radio for Surrey & Hants, 24 hours a day.

Direct Line Radio 105.2 FM
A mixed bag of shows going out on Bank Holidays to S. London.

BBC Essex 95.3 FM
The BBC Local Radio station for Essex.

Essex Radio 96.1 FM
Independent radio for South Essex, 24 hours a day.

Eurojam International 89.5FM
Soul, Reggae and more to North London 24 hours a day.

Radio Four 93.5FM
The BBC's network news and speech service.

Fresh-FM 103.3FM
Black music to North West London 24 hours a day.

Friction Radio 95.4FM
Soul to South London every weekend.

Radio Gemma 105.8FM
Rocking North West London every Sunday lunchtime.

Greater London Radio 94.9FM
Rock and talk in the day, specialist shows evenings & weekends.

Groove Radio 93.8FM
Black music to South London 24 hours a day.

Hotwire Radio 105.2FM
Soul to South Essex and NE London every Weekend.

IBMS 97.0FM
Black music to North London, 7 Days a week.

Invicta Radio 103.1FM
Independent Radio for Kent, 24 hours a day.

Joy Radio 97.85FM
Soul and Reggae to London, 7 days a week.

Radio Kent 96.6FM
The BBC Local Radio station for Kent.

Laser-FM 94.0FM
Soul to the Capital, 24 hours a day.

LBC 97.3FM
The Independent News & Information station for London.

London '88 Greek CR 96.2FM
Greek Music for North London, 7 Days a week.

Radio Luxembourg 1440AM
Pop music from the Grand Duchy, daily 7pm-3am.

Radio Mercury 102.8FM
Independent Radio for North Surrey, 24 Hours a day.

Meridian Radio 90.0FM
Soul to SE London, 7 Days a week.

Middlesex Music Radio 105.8FM
Pop for NW London every Sunday evening.

Radio One 104.8FM
The BBC's network pop and rock service.

Passion Radio 90.6FM
Black music to South London, 24 Hours a day.

People's Radio 103.7FM
Black music to South London, 7 days a week.

Q-102 102.4FM
Rock in the day, soul and jazz in the evening, every weekend.

Radio Reflection 92.9FM
Reggae and Soca to London Town

RFL 92FM
Soft rock on Sunday nights from the longest running pirate.

RFM 94.3FM
Classic rock to North London every Sunday.

RJR 90.0FM
Reggae, Soca and Soul to North London, 24 hours a day.

Rock To Rock 90.2FM
Black music to SE London, 24 hours a day.

Sky-FM 91.7FM
Black music to South London, 24 hours a day.

Stage-FM 98.0FM
Black music to South London, 7 days a week.

Star Radio 93.1FM
Reggae and Soul to London Town, 7 days a week.

Starpoint Radio 93.2FM
Cliche free Jazz, Soul, Reggae, humour and more each weekend.

Stomp-FM 105.4FM
Beaming soul to London from Essex every weekend.

Studio-FM 92.7FM
Pure soul music for North London every weekend.

Sunrise-FM 88.7FM
Soul music for East London, 7 days a week.

Supreme Radio 90.4FM
Black music for North London, 24 hours a day.

Radio Sussex 104.5FM
The BBC Local Radio station for Sussex, Surrey & Hants.

Switch-FM 98.1FM
Black music to South London, 7 days a week.

Radio Three 91.3FM
The BBC's network classical and serious music service.

Time Radio 102.2FM
Black music to NW London, 24 hours a day.

Radio Two 89.1FM
The BBC's network Easy Listening service.

Radio 210 97.0FM
The Independent Radio station for Berkshire.

Radio Veronica 101.8FM
Solid oldies to North London every Sunday.

World Service 648AM
The BBC's worldwide service of news, music and features.

WLIB 90.9FM
Community Radio for East London, 7 days a week.

Lightning Source UK Ltd.
Milton Keynes UK
UKHW030634051022
409964UK00014B/1179